HISTOR'CA[...]TION CENTER
3 Ea[...]
Vermillion, S.D. 57069-0417

P9-EDB-639

HOW TO PHOTOGRAPH
BUILDINGS AND INTERIORS

Princeton Architectural Press, Inc.
37 East 7th Street
New York, New York 10003
212.995.9620

©1993 Princeton Architectural Press, Inc.
Printed in Canada
96 95 94 93 5 4 3 2 1
All rights reserved.
No part of this book may be used or reproduced in any manner without
written permission from the publisher except in the context of reviews.

Book design: 2^b Group
Editing and layout: Clare Jacobson
Special thanks to Judy Blanco, Scott Corbin, Antje Fritsch, Stefanie Lew,
Laura Mircik, Erika Updike, and Ann C. Urban—Kevin C. Lippert

Library of Congress Cataloging-in-Publication Data
Kopelow, Gerry, 1949-
 How to photograph buildings and interiors / Gerry Kopelow.
 p. cm.
 Includes index.
 ISBN 0-910413-70-3 :
 1. Architectural photography. 2. Photography—Interiors.
 I. Title.
TR659.K66 1993 92-5784
778.9'4—dc20 CIP

HOW TO PHOTOGRAPH BUILDINGS AND INTERIORS

GERRY KOPELOW

PRINCETON ARCHITECTURAL PRESS

To my friend and mentor in architectural matters, Ron Keenberg.

I am grateful to Peter Lindsay, Professor of Photography at Ryerson Polytechnical Institute, Toronto, for his meticulous technical review of the text. Special thanks to my wife Lorna and my children Leo and Sacha, who tolerated and understood my regular disappearances as I traveled the country for my architectural clients. Heartfelt thanks to Clare Jacobson, my editor at Princeton Architectural Press, for her subtle and intelligent modifications to my work.

Technical Notes
My main camera for architectural work is a Toyo 4x5in view camera, with which I use several Fujinon lenses. Since films have improved substantially in the past few years, I have been able to do more work on medium format—I use Hassleblad cameras and lenses on a regular basis. When assignments call for 35mm slides, I switch to Nikon equipment; the Nikkor 28mm perspective control lens is my most frequently used optic.

Except where otherwise indicated, all the photographs reproduced in this book were made with Kodak color negative films—principally Vericolor III—and printed on Kodak Ektacolor RA paper. I hand processed all materials in my own darkroom.

For critical work in both large and medium formats I always make test exposures on instant film. My favorite materials for this purpose are Polaroid 54 (4x5in) and Polaroid 664 (medium format).

The line drawings were created by Leo Kopelow and computer-enhanced by Steve Rosenberg of Doowah Design, Winnipeg. High-resolution printouts were provided by Ed Beddam of BW Data Services, Winnipeg.

Photo Credits
Cheryl Albuquerque: 14, 15, 59b, 62b, 99, 116.
Michael Holder: 8, 30, 31, 54, 59t, 62t, 63, 98, 117.
Kodak, Canada: 118.
All other photographs by Gerry Kopelow.

CONTENTS

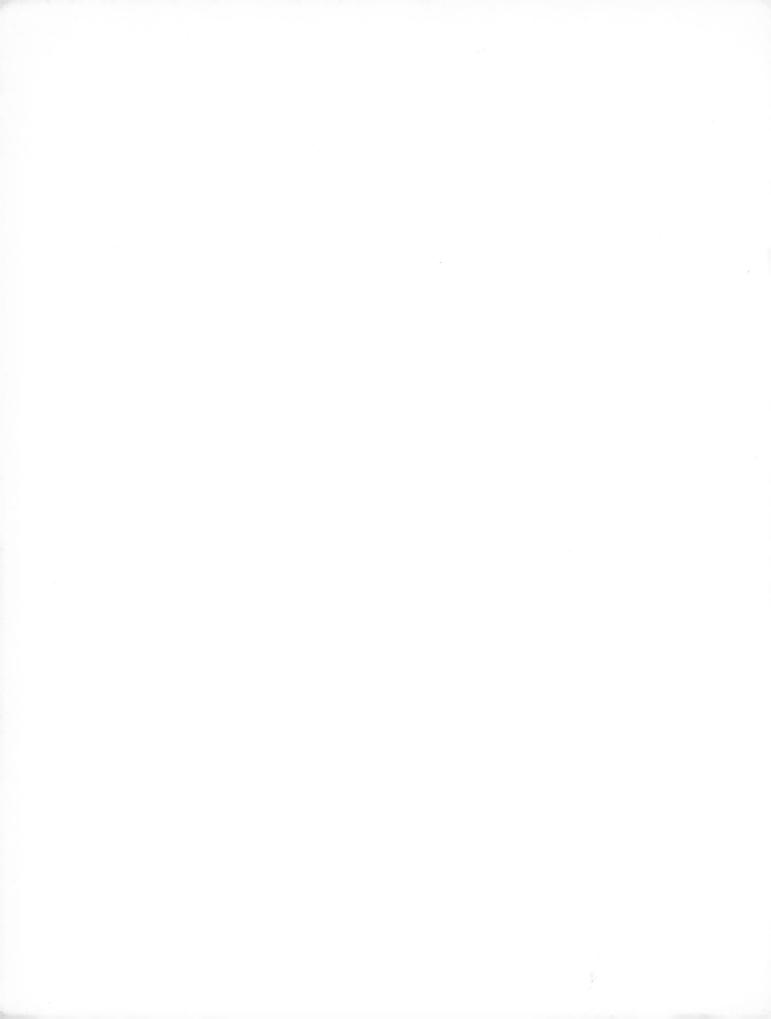

INTRODUCTION

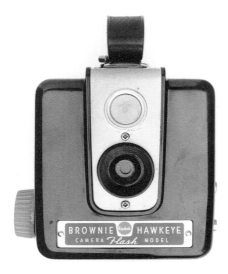

Two versions of "you push the button, we do the rest" cameras—a 1950s vintage Kodak Brownie Hawkeye and a 1990s Minolta Freedom 101.

INTRODUCTION

In the early days of photography, when everyone used simple box cameras to take black-and-white family snapshots, Kodak advertised their services with the motto "you push the button, we do the rest." Today, with an abundance of sophisticated tools available for both professional and amateur photographers, the implied message remains the same: technology will make the picture.

Unfortunately, auto-everything cameras do not and cannot make "good" pictures all the time. Some human intervention is required to elevate what would otherwise be an ordinary, if technically adequate, snapshot. A little investigation into the process of producing photographs that transcend the mechanical reveals that even in today's micro-chip environment, the aesthetic sensitivities and technical judgment of human beings are paramount.

This book is intended to help those people who require excellent photographs of buildings, inside and out. Regardless of whether those photographs are obtained through the services of a professional or an amateur photographer, the process will be facilitated with a basic understanding of photographic technique. Acquiring such knowledge need not be an intimidating proposition. Keep in mind that despite the complicated bells and whistles that are flogged so insistently at the camera store, photography's 150-year-old mystery—how best to make two dimensional representations of three dimensional objects—is not so much a technological problem as an intellectual one. Architects, interior designers, heritage preservers, and city planners are, likely, already well-prepared for the task. Anyone with some knowledge and appreciation of the design and structural elements of buildings has potential as an architectural photographer or an informed purchaser of architectural photographs.

THE CURRENT STATE OF ARCHITECTURAL PHOTOGRAPHY

People who need good photographs of buildings are plagued with the same frustrating paradox that confounds consumers of many other goods and services: they are propagandized by the media. Because of its effectiveness as a selling tool, excellent photography is now commonplace. Well-produced magazines, in particular, condition us to very high visual expectations. National and international architectural journals regularly publish wonderful color photographs and we readily absorb these images, assuming unconsciously that what we see so often must be easily accessible. When the time comes to buy or make such photographs on our own, however, there is inevitably a certain "reality gap" between what we want and what we get. The current state of affairs finds most practitioners caught somewhere between the slick work of first-class professional architectural photographers and the fuzzy, off-color efforts of the office novice. The discrepancy between what is seen in the glossy trade journals and what is possible in real life can be narrowed by common-sense practices that can be learned with a little effort. The first step is a study of results obtained by the published professionals.

Any respectable journal will include a range of images, most made by paid professional photographers working on assignment for the magazine or on behalf of the contributors. The best work will be distinguished by natural color, an abundance of detail, pleasing lighting, controlled representation of vertical and horizontal lines, and a suitably graphic composition that affords the viewer an exciting and/or informed look at the building.

Much goes into making such extremely effective images. The photographer and client must be able to understand one another, the photographer must be sufficiently skilled so that all the technical variables will be well-managed, and the production values of the printing process must be high enough to accurately reproduce the original photographs. That this occurs often and consistently in the well-known publications means that at least some users of architectural photography are well served.

However, what is in the magazines is not necessarily typical of general conditions, because what the media does best is reproduce many copies of few pictures. These pictures then become visual icons and the object of photographic envy. In reality, most "working" architectural images do not get industry-wide exposure. Instead, they are made and used locally as documentation for ongoing projects, as samples for practitioners' portfolios, as support material for proposals, and more. These pictures are made by all sorts of people, the majority of whom are not professional photographers, usually because of budget

restrictions. Most users of these images would prefer that they reflect the highest industry standards but, for a number of reasons, accept work of substantially inferior quality.

THE PURPOSE OF THIS GUIDE It is my intention to provide a compact and informative handbook of architectural photography that will serve as a reliable reference to professional users of architectural photographs.

First, the special problems and advantages of working with a professional photographer will be examined with a view to making the collaboration of end user and producer as efficient and enjoyable as possible. In this scenario, a knowledge of photographic technique is not required. However, an appropriate vocabulary for discussing such specialized work will be provided and thoroughly explained.

Next, the production of in-house photography will be extensively discussed and analyzed. Here familiarity with the technology as well as the vocabulary of photographic practice is a necessity. A little patience will be required as, step by step, a working knowledge of both the basics and the subtleties of photographic architectural documentation is acquired.

Finally, I will offer advice to aspiring or established professional photographers who would like to excel at architectural work.

EXPECTATIONS AND BENEFITS By discovering and appreciating how professional photographers think and work, you can direct them more effectively as well as evaluate the work they do for you more competently. You will save time, money, and frayed nerves. By going further into the process and learning how to do some of what the professionals do yourself, you will save even more time and money, but there will be an added bonus: personal satisfaction.

People with an interest in improving their visual skills can expect to produce pictures that will be acceptable for publication, and more than acceptable for many less glamorous purposes. The difference between "acceptable" and "inspired" is something you must provide yourself. However, the difference between "acceptable" and "unacceptable" can be learned. Likely you or your photographically minded associates already own a 35mm camera, so aside from a little time, film, and processing, the lessons will be relatively inexpensive.

The final benefit, and perhaps the most significant, is a qualitative improvement in your ability to communicate. All photographs are evidence, visual proof of some situation or condition. To whatever purpose a photograph is put, there is a transfer of a unique kind of information that cannot be conveyed by words. Making better photographs means this highly subjective and rather tenuous process will be much more straightforward.

I WORKING WITH A PROFESSIONAL

12

WHAT A PROFESSIONAL PHOTOGRAPHER DOES

DEFINING THE JOB Anyone can take a picture, and these days, with wonderful films and cameras so easy to obtain, the average picture is not half-bad. Even so, "not half-bad" is not good enough for most commercial purposes. (By "commercial" I mean any application where the photograph is used to support or sell some activity, or any service associated with doing business.) When reliable results of very high quality are required, when the picture must come out every time, the first and often the best resource is a professional commercial photographer, someone who makes a living by selling photographs produced according to clients' specifications.

Unless you are living in a very large urban center, or unless you have the money to import a specialist from out of town, it is unlikely that a professional photographer who specializes in architectural photography will be found close at hand. In virtually every community, however, there will be one or more individuals who are reasonably competent at a number of photographic disciplines. I have already defined a professional photographer as someone who produces photographs as a business for other businesses. In all but the most sophisticated markets, such people must of necessity be competent generalists, and they do a credible job shooting in a wide range of situations. The difference between the generalist and the specialist will be the experience they each bring to the task and, consequently, the efficiency with which the job is completed. Both varieties of photographer must approach architectural photography with a specific arsenal of technical skills and equipment, supplemented with an intellectual and aesthetic gestalt similar to, or at least compatible with, that of an architectural designer.

All commercial photography requires the production of photographs that are technically excellent and aesthetically appropriate. However, dealing with buildings and interiors introduces a number of variables that are not necessarily common to other types of photography. First, buildings and rooms are larger in scale than most objects the typical commercial photographer has to deal with. Outsized subjects require special wide-angle lenses and a substantial investment in powerful lighting equipment. Second, architectural

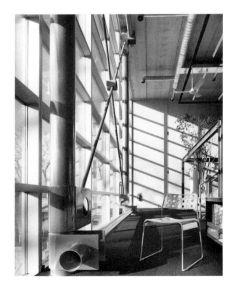

This office is a cement slab box with glass ends. The chair provides a sense of scale. The wind-stress support is clearly delineated just inside the glass curtain wall. This image shows the dramatic effects of the mid-morning sunlight. The grid pattern on the far wall echoes the pattern of the window mullions. Camera: Toyo 4x5in, lens: 90mm (moderate wide-angle), film: Kodak Vericolor III Type S. Perspective controls were required.

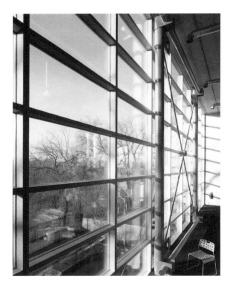

This is a simplified version of the first image. The composition was streamlined by moving to a higher camera position and angling the camera to eliminate everything except the window and chair. Camera: Toyo 4x5in, lens: 75mm (extreme wide-angle), film: Kodak Vericolor III Type S. Perspective controls were required.

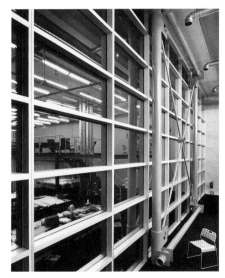

Similar nighttime view of the office back wall. The dark window makes a dramatic backdrop for the structural elements while the diminishing reflections add depth and a sense of the room. Camera: Toyo 4x5in, lens: 90mm (moderate wide-angle), film: Kodak Vericolor III Type S. Perspective controls were required.

subjects (except for renderings and scale models) are situated in their own unique (and immutable) settings. That is to say, variables such as camera position and color balance are to a large degree predetermined by existing conditions and not totally controllable as they are in a studio. Third, there is formidable physical effort associated with architectural work: the equipment is heavy, bulky, and delicate, and consequently difficult to transport to, from, and around the job site. Since much of the work is done outdoors, the work is compounded by the vagaries of weather and seasonal conditions.

The foregoing is not intended to discourage those who would like to retain a commercial photographer, but rather to point out that first-class architectural work involves some effort, and anyone who can make a living (or part of a living) at it is probably sensitive, intelligent, and physically fit.

I will discuss the specifics of selecting a professional photographer shortly, but it makes sense to provide a job description first. I believe the following criteria define quality architectural photography:

1. The image must be clear, with an abundance of detail and consistent focus.
2. The color must appear natural and appropriate for the scene.
3. Perspective and point-of-view should be natural and pleasing.
4. Sun angle, sky conditions, and seasonal variations should be appropriate.
5. The subject must be portrayed in its proper context relative to the site.
6. The scale of the subject must be properly established.
7. Location photos must be made discretely, with consideration for the occupants.
8. Deadlines and other professional obligations should be scrupulously observed.

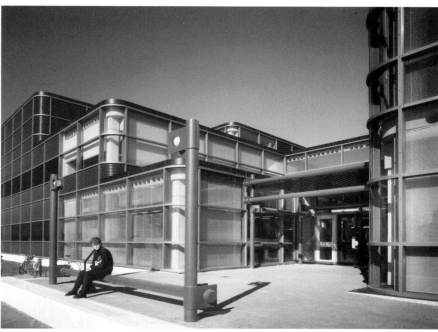

The superior photographer will fulfill these requirements and still display a degree of individuality. Clients are required to be realistic about the potential of specific projects.

IKOY Architects' Earth Sciences Building at the University of Manitoba. I included a curious student to give a feeling for the scale of the project, but also to show how the structure and its embellishments are put to use. Camera: Toyo 4x5in, lens: 90mm (moderate wide-angle), film: Kodak Vericolor III Type S printed on B&W Kodak Panalure paper. Perspective controls were required.

THE LARGE-FORMAT ADVANTAGE In this chapter I will point out those factors that distinguish one professional from another. There is, however, one notable factor that distinguishes the professional from all but the most sophisticated amateur: large-format view cameras.

Most people are familiar with miniature-format cameras that use 35mm film. The term "35mm" refers to the actual width of the film stock, but, because of the area lost to the double row of perforations, the image area is only 24x36mm. Still, many modern films do a very good job of holding detail, considering that a standard 8x10in enlargement involves a magnification of about seven—more if the image is cropped.

As both an amateur and professional format, 35mm is popular because the cameras and lenses are small, light, and easy to operate as well as relatively inexpensive to buy and run. Despite these obvious advantages, the prolific midgets are not the favored tool of the professional architectural photographer. In fact, most published photographs of buildings and interiors have been made with picture-taking machines that look very much as they did in the nineteenth century. Just like their ancestors, today's view cameras are equipped with an accordion-type bellows and a ground-glass focusing screen that is typically viewed from underneath a dark cloth. The modern large-format camera is in fact a genetically accurate descendant of the earliest view-cameras, and can only be used mounted securely on a tripod.

Although the basic physical configuration has endured for over a hundred years, some things have changed. First, the original cameras were made of hand-crafted tropical woods, while the modern view-camera is wrought from exotic alloys and space-age plastics that have been finely machined for precise fit and repeated adjustment. Second, advances in

film technology have allowed the cameras to be sized down to a degree, thus making them much more manageable; today the most common size uses 4x5in film, as opposed to the 5x7in, 8x10in, 11x14in (and beyond) in vogue years ago. Nevertheless, some die-hard perfectionists still use gigantic view cameras for special projects.

Regardless of twentieth-century refinements, the view camera is a clumsy giant compared to the slick "35," so it must have some impressive advantages to retain such a loyal following among pragmatic professionals. There are two big pluses: image quality and image control. The quality factor is a simple function of size. An 8x10in enlargement from a 4x5in negative is a magnification of only two, so every aspect of image integrity is easily preserved and mechanical faults minimized. Detail and tonal gradation are excellent. Color saturation is spectacularly rich. And, as an added bonus, the large images are easy to view without a loupe or magnifier at the editing stage.

None of the elements of image quality are difficult for the nonprofessional to appreciate. The degree of image control that the view camera offers the competent professional is not so easy to understand without some theoretical background.

HOW THE VIEW CAMERA WORKS The view camera, or technical camera as it is sometimes called, provides a wonderfully clever system of opto-mechanical adjustments that allow precise control over field of view, focus, and perspective that no other camera system can emulate.

Ordinary cameras are rigidly constructed so that the lens and the film are always held in a particular alignment to one another. Although the lens is focused by mechanically varying its distance from the film, the mechanism by which it is moved is carefully designed so that the axis of the lens always maintains the same orientation relative to the film plane. Thus, the lens and the film may not always be the same distance apart, but, in all conventional solid-body cameras, a line drawn through the exact middle of the lens will always be located perfectly perpendicular to the film plane and always in a position that is perfectly centered within the image area. View cameras are designed to be similarly rigid and precise, but the alignment between the lens and the film plane is not fixed. Instead it may be adjusted and then locked in position. These adjustments (or movements) make the view camera a powerful and versatile photographic tool.

The modern view camera is constructed from a modular system of interlocking parts that may be selected by the photographer according to the requirements of various types of work, but the basic configuration typically consists of a rigid bar or tube (called the monorail) on which are mounted front and back standards linked by a flexible light-tight bellows. (The flatbed camera or field camera is an alternate configuration that is collapsible and lighter in weight, thus more portable but significantly less adjustable.)

The standards are sophisticated mechanical supports for the lens and the focusing ground glass/film holder. They are built to allow all the movements necessary for complete image control. They can be moved forward and backward (focus/magnification), up and down (rise/fall), and side to side (shift). They can be rotated around a vertical axis (swing) as well as tilted forward or backward around a horizontal axis (tilt). Fancy view cameras achieve the movements by manipulating precision geared mechanisms with finely calibrated vernier dials, while less expensive versions use friction-dampened sliding controls. All view cameras have some method of freezing the adjustments (lock) so that nothing changes just before or during the actual exposure.

View camera movements have three main functions: control of magnification, focus, and perspective. Control of magnification is sometimes important when making precise copy photographs of renderings or of architectural models. Focus control and perspective control are critical when making architectural photographs of rooms and buildings. For example, a street-level, wide-angle view of a tall building with a landscaped courtyard in the foreground might require a perfectly vertical rear standard to keep the image of the structure rectilinear in appearance, a substantial rise on the front standard to bring the top of the building into the field of view, and, in order to shift the plane of focus to include the complete foreground, a slight forward tilt of the front standard. The variations are subtle and endless and magnificently effective. Professionals cope with the long set-up times, the expense, and the physical burdens because the images that may be achieved with view cameras are consistently superior to those of other cameras. (See chapter 3 for more information on view cameras.)

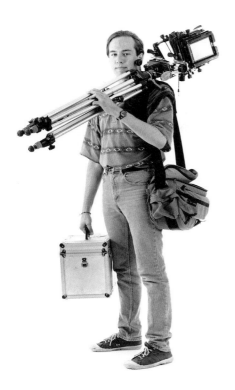

Photographer apprentice Leo Kopelow demonstrates my method of carrying around a 4x5in kit for available-light photography. The soft case holds twenty-five 4x5in film holders, while the hard case holds lenses and other accessories. A dark cloth is used as a shoulder pad to cushion the weight of the camera/tripod combination.

HOW A PROFESSIONAL CREATES A PHOTOGRAPHS Big cameras are not a guarantee of success in architectural photography. The technology must be in place, of course, but the real work is intellectual in nature, and requires a tricky balance between aesthetic and practical considerations. The process is called "previsualization," and it involves the assimilation and analysis of all information concerning the purpose of the photograph, the nature of the subject, the budget, and the expectations of the client. The term "previsualization" has a respectable pedigree: it was first introduced by the venerable nature photographer Ansel Adams as a compact way to describe the essence of the Zone System, the sophisticated method of exposure control Adams developed with Fred Archer.

Clients of competent professional photographers must expect to answer the following questions when a job is in the preliminary stages:

1. What is the purpose of the photography?
2. When is the photo required?
3. What is the state of completion of the subject building?
4. Is the landscaping in place?
5. Is the building occupied?
6. What is the orientation and material of the main facade?
7. How many different views are required?
8. Are architectural details and embellishments to be photographed separately?
9. Are there any special features that the client wishes to highlight?
10. Can furnishings and artwork be moved around during photography?
11. Is access to the site restricted to any particular time of day?
12. Is access to the site restricted by other structures nearby?
13. Is the client willing to arrange access, security, and site clean-up/preparation?
14. Will the client attend the shoot?
15. For out-of-town jobs, how will parties deal with time lost to bad weather?
16. Is the photographer's client the architect, the architect's client, or a magazine editor?
17. Who will evaluate the work and how will any costs for reshooting be handled?
18. Who will own/store the negatives after the job is done?
19. What is the budget, and who is to be billed? (see #16)
20. Will the client attend a pre-shooting walk-through of the project?

As these questions are answered the photographer will assemble a visual database that will assist in the selection of equipment and photographic approach. Every assignment is different. A tour of the site will suggest certain times of the day/year and certain camera angles. The client's expectations and budget will determine the degree of effort necessary and/or possible. Before the photography begins, most of the technical and artistic decisions will have been made, although flexibility and adaptability are necessary to cope with on-location variables such as weather and the activities of other people in or around the building.

Seasoned professionals are so good at previsualization that they can discuss the proposed photo as if it were a real object, although certainty will be moderated by common sense and no promises will be made that cannot be kept. The degree to which the description of the previsualized photo matches the picture that is actually delivered is a measure of a photographer's abilities.

PRICING Aside from simply having to get the job done well, the cost of architectural photography is a fundamental concern for any client. Even the most well-established firm might hesitate to spend thousands of dollars for a comprehensive photographic documentation of a large project. Those unfamiliar with the price structure for professional work are often alarmed to learn the facts, and might quickly decide that first-class photography is financially out of range.

Although there will always be wide variations in pricing from place to place and between photographers working in different circumstances, some typical scenarios can be drawn by examining the evolution of a "day rate" for a well-established commercial photographer (a generalist of the type discussed earlier) who is asked to produce some first-rate views of a new building for publication in a national journal.

Most of the photographer's time is probably spent shooting a variety of assignments for advertising agencies, graphic designers, institutions, and corporations. Some of the work is done on location, but much is done in a studio (which the photographer owns or

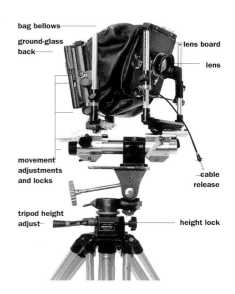

bag bellows
ground-glass back
lens board
lens
movement adjustments and locks
cable release
tripod height adjust
height lock

My battered and often repaired Toyo 45g 4x5in view camera with bag bellows and movements.

16

rents) under controlled conditions. This necessitates a sizable investment in lighting paraphernalia. Since the 4x5in view camera is the advertising industry standard for critical work as well as the camera of choice for architectural work, the basic equipment is close at hand. (Although much of the equipment used for commercial work is suitable for architectural work, some specialized items may have to be purchased. Three or four ultra-wide-angle lenses, at $1000 each, are commonly required for shooting buildings and interiors but not essential for the majority of regular jobs.) Of necessity, the photographer will also own a complete 35mm kit. A medium-format camera, using 60mm roll film is a mandatory, but expensive, requirement for commercial work. Very likely the photographer will maintain a darkroom for processing black-and-white, and possibly color, film and prints. Large-volume studios and the occasional perfectionist may also invest in equipment to process color transparencies.

Working tools quickly add up to an investment of between $100,000 to $250,000, excluding the cost of renting or purchasing a building in a downtown location for studio and darkroom space. A busy photographer may require a full-time or part-time assistant and a secretary. An agent or "rep" employed to find new clients or attend to existing accounts may get fifteen to forty percent of gross billings. All these expenses can easily create an overhead of several hundred dollars per day.

Other factors, such as a reputation for reliability, contribute to the rates photographers charge: a reputable shooter will guarantee good results first time out, relieving the client of the worry and aggravation of having to reshoot. In the advertising business, where the ability to produce extremely high-quality work in a very short time is critical, fees escalate according to the cost of the campaign. A photographic illustration for an ad in a glossy national magazine (which might charge $50,000 for a one page insertion) may fetch up to $5000, while a similar image for a local newspaper (at $1000 for a full page) may be had for $200 or less. The operating principle here is that the more money is being spent buying the advertising space, the more responsibility rests on the shoulders of the photographer to produce work that justifies the expenditure.

Well-established photographers typically bill at levels similar to lawyers and accountants. A day rate for commercial work, the cost to the client for six to eight hours of a photographer's time, may be anything from $500 to $5000, depending on the circumstances of the job and the particular professional.

The normal day rate for architectural work falls closer to the lower end of the scale. This is because the client, who might be an architect or interior designer, is likely to be the end user of the photographs and will not be reselling them at a profit; the budget for photography will therefore not support higher fees. Unfortunately, we have already seen that the good photographers (consequently the busy photographers) need higher rates to stay in business. In the specific case of photography for architectural journals, the rate structure is depressed compared to advertising photography standards because the photos are to be used for editorial purposes rather than commercial purposes. Even assignments from national magazines rarely exceed $1000 per day.

In addition, most users of architectural photography are ignorant of the incidental costs of producing professional work. Other than the fees to the photographer, the client is ultimately responsible for Polaroid test shots, conventional color or black-and-white film, processing, proofs, and prints (as well as such extra expenses as transportation, accommodation, and meals on location).

The ubiquitous 35mm camera and the processing industry that supports it have conditioned consumers to low prices for photographs. Professional films are produced to much higher standards and in significantly smaller quantities, so they are substantially more expensive than materials intended for the amateur market. A typical professional photograph, produced in 4x5in format, might require the following expenses:

1. One to four Polaroid tests (to check camera alignment and exposure) at $3.00 each.
2. Two sheets color negative film (insurance against mechanical damage) at $3.00 each.
3. Film processing at $3.00 each.
4. Proof print or contact sheet at $5.00 each.
5. Reproduction quality 8x10in enlargements at $20.00 each.

If clients are accustomed to buying blowups for $4.95 at the one-hour photo outlet, $40 or $60 per shot can be upsetting, considering that in an eight-hour day of continuous shooting, a quick photographer can produce thirty or more large-format exposures.

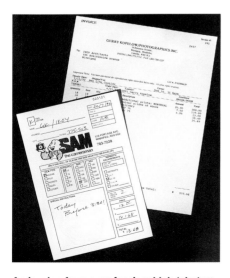

An invoice from a professional lab/photographer and an order form/envelope from a one-hour lab. Same industry, but profoundly different approaches.

There are several other variables that exert upward pressure on the cost of professional photographic services. First, most architectural work must of necessity be carried on outdoors, so the photographer and equipment are subjected to environmental stresses like temperature, moisture, dust, and wind, all of which are destructive to optical devices (and concentration). Second, variations of weather, sun angle, and the seasons sometimes result in canceled sessions due to conditions that are beyond the control of the photographer. Furthermore, location work demands advance planning, site inspections, and a variety of official authorizations.

Because commercial photography is essentially an exercise in control, the politics of the job and other capricious disruptions are disconcerting and, inevitably, expensive. Finally, within the advertising milieu the work of commercial photographers is usually judged by professional buyers of photography, so inconsistent and misguided evaluations, although possible, are rare. When the same photographers work for architects and related practitioners, the evaluation process is usually subjective at best, and often just plain arbitrary. Since the cost of reshooting to the client's satisfaction is often borne by the photographer, some cushion must be built into the negotiated price of the work.

SELECTING A PROFESSIONAL PHOTOGRAPHER

EXPERIENCE AND TEMPERAMENT Finding someone to make reproduction-quality architectural photographs involves a little research and some subjective decisions. The research is necessary just to turn up a few names: the yellow pages in the phone book will list "photographers, commercial," while colleagues and friends will recommend whomever they have been using. Probably the most reliable source will be the art directors at advertising agencies. Since these people regularly risk their reputation and many thousands of dollars of their clients' money on the work of professional photographers, they will know who is good in town.

As I mentioned earlier, it is unlikely that your search will turn up a professional who shoots only architectural work. It is more likely that your search will turn up competent people who have never shot architectural work. Even if you do find someone highly recommended who has shot some architectural work, the next step is the hardest: evaluating their photographic credentials and deciding whether or not you can work together.

Making a determination on a photographer's ability to perform on your behalf is a three-tiered process. First it is necessary to meet the person and, during an interview, make a judgment about character. Next, you will be shown a portfolio, and from that you will have to make a judgment about the quality of the work. Finally, you will have to assign at least one actual job, the results of which will hopefully confirm your choice.

Information about character and temperament will be gleaned in perfectly natural ways. Unless the name was actually plucked from the phone book, some aspects of reputation will be volunteered by whoever recommended the photographer. Look for genuine patience as the central element of the personality in any photographer you may consider. Typical advertising jobs might be conceived, organized, and shot within only two or three days, which is considerably shorter than the time required to design, construct, and photographically document a building. On assignment an architectural photographer stalking a certain shot might be obliged to wait hours for the right sunlight, days for the right weather, or months for the right season.

Since architectural assignments tend to involve extensive planning and the cooperation of many people, tact and consideration are necessary characteristics. Some successful commercial photographers work in a jet-set world of big budgets and bigger egos; in response, they can develop a rather abrasive and demanding personal style simply as a way of getting things done. This is inappropriate in the more measured and conservative environment in which architects and related practitioners function.

Finally, look for a photographer with a quick and original mind and an obvious and natural graphic sense. Much commercial work, although demanding, is highly stylized and rigidly structured. Photographers are generally provided with detailed layouts that must be matched precisely. There is no question that a great deal of skill is required to do this well, but a slightly different process exists in architectural photography. There are no layouts to follow on location; instead, the photographer must walk through and around the structure and extract views and angles that will result in an effective two dimensional

representation of the architect's intentions. As a client, you will depend on the photographer's ability to understand your work, and then respond to it in another "language."

EVALUATING A PHOTOGRAPHER'S PORTFOLIO Should you encounter a photographer who has done architectural work already, his or her portfolio will include original prints and possibly some recent tear sheets of published images. Presumably, anyone who has had work published in reputable journals has the skills that you need. I have already listed what I consider to be the necessary elements of good architectural photography. Nevertheless, trust your own response to the pictures you are shown. Do they evoke a mood appropriate to the subject? Do they accurately convey the intentions of the designer of the building pictured? Do they demonstrably enhance the positive characteristics of the building and minimize its flaws? Do you feel comfortable looking at the photographs, or must you exert some effort to extract the information you want? If your first response to the portfolio is ambivalent, you will likely have a negative reaction to photographs of your own projects produced by the same person. Fortunately, one's initial positive reaction can usually be trusted.

If the portfolio presented by the photographer does not contain specifically architectural images, the process of evaluation is somewhat more convoluted. You will have to extract from the photographs not only whether the photographer is competent, but also whether he or she can be educated (largely by you) to provide the results you need. If you feel out of your depth, perhaps a graphic artist friend might help you with the evaluation. Here are some basic guidelines:

1. The photographs should be clear, detailed, and natural in color.
2. Special effects should have a readily perceived purpose.
3. The graphic approach should make immediate sense.
4. The photos should include examples of first-rate work with all formats.
5. The graphic sense of the photographer will be easier to perceive in a B&W photograph.
6. There must be some photos that show an ability to work with large-scale subjects.
7. Photographers should select images to present that logically apply to your situation.
8. A photographer who shows more than a dozen photos is likely lacking in confidence.

ESTABLISHING A WORKING RELATIONSHIP Once you have found someone whose work and personality appeals to you, the next logical step is to give a test assignment. It should be a simple matter to select a project and describe the kind of photographs required, and then see if the photographer can complete the job on time and within the budget. Things get somewhat more complicated if the final shots are not exactly what you wanted. When the shoot goes well, everyone is usually happy. However, a photographer cannot produce exactly what is requested every time; why this is so, and the manner in which this situation is handled by the client will determine the nature of the relationship between the client and the photographer.

In assigning work, the client has a responsibility to keep his or her level of expectation within reasonable bounds. The experienced photographer will help (basically out of self-defense) by pointing out the limitations of the site and the building from a photographic perspective. Quite often, adjacent structures interfere with the best site-lines; sometimes the orientation of the building or the time of year prevents a decent sun angle. In fact, everything mentioned on the list of what makes a good architectural photograph has some sort of negative manifestation under certain circumstances, and clients must respect the photographer's diagnosis when expectations are being formulated.

The most difficult of all of these possible negative factors (and unfortunately, one that sometimes remains unspoken) is the architectural design of the building in question. Architects view their projects in the same way most people view their own children; they should always look good in a picture. The forces of ego work so strongly that even when presented with photographic evidence of deficiencies in the building, the unrealistic client would rather shoot the messenger than admit to any shortcomings in his own work. Such a client tends to try out one photographer after another, seeking the one who has the magic touch that will turn a sow's ear into a silk purse. Personal dishonesty is essentially self-defeating. It is in everyone's best interest to be profoundly realistic about the visual potential of projects that are to be documented.

Many designers make the mistake of assuming that professional photographers will immediately recognize and relate to the subtleties of their work. This assumption can lead to all kinds of trouble, especially at the beginning of the designer/photographer relationship. It is important to remember that in the absence of specific instructions most photographers, particularly those who are not specialists in architectural work, may not immediately understand what is good, bad, or indifferent about the project to be documented. It is only reasonable to point out those elements that are to be featured as well as deficiencies to be avoided or de-emphasized. Clients who avoid this process are like sick people who expect the doctor to guess where they hurt.

EVALUATING THE FINISHED WORK

LOOKING AT PROFESSIONAL PHOTOGRAPHS Excellence is a mark of professional work in any field, and some technical guidelines have already been provided for evaluating architectural photographs. Mastery of technique is a prerequisite, a foundation for the real work of making buildings look great. Everyone involved in the process—designer, photographer, publisher—essentially wants the same thing. However, it falls to the photographer alone to turn expectations and desires into two-dimensional reality. The final photograph is the evidence of how successful the effort has been.

The reasonable evaluation of a professional photograph is a process that begins long before the picture is delivered. In fact, the guidelines are established by the photographer, during the preparation for shooting. Earlier I mentioned the term "previsualization," the mental exercise that allows the photographer to accurately predict what the final images will look like. The wise buyer of architectural photography will become involved in the previsualization exercise during the site-tour, and perhaps at a meeting a day or two later, as a means of establishing what is and what is not reasonable to expect of the photographer. Once this has been established, a reasonable criterion, a reality-based criterion, by which the final images may be judged will have also been established. The evaluation of the photographer's work is therefore not an arbitrary exercise based on the subjective demands of the client; rather, it is a simple comparison between what the photographer said would be delivered and what is actually delivered.

Working together in this way through one or more cycles of previsualization/photography/evaluation will quickly show how trustworthy the photographer's judgment is.

TYPICAL AREAS OF DISPUTE Almost all grief related to architectural photography by professional photographers involves a foul-up in one of three areas: cost, deadlines, and "quality" of the images.

It is only prudent to work out the money matters before any shooting begins. The process of previsualization should encompass the budget as well as aesthetic matters, so the experienced photographer will be able to make an estimate that will accurately predict the amount on the final invoice. It is amazing how often the subject of money is avoided until the job is done and a bill is delivered. There must be some kind of subconscious avoidance mechanism at work that prevents otherwise rational people from dealing with such matters up front. It just does not make any sense.

At the beginning of a professional relationship, it is sensible to have a written quote in hand before giving the go-ahead on any job. It is not unfriendly or mean-spirited to maintain this practice as the relationship matures. Inevitably, a written agreement is protection for both parties. Nevertheless, it is very common in the high-speed world of commercial photography to rely on verbal agreements only; in the event of a dispute, lack of a contract or letter of agreement is a big disadvantage.

Unforeseen circumstances can punch holes in any agreement and some flexibility is required to make things work in the real world. Bad weather, uncooperative tenants, and clients who add to the shot-list while the job is in progress will slow down any photographer. The key to holding the line on costs and deadlines is consultation, however brief, whenever circumstances change. Surprise, not change, is the real killer. Photographers must not assume that clients will accommodate what might seem like unavoidable delays or expenses and clients must not assume that photographers are godlike manipulators of reality. A quick progress report or a civilized inquiry during the work will go a long way towards avoiding disputes later on.

Money and deadlines are fairly clear-cut matters and can be dealt with objectively, especially if a written agreement is in effect. "Quality" is not so easy to pin down, but if the procedures I suggested earlier are followed, really bitter disagreements over the professionalism of the work simply will not arise.

There is one circumstance, however, that can result in major arguments, regardless of the degree of harmony between photographer and client. In this case, the mutual preparations are useless, because there is a hidden client, a third party, that must evaluate the photographs for their own purposes. This happens whenever photographs are intended for publication, or when the client's client will be the ultimate user. In these situations the photographer's client is in reality acting as an agent for somebody else. The wild card is the third party's prerogative of rejecting the work. It is amazing how quickly things change for the photographer when the person for whom the photos were produced is under negative pressure from outside.

This is a circumstance in which the integrity and self-confidence of both photographer and client are tested. Some clients will approve the results of a particular assignment but then, at a later time, will defer to the negative judgment of a third party and demand a reshoot. This, in my opinion, is unprofessional behavior. On the other hand, a client with some backbone and self respect will stand by his own good judgment and support his or her supplier. More often than not, a tactful yet strong show of support will be enough to reverse what is, in reality, a subjective evaluation made at a distance.

CIRCUMSTANCES THAT REQUIRE A RESHOOT From time to time even the most meticulous preparations will result in photographs that are unacceptable. The photographer's client is the ultimate judge, and if the photographer wants the work, the client must be satisfied. A reshoot will only be necessary when a photographer has not delivered what was promised; the promise will have been made and understood early on, so the failure to deliver will be obvious, and the remedy is to do it again. Incompetence is not necessarily the reason for such failures, and a reshoot, although unpleasant and inconvenient, does not necessarily mark the end of a productive relationship. The opposite may often be true. When working with reputable people a reshoot will simply serve to sharpen attention, thus enhancing the process of collaboration and planning on the next go-round.

When the reshoot is precipitated by the photographer's own error, misjudgment, or carelessness, there is no question that the entire cost of the "repair" is his. However, when the client's ambiguous instructions or simple change of mind has caused the problem, the costs should be covered by the client. When the reason for the reshoot falls somewhere in the middle, when bad photos result from assumptions and expectations on both sides not properly resolved in the previsualization stage, a negotiated sharing of expenses is the only acceptable course.

When dealing with a third-party demand for a reshoot, the satisfied client should make the case that extra costs should be covered by that third party, unless this will result in a loss of face that cannot be accepted. Then the client must bite the bullet and pay for the additional work. When budgets are tight and the client/photographer rapport is strong, the photographer may chose to share the burden as a professional courtesy. Should this happen often, however, the client risks losing the goodwill of the photographer.

Any self-respecting photographer will have a clear insight into what is and is not acceptable work. In most cases a good professional will arrange for a reshoot, without even informing the client, whenever the results of a session fall below his or her professional standards. It is not unusual for some tricky shots to be redone two or three or even four times before a particular effect is captured exactly as the photographer wishes. The seemingly high rates of some photographers are calculated to accommodate this level of perfectionism. Bargain-basement shooters do not work in this way because they don't know any better or simply cannot afford the expense. Professionals work in this way when they are paid well enough. Clients who shortchange their suppliers ultimately do themselves an injury.

TRAINING YOUR PHOTOGRAPHER A good commercial portfolio will demonstrate technical skills, and an accommodating personality will assure satisfactory interaction on a human level, but if a reshoot of the first or second assignment is necessary it will indicate that the photographer you have selected needs some instruction specific to the discipline

of architectural work. What is missing will most likely be a subjective element and, consequently something difficult to convey in words. The process of teaching a photographer to properly record your projects is more of an apprenticeship, a transmittal of a design tradition, an introduction to your world view.

My own introduction to architectural photography exemplifies this process. Some fifteen years ago I was starting out as a commercial photographer in Winnipeg, a city of 500,000 in the Canadian midwest. By a stroke of fate one of my clients, a graphic designer, asked me to produce some photographs to illustrate a color brochure he was doing for a group of mechanical engineers. The job involved photographs of several high-profile buildings that the engineering firm had worked on. These buildings were spread out across the country, and one "pretty" image was required for each of them. I would have one day to shoot at each location.

I had no previous experience with buildings, so I treated them like any other product. Because I was unable to consult with the architects, I asked myself what camera angle and what sun angle would best showcase what I felt were the important features of the structures, and, with only a few hours to work, I took my chances with the sky and weather conditions. The resulting photos were simple, but graphically strong. I had responded intuitively to the design of the buildings, and I had good luck with the lighting. The printed brochure turned out to be an attractive piece, and with a dozen copies under my arm I approached some local architects directly, hoping that there might be a market for this type of work.

I had no takers at first, but six months after my "campaign," one firm called me back. They had been short-listed for a major project, but had just lost out. They figured that the deciding factor was that their competitor had a better slide show; it was time to upgrade their library of photographs and the chief of design had remembered my work. He wanted to know if I would be interested in shooting a building they had recently finished.

The job was located in a city a few hundred miles away from home. I packed up my 4x5in gear and flew out there for a day and produced a dozen pleasing views. On my return I printed up some sample enlargements and presented them to my client, who was not satisfied. The pictures were attractive enough, he said, but I had missed shooting the "details." Would I go back again, and work closer to the building this time? This time bring back lots of pictures. He should have been more precise in describing what he wanted, he said. Money was not a problem. I could work for a couple of days if I needed to.

On the second trip I examined the building more closely; the second set of images used the overall architectural design as a starting point, but my main focus was on the components and surfaces of the building, on the mechanical fittings, the details of windows and doors, the textures of the building's skin. I started to realize that a building is more than a product, more than a just a big object. Buildings are densely designed, mechanically layered, sculpturally represented—all the important elements were not accessible in one glance.

When I spread out the second set of enlargements, thirty in all, I was confident that I had been successful in fulfilling the client's demands. Yes, he said this was good, and this was good, and this was good: but of the thirty prints he liked only six. Go back again, he said, and redo this shot in the early evening, just as the sky was turning magenta or dark blue. Reshoot this corner detail, but at sunrise so that the surface just catches the orange glow as it slides around the edge. Yes, this view of the windows on the west side is great, but go back and shoot it again at mid morning when the facade is in shadow. You would get a spectacular reflection of the building next door that will put all the other shots in some kind of context.

So, I went back again, but this time I was working differently. My client cared about his work. My client loved his work. He expected me to understand and to appreciate his work on the most subtle and rarefied levels. Also, he expected me to do my work in the same way—to complement his designs with strong photos that showed what he had done, and why. My client educated me to his needs, and, after that introduction, I was able to regularly (and much more efficiently) provide what he wanted.

II WHEN TO DO IT YOURSELF

TYPICAL IN-HOUSE PHOTOGRAPHY

COSTS AND BENEFITS Professional architectural photography is an expensive proposition. The benefits that result when your firm's work appears in a national or international journal or when new work is brought in because of an impressive photographic presentation do ultimately justify the costs. Nevertheless, image-building is a slow business and a return on investment may be years in coming. The question arises; how can a range of utilitarian and exotic photographic needs be satisfied without breaking the bank?

One solution might be to find a talented photographer just beginning his or her career, and teach them how to do the necessary work. This is a satisfactory approach as long as one is prepared to start again with someone new whenever the first protege evolves beyond one's price range or moves to a bigger or more glamorous market. This can be a yearly cycle with ambitious young photographers.

If the money and the time it takes to "break in" a fresh photographer are obstacles that stand in your way, consider learning to do the photography yourself. You, or someone in your firm, can use the time that would otherwise be spent supervising a professional to acquire the basic technical skills. At the same time, the money, or part of the money, that would have been spent on professional fees and expenses could be spent acquiring the basic tools and materials to produce the work. Of course, an amateur will never be able to compete with a professional all the time, but with the right approach a motivated amateur can do a tremendous amount of pleasing work at a fraction of the cost. At the very least, someone who has attempted to do this work on their own will end up qualified to manage a professional architectural photographer when sufficient funds do become available.

We have seen that the fixed costs borne by a professional can result in a cost of up to $60 per image when that image is produced with several others during a day or half-day of shooting. When only one signature image is requested the tariff can rise to $100 or even $500. Such costs are justified by the equipment, the time, and the talent of the photographer. It is unlikely that a nonprofessional will match the professionally obtained results exactly, no matter how inspired that amateur may be. One major difference, as we have seen, is the formidable technical gap between 4x5in and 35mm equipment.

But let us agree, for the moment, to overlook this opto-mechanical barrier. Can the amateur compete with the professional on the aesthetic level? I say yes, particularly if the amateur is trained and experienced in some other design modality. Even an appreciation of design in some other form—be it architectural, mechanical, or structural—is enough to engender an ability to render a pleasingly composed photograph, provided a minimum of technical knowledge is present as well. Photographic technology is just not so intimidating that it prevents professionals working in some other discipline from learning to use it effectively.

A direct comparison of the costs of professionally produced work and that produced by amateurs is difficult unless the technical approach is consistent for both of them. However, assume that a large-format-equipped professional can produce a decent 8x10in print of a certain building under certain conditions for $150. My opinion is that a well-prepared amateur, using 35mm equipment, can produce an 8x10in print of the same shot, made under the same conditions, for under $25. Now, a "well-prepared" amateur will have spent some money on equipment and some time learning how to use it, but if that is done properly, the only unavoidable difference between the photos will be the technical superiority of large-format cameras over small-format cameras. Again, in my opinion, this technical disparity can be made small enough to be insignificant for many applications.

WHO DOES THE WORK Photographs play a significant role in any marketing or promotional thrust. Secondary uses might be progress reports, historical documentation, or documentation of deficiencies in a contractor's performance. If architectural photography is to be done in-house, it seems logical that the person who has the most pressing need for the photos should actually produce them, or directly supervise whoever does. However a problem arises in pinpointing the appropriate person because each area of photography is important to different people. For example, the partner who is responsible for litigation with a dishonest sub-contractor has a pressing need for clear visual evidence of shoddy workmanship, while the partner responsible for finding new work has a pressing need for strong, attractive images that will showcase the firm's premier projects.

Professional photographers sidestep this apparent dilemma because they usually are people in whom a love and appreciation of the technical and the practical are combined with an active and highly developed aesthetic impulse. Architects fit this same profile to some degree in that all levels of design, from the aesthetic to the mechanical, are major concerns. In actual practice, however, hands-on technical work is often minimal. Selecting structural materials and site inspections are the closest most designers get. The production of decent photographs begins as an exercise in the control of a moderately complicated technical process, and anyone who will do well at it must have an affinity for technology itself. Still, a technician alone cannot produce beautiful photographs: an artistic element must be grafted onto the mechanical.

Every firm will already have established a productive system for the division of labor among members of different temperaments and capabilities. If in-house architectural photography is to be undertaken, then the responsibilities for doing a proper job of it should be integrated into the existing structure, rather than haphazardly imposed upon it. Sufficient time should be taken in the early stages to plan who is to be responsible for what based on interest, capability, and the need to know. Because photography is popularly conceived to be something anyone can do, there will be pressure not to take this process very seriously. It is counterproductive to take this view, however. Later, when the work is flowing smoothly and the benefits of producing the photographs in-house start to accrue, everyone will be pleased.

TYPICAL EQUIPMENT, MATERIALS, TECHNIQUES Most practitioners who attempt to photograph their own work start out with some form of 35mm camera. Occasionally, an instant camera will be used, but only for "quick and dirty" snapshots where the quality of the image is not as important as the content and the speed with which it develops.

Generally slides or prints are shot with somebody's personal camera (likely equipped with zoom lens and auto-exposure) and then processed at the drug-store or one-hour photofinishing outlet. The resulting piles of unedited slides, negatives, and 3x5in prints are stashed haphazardly around the office. A proposal call or a presentation to a prospective client precipitates a feverish search for a few vaguely remembered images, and then a mad rush back to the photofinisher who is hard pressed to produce four or five mushy looking machine-made enlargements by two o'clock the same day. These substandard prints are then meticulously mounted on carefully laid-out and lettered display boards and sent by a courier in a panic to wherever the meeting is to take place; lack of time is offered as the excuse for the poor quality of the photos . . . sound familiar?

The more organized office may already own a 35mm camera, two or three interchangeable lenses, and perhaps a tripod. Whoever heads out on an inspection tour of a job in progress will grab a few shots on the run. When the job is completed, the designer responsible for the project might take a couple of photos before the client or the tenant moves in. Technically, the final images are more consistent because a professional lab rather than the one-hour outlet at the mall does the processing. The prints, negatives, and slides may even be chronologically arranged in a dedicated binder with plastic storage pages. Overall, this approach is superior to the first, but the images themselves, although noticeably better technically, are still just snapshots.

WHEN TO IMPROVE YOUR SKILLS

EVALUATING YOUR CURRENT PRACTICES As I mentioned earlier, we are experiencing a proliferation of highly "produced" images. All printed media, from billboards to soup-can labels, incorporate photographs that are skillfully made and lavishly presented. Popular magazines, professional journals, and gorgeous "coffee table" books regularly deliver first-class architectural photography. Consequently, all of us are fully aware of what level of work is possible, at least from professionals.

We have been educated by a kind of visual osmosis, and it is this unconscious awareness of what is possible that allows a practical evaluation of one's own photographic efforts. Right now, it may not be possible to identify exactly why one photograph is different from another, but certainly some discrepancy is immediately evident. If this discrepancy is creating discomfort when presentations are being prepared and presented, when prospective clients are reviewing your shots of completed projects, or when you are simply looking

for something decent to tack up on your walls at the office, it is time to improve your skills as a photographer.

FORMALIZING YOUR REQUIREMENTS To improve one's efforts requires the establishment of a goal, and a path by which that goal may be obtained. It is not unreasonable to wish to emulate the work of the very best professional photographers, but it may be technically and financially impractical. Let us assume for now that some professional-level work is not impossible for an amateur to produce, given the right tools, materials, and training. At this point it is necessary to determine what the requirements really are, and which of those requirements may be economically and efficiently fulfilled in-house.

Here, arranged basically in ascending order of technical difficulty, is a comprehensive list of photographic problems routinely dealt with by professionals:
1. Copy work of drawings, renderings and perspectives.
2. Progress/construction photos/historical documentation (exterior views).
3. Exterior views of uncrowded, well-landscaped low, medium, and high-rise buildings.
4. Progress/construction photos/historical documentation (interior views).
5. Photographs of architectural models.
6. Interior views of large and very large spaces (available daylight).
7. Interior views under tungsten, fluorescent, or mercury/sodium vapor artificial light.
8. Interior views under mixed artificial light.
9. Interior views as above, but with supplemental photographic lighting.
10. Exterior and interior views as above but in very crowded conditions.
11. Exterior views as above but at night.
12. Exterior views as above but with supplemental photographic lighting.
13. Exterior views as above but under winter conditions.

All the work mentioned can be produced at any of several different levels of sophistication (in ascending order):
1. Legal/documentary.
2. Reproduction-quality black-and-white for newspapers or press releases.
3. Color prints for portfolio/presentation.
4. Reproduction-quality color prints or slides for publication in professional journals.
5. Fine-art-quality prints for display in homes, offices, galleries, and "glitzy" books.

An image that exists on the fine art level can be rendered suitable for legal/documentary purposes, but the reverse is not usually possible.

At some time or other, photographs that represent every combination of these two lists will be required by every practitioner. I suggest that, by extrapolating from my lists, a list of your own be drawn up (arranged in ascending order of importance) that records your requirements from the past couple of years. Add to your list whatever you anticipate will be needed in the near future.

REASONABLE EXPECTATIONS There is no question in my mind that anyone interested in doing so can learn to produce results of portfolio/presentation quality working in the situations one through seven as described above using only a 35mm camera and a modest assortment of accessories. Highly motivated individuals, who are willing to invest more time and perhaps an additional $1500-$2500 in more sophisticated accessories, can expect to add eight through thirteen as well as push their work up to reproduction or even fine art quality in some circumstances.

PROFESSIONAL VERSUS AN ADVANCED AMATEUR In the description of how a professional photographer goes about creating a photograph I indicated that the operative principal was a process called previsualization. In the following chapters technical information and aesthetic guidelines will be offered that will allow those of you who are interested to use this same technique to determine what is and what is not possible for you to undertake successfully on your own. Once you are capable of making this decision reliably, you will know when it is appropriate and financially sensible to hire a professional and when to tackle the job yourself.

EQUIPMENT

VIEW-CAMERA BASICS Although I have assumed so far that any amateur who wishes to do architectural photography will select 35mm cameras as working tools, this need not always be the case. An informed choice of cameras cannot be made without an understanding of the relative advantages of the various systems available. We have already learned that the view camera offers a wide range of technical adjustments, but exactly what these adjustments are and how they facilitate the photography of buildings deserves a little more study. Once an understanding of the control possible with a large-format camera is achieved, the capabilities of small- and medium-format cameras will be much easier to appreciate.

As described in chapter one, the view camera is mechanically configured to allow virtually limitless adjustments to the relative positions of the film plane and the lens. Solid-body cameras need lenses that project an image just large enough to cover the frame from corner to corner, but view-camera movements work only if the projected image is sufficiently wide to accommodate any significant off-axis displacements. Lenses with good coverage and high resolution are difficult to make and expensive to buy, particularly for the extreme wide-angle types so necessary for architectural work. It is encouraging to note, however, that truly excellent large-format lenses are readily available today, whereas even ten years ago they were very hard to come by at any price.

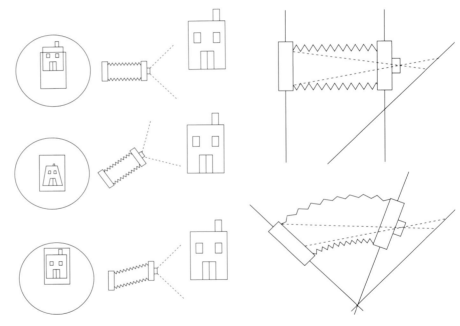

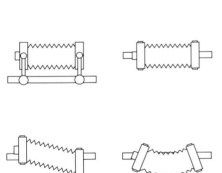

Clockwise from top left: A schematic of a conventional monorail view camera as seen from the side, with no movements; the same camera viewed from the top— again, no movements; a top view showing front and rear swing; a top view showing front and back shifts.

The top figure shows how the image of a tall subject is projected by a lens mounted on a view camera employing no movements. The top of the building is cut off at the film, even though a complete image of the subject is present within the image circle projected by the lens. The center figure shows how the image of the subject changes when the camera and lens are tilted upward. The image of the subject is now within the boundaries of the film, but the vertical lines of the subject now converge. The bottom figure shows how the image of the subject is affected by implementing front rise. The image of the subject is now within the boundaries of the film, and all vertical lines are parallel.

These drawings illustrate the famous Schlemflug principal governing view camera focus-control technique. In the top figure the film and lens planes are parallel, but not the subject plane. The Schlemflug principal states that the image of the subject will be in perfect focus at the film plane only if imaginary lines extended from the film, lens, and subjects planes intersect at a point. The bottom figure shows how front and rear view camera tilts permit this condition to be achieved. Note that projections from the three critical planes now intersect. The subject will now be in critical focus at the film plane.

Front rise is the most useful view-camera control for architectural photography. Ordinarily, if a camera is level and pointed at a tall subject, the top part of the subject will not be visible, even if the camera is fitted with a wide-angle lens. Tilting the camera upward brings the whole subject into view, but the vertical lines of the subject will appear to converge. Front rise keeps the vertical lines parallel by allowing the film plane to remain vertical. The upper part of the subject is brought into view by a vertical displacement of the lens above the center of the film plane (the lens is physically moved upwards), rather than by tilting the camera. (Refer to the accompanying diagrams for a technical explanation of this procedure.) Front fall is used in a similar way when the subject extends below the uncorrected field of view. Rear rise and fall are used whenever front rise and fall is insufficient, but the camera will have to be raised or lowered to maintain the composition.

Front and rear shifts are horizontal displacements of the lens or the film. These controls allow very wide subjects to be accommodated in the same way that front rise and fall accommodates very tall subjects. Sometimes a dead-on rectilinear view cannot be achieved because the perfect camera position is blocked by an obstacle; in such awkward circumstances shifting the lens and/or the rear standard will allow an off-center camera location while still maintaining perspective integrity. This is very useful for shooting architectural interiors and for eliminating bothersome reflections.

Front swings and tilts are focus controls. Virtually all lenses are designed so that the plane of focus is a flat field oriented perpendicular to the axis of the lens. Focus problems arise whenever the plane of focus is not parallel to the subject plane. Such a misalignment occurs whenever the camera must be tilted, for example, to encompass a tall subject. The view camera allows the lens, and thus the plane of focus, to be conveniently manipulated; close and distant subjects may be reproduced in sharp focus by simply tilting or swinging the lens board.

Back swings and tilts are movements of the film plane used to alter perspective, vantage point, and plane of focus. To preserve natural perspective, the subject and the film plane must be parallel. Back swings and tilts are used to maintain this critical relationship whenever the camera must be tilted or angled to accommodate a particularly wide subject that cannot be included even with fully extended front rise, fall, or shift. In such cases front tilt and/or swing is used to restore focus.

On a monorail-type view camera both front and rear standards may be used for focusing. Image size (magnification) at the film plane is a function of the lens-to-subject distance. This is controlled by first setting the lens-to-subject distance on the front standard and then fine-tuning the focus by adjusting the rear standard. Flatbed or field cameras do not usually allow back focusing, so the whole camera must be moved to change image size. This is a limitation in precise studio work, but not a problem for general architectural photography.

Focusing is accomplished by viewing the reversed and inverted image that the lens projects on a ground-glass screen. The shutter must be open and the film holder removed before the image can be seen on the ground glass. Unfortunately, the image is often maddeningly dark and difficult to evaluate, particularly with wide-angle lenses. A loupe or flip-down jeweler's magnifier is an indispensable focusing aid, as is a light-proof, dark cloth to shade the ground glass. Once the photograph has been lined up and carefully focused, the shutter must be closed and a film holder inserted in order to make an exposure. The vagaries of focusing a view camera under difficult circumstances make Polaroid tests for focus and composition indispensable.

View cameras are available in an astounding variety of sizes. Film dimensions range from 2 1/4x2 3/4in to 20x24in. The most common large format, 4x5in, has evolved as the compromise; it successfully balances technical quality, camera weight, and a focusing image that is sufficiently large to view without eyestrain.

SMALL-FORMAT BASICS Miniature cameras forgo almost all the technical advantages of larger cameras in exchange for convenience of operation. In the not-too-distant past, this trade-off made small cameras third fiddle to medium- and large-format cameras, at least as far as professionals were concerned. Recently, however, there have been some changes. Like the internal combustion engine, which has been sustained over many decades by heroic engineering, the 35mm camera has been revitalized and elevated by several scientific advances, particularly in film technology. Fortunately for 35mm enthusiasts,

small-format images are noticeably improved. Even in professional circles the little negatives are acknowledged as quite satisfactory in many applications, whereas previously they were barely acceptable. (Large-format users have also benefited from film improvements; 4x5in image quality has skyrocketed.)

Although there are several different mechanical manifestations of 35mm equipment, the single lens reflex, or SLR, is the most highly developed and the one most suited to our purposes. The term "single lens reflex" refers to the basic design of the camera, which uses a hinged, front-surfaced mirror to divert the image projected by the lens into the viewfinder. A prism in the finder presents a bright, right-side-up image at the camera's eyepiece. Because the taking lens is also the viewing lens, it is possible to preview almost exactly what the film will record, at least in terms of the composition. The mirror retracts up and out of the way during the instant of exposure. This clever system permits lenses with different characteristics (wide-angle, telephoto, zoom, etc.) to be easily interchanged, making the SLR a very versatile tool.

This illustration describes the function of a single lens reflex (SLR) camera. In the viewing mode, the image projected by the lens is diverted by a mirror onto a small, ground-glass screen. The image that is formed on the screen is reversed left to right and upside down by the lens. This condition is corrected by the prism, which also diverts the image to the eyepiece for viewing. When a photograph is made, the mirror is momentarily flipped up out of the way so that the image projected by the lens can reach the film. At the same instant, the automatic diaphragm mechanism sets the aperture to the correct f-stop. After the exposure the mirror and aperture automatically return to their former positions.

A comprehensive 35mm system. The top row shows various lens shades; below are lenses from 20mm to 300mm in focal length. My rather battered Nikon F3 SLR camera sits on top of a motor device attachment. A 28mm PC lens (shown on page 54) should be included.

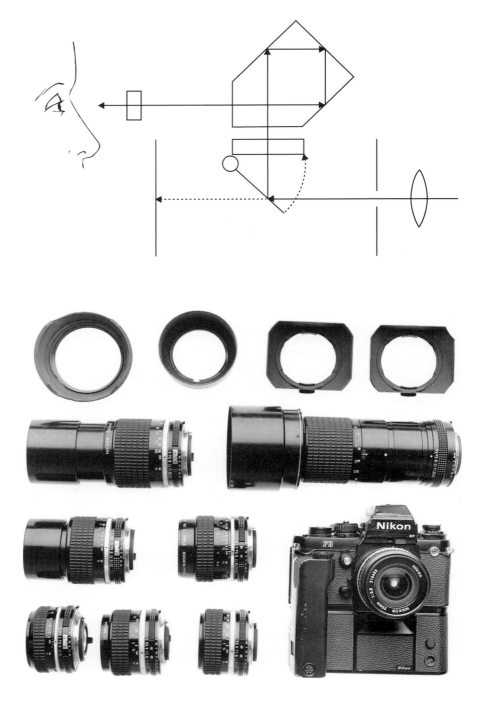

There are, of course, many optional bells and whistles, such as auto-focus and auto-exposure, associated with today's SLR cameras, but for our purposes, nothing except lens interchangeability is really important. Improvements in optical performance and a wider selection of lenses are the recent developments specific to small-format equipment that are critical for architectural work. Because the 35mm SLR is so universally popular, high quality cameras and lenses are available at prices that are only a fraction of the cost of view-camera equipment. Because the viewfinder system is bright, accurate, and quick, 35mm SLR cameras are extremely easy to use. A comprehensive system consisting of several lenses, a couple of camera bodies, and a few other accessories can weigh less than twenty pounds and occupy less than one cubic foot of space. Because 35mm film is consumed in huge quantities, and because ten 35mm images use the same amount of material as one 4x5in image, operating expenses for small cameras are remarkably low.

MEDIUM-FORMAT BASICS Medium-format cameras use 60mm-wide roll film. They are hybrids that borrow technical features from both large and small formats. As is the case for 35mm systems, the most popular medium format configuration is the single lens reflex. Effortless interchangeability of lenses is again the major advantage, although interchangeability is often extended to film backs (35mm, 6x4.5cm, 6x6cm, 6x7cm, 6x9cm and Polaroid backs are available for some professional cameras) and viewfinders. With an image area up to five times greater than that of 35mm images, medium-format negatives and slides can be made sharper and more detailed; they are also much easier to view when editing. Unfortunately, a penalty in bulk and weight must be paid in exchange. Only very recently have medium-format systems evolved close to the point where they are as fast to operate as their miniature counterparts. (Some roll-film cameras have motor drives, although none have auto-focusing as yet.) The choice of lenses offered even by the most progressive manufacturers is limited compared to what is available for 35mm. Prices for quality equipment are astronomical.

SELECTING A FORMAT Deciding on a working format involves a three-way trade-off between cost, image-making ability, and practicality. In absolute terms, large-format wins for sheer technical virtuosity and small-format wins for ease of operation and low cost. In the commercial world, work that does not require view-camera movements is usually done with medium-format equipment, the most efficient way of producing excellent technical quality while still permitting the photographer to maintain a rapid pace.

A medium-format SLR system (Hassleblad). Left to right rows, top to bottom: roll film back, Polaroid back, incident meter; 6x6 SLR, cable release, hand grip; 40mm, 60mm, and 150mm lenses; level, lens shades.

The choice for budget-restricted architectural photographers is difficult to make, since view-camera movements are absolutely essential for many difficult shots. Nevertheless, two special considerations, both of which I have held back until now, tip the scales toward 35mm as the most sensible way to go.

The first special consideration has to do with the recent introduction of several high-performance films, most notably Kodak's Ektar 25 and Ektar 125, new high resolution color negative films. Enlargements pulled from 35mm Ektar 25 negatives look like prints made from the very best medium format films of only three or four years ago. (Ektar 125 sacrifices surprisingly little resolution for a significant increase in speed.)

The second, and equally persuasive, consideration is the availability of certain special lenses that mimic some view-camera movements. These clever devices, referred to as perspective control (PC) lenses, provide a limited degree of vertical rise, vertical fall, and/or horizontal shift. Although PC lenses are available for medium-format cameras, they are not as flexible as the 35mm variety. A little later I will be more specific about the technical capabilities of the 35mm format, PC lenses, and high-resolution films like Ektar 25, but for now I will simply say that I recommend the small-format approach for in-house architectural photography. *(See color plates 1 and 2.)*

32

An interesting coincidence. My 35mm photo on the front cover, and my 4x5in photo on the back cover. Quality is fairly consistent since the 35mm image is simple and bold, while the 4x5in image is highly detailed.

CAMERA BASICS Having made some preliminary arguments, it is time to begin assembling the technical knowledge necessary to start shooting.

A camera is a light-tight box that holds a lens and a light-sensitive material (film) in precise mechanical alignment. The lens projects an image of some object onto the film, which, after chemical development, becomes a permanent record of that image. The amount of image-forming light must be regulated to accommodate the physical characteristics of the film. This regulation is achieved with two specialized mechanical devices: a shutter and a diaphragm.

The shutter is a door through which the light must pass. It may be set to open and close automatically for short periods of time (1/1000 second to 1 second), or it may be operated manually for longer periods of time.

The diaphragm controls the size of a variable aperture (much like the iris of the human eye) that is built into the lens. The size of the opening is carefully calibrated in units called f-stops. The larger the area of the aperture opening, the greater the intensity (or brightness) of the light that is passed by the lens. F-stops are determined by the formula f=F/d, where "F" is the focal length of the lens (the distance from the center of a particular lens to the film plane when the lens is focused precisely on a very distant object), and "d" is the diameter of the lens entrance pupil. A large "f" number means that a dim or low intensity light is passed by the lens. For photographic purposes a maximum aperture of f1 is considered quite large, whereas f64 would be considered small. The light-gathering capability of the lens (the speed of the lens), is a function of the size of the aperture.

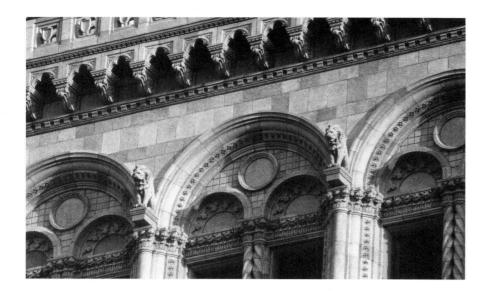

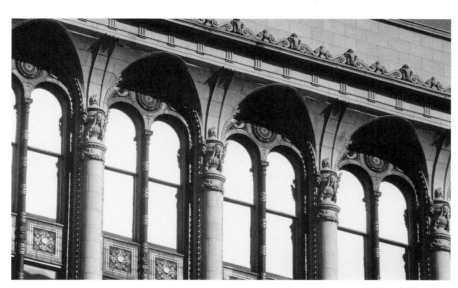

These 35mm slides show how quick and easy to use small-format equipment can be. These photos and color plates 3–8, details of heritage buildings in downtown Winnipeg, were all made during a two-hour stroll on a warm summer evening. I carried only a camera and a long telephoto lens. In lieu of a tripod, I braced myself against various street-level objects like posts or buildings to avoid camera shake.

For the purpose of determining the correct exposure (the amount of light permitted to strike a particular film), the aperture setting and the shutter speed are inversely related; in other words, if the aperture is increased (widened) the shutter speed must be decreased (shortened in duration), and vice versa. All cameras of all formats incorporate a lens, a diaphragm, a shutter, and a light-tight box to hold them together.

A 35MM PRIMER We have, of course, a special interest in the 35mm versions of the light-tight box. The evolution of the 35mm camera began with basic elements but now includes comprehensive photographic systems that may be tailored to suit a wide variety of photographic purposes. Much of what is offered by the various manufacturers is not necessary for what we have to do. You will see that many of the innovations that are so prolifically advertised at such great expense are actually hindrances. In fact, 35mm architectural photography requires only the most basic camera functions.

Here is a list of the most valuable features, followed by a brief explanation of why I think they are so important:

1. Sturdy and precise construction.
2. A built-in light meter that may be operated manually.
3. A wide selection of quality optics (including PC lenses).
4. An electronically governed shutter with an extended slow-speed range.
5. A tripod socket.

1. As a fundamental prerequisite, the machine with which the work is done need not be fancy, but must be reliable and accurate. This means that the camera body, the "light-tight box," must be physically robust with an accurate film-handling mechanism and a rigid lens mount. 35mm SLR cameras always have a shutter built in, unlike view cameras and many medium-format cameras that have a separate shutter in each lens, so results with all lenses depend on the performance of the camera itself. Since the single lens reflex design uses a moving mirror together with a fixed prism, a small ground-glass screen, and a Fresnel lens for viewing and focusing, the positioning and stability of these components is also critical. Fortunately, all of these variables are well controlled in the products of the major camera manufactures.

2. It is necessary to measure the brightness level of any scene that is being photographed so that the camera shutter and the lens aperture can be preset to produce the optimum result on the film. Virtually all SLRs available today have a metering system that measures the light gathered by the lens. Since these meters see what the lens sees they are called through-the-lens (TTL) or behind-the-lens (BTL) meters. Although many professionals prefer hand-held exposure meters of various types, BTL meters are more than satisfactory in most circumstances provided they can be used in a nonautomatic mode. The situations encountered by architectural photographers are not the same as the scenes with which automatic-exposure systems are programmed to cope. If the auto-exposure system cannot be disabled by the photographer when necessary, results are poor. When and how this should be done will be examined later.

3. Easy lens interchangeability is one of the most attractive features of small cameras. All modern cameras use a bayonet-type mount with a spring-loaded latch. Some older cameras use fussy screw mounts, while bargain-basement brands have mounts that are sloppy and unreliable. Precise focus depends upon precise alignment between lens, film, and focusing system. This is, in fact, the camera body's main mechanical function. In addition, since SLRs use the taking lens as part of the viewfinder, the lens's diaphragm must be open wide to allow the brightest possible image for ease of composing and focusing. At the instant of exposure the diaphragm must be closed down to the correct working aperture as determined by the exposure meter. An automatic diaphragm (as opposed to a manual or preset diaphragm) that accomplishes this function is built into the camera body and couples to each lens via a small pin or lever in the lens mount. The complexity and inherent fragility of this important mechanism is another reason to buy professional-quality equipment.

The most important aspect of lens interchangeability is not mechanical, but optical in nature. On a basic level, various kinds of lenses offer various kinds of photographic effects, the value of which will be discussed in detail shortly. On a more sophisticated level, the optical properties (the performance) of a particular lens sets an upper limit on the quality of the final images. There are many subtle technical parameters that must be carefully optimized by lens makers, particularly for extreme wide-angle and PC lenses. Superior lenses are absolutely essential for good work.

4. Earlier I discussed the role played by the adjustable diaphragm in setting the correct exposure. There is, however, another crucial photographic variable that is altered whenever the diaphragm is changed in size. It is called depth of field and refers to the range of acceptable image sharpness around the point of perfect focus. For example, a lens set at a moderately wide aperture and focused on an object ten feet away might render two other objects positioned nine and twelve feet away as acceptably clear; in this case, the depth-of-field would be two feet. If, however, a much smaller aperture was selected, objects located at seven feet and at fourteen feet might be in focus, as well. The depth of field would now be seven feet. Wide depth of field is often required for architectural subjects. You will recall that reducing aperture size also reduces the amount of light reaching the film, and that extending the length of the exposure compensates for this. In practice, the exposure times for much architectural work ranges from one-half second to sixty seconds. A camera that is capable of electronically timing long exposures is very convenient.

5. Of course, it is impossible to hold a camera critically steady for long exposures without a tripod.

AN OVERVIEW OF FILM TYPES Photographic films are made by coating a thin layer of light-sensitive material on a plastic base. Energy, in the form of photons, triggers changes in the sensitive material at the molecular level. These changes are rendered permanent, and visible to the human eye, by chemical development. When the photons are organized and delivered to the surface of the film by a photographic lens, an image of some object can be recorded as a two-dimensional pattern. When photography was a new technology, these patterns could only be captured as variations of light and dark, but soon systems for color reproduction were devised as well. Today there is an amazing choice of photographic films available from three basic categories: black-and-white negative, color negative, and color positive. Each film type has very specific properties and applications.

Black-and-white photographs are required for newspapers, newsletters, historical records, and legal documentation, as well as for reproduction in magazines and books. As an aesthetic statement, monochromatic images bypass the distractions of color and emphasize the form of the image as opposed to the content. Chemically the black-and-white process remains very much as it was in the early days of photography, although present-day materials are much more sensitive to light and capable of much higher resolution. The overwhelming proliferation of high-quality color films and processing have made it difficult to get black-and-white films properly developed and printed; as a consequence some professionals maintain their own black-and-white darkrooms. Special printing papers that allow photographs originally produced in color to be accurately rendered in black and white have been developed, although it is not easy to locate a photofinisher who can make a good job of such conversions.

Color negative films combine three or more layers of light sensitive material, each of which records a portion of the color spectrum. As in a black-and-white negative, the tonalities in a color negative image are reversed compared to the tonalities of the subject. Color negatives look very strange because this reversal applies to color (a yellow object is represented by a blue image, since blue and yellow are complementary colors) as well as density. The color and the density return to normal when the negative is printed.

Color positive films (also called transparency, reversal, or slide films) are intended for direct viewing or reproduction. Positive films are processed to become an unreversed, true-to-life image without the additional step of printing, so the final image is potentially higher in quality than that made from negative films.

CONSIDERATIONS FOR BLACK-AND-WHITE These days, the cost of producing excellent work in black-and-white is about the same as for color. In fact, in most cases color is cheaper. As a result, the skills necessary for shooting and processing black-and-white are atrophying among professionals and have become virtually extinct among amateurs. This is a sad state of affairs. To my mind, a working knowledge of black-and-white technique and a deep appreciation of a beautiful black-and-white print are indispensable fundamentals, at least for professional photographers.

If there is any place where aesthetics and technology obviously intersect, it is at the point where black-and-white images are evaluated. Just how does one know when a print is technically superior? A good print, in commercial terms, is one that can be accurately reproduced in some other medium. Of course, such a print will be sharp and free of mechanical defects like fingerprints, dust spots and scratches. However, a wide range of tones with significant details visible in both highlight and shadow areas is the most important factor for reproducibility.

The densitometer is a special form of light meter used to measure density. A reflection densitometer measures reflection densities from photographic prints. In the case of negatives, a transmission densitometer measures image density by quantifying the amount of light transmitted through various points on the film. The brightness range, the range of tones from very light to very dark, may be plotted on a graph according to the densitometer readouts. These graphs, called characteristic curves, are different for various films and paper types, and they may be further altered by variations in exposure and development.

35

A scientific appreciation of black-and-white image quality takes years to achieve. Some dedicated photographers are practitioners of the Zone System developed by Ansel Adams and Fred Archer. This comprehensive system for image control divides the possible range of photographic densities into ten zones, from deep black to pure white, and describes techniques that enable the photographer to fit subjects onto the tonal scale. Those proficient in the Zone System can exactly previsualize how any negative and print will look before the shutter is tripped.

Although I have never practiced the Zone System, I have read two books by Ansel Adams: *The Negative* and *The Print.* Together, these densely written tracts offer an intense lesson in how far photographic technique can be taken in pursuit of beauty. I highly recommend them.

Many of the skills used in photography interlock; refinement of one ability leads to or requires advancement in other related areas. For example, someone who regularly makes black-and-white prints inevitably acquires a really thorough understanding of what constitutes a good black-and-white negative, because bad negatives are extremely difficult to print; what is not present in the negative to begin with cannot be added in the darkroom. Producing a negative is a process that begins in the camera and is finished in the darkroom. Producing a print is a process that takes place entirely within the darkroom. It is necessary to master the whole process of exposure, negative processing, and print making in order to always achieve first-class results.

I do not recommend that everyone become an expert, but it pays to become familiar with the potential of the medium, so as not to contribute to, and suffer from, the decline in visual standards that is now occurring. Study the examples provided, and insist that any professional black-and-white photography or photofinishing you buy are first-rate.

COLOR POSITIVE VERSUS COLOR NEGATIVE Modern color materials are vastly superior to the films available even a short while ago. There is, however, a prejudice in the nonphotographic printing trade that transparencies are superior to prints from negatives. This was true ten years ago but now a color transparency has only a marginal edge.

Color negative is a tremendously flexible medium. It is much more tolerant of exposure error and unusual lighting conditions than color positive films. Color balance, density, and cropping are easily controlled in the darkroom and multiple copies can be made quickly at a reasonable cost. Retouching a large print is easier and safer than fiddling with an original slide. Similarly, prints may be given away or lost, while the original negative remains secure.

Despite all this, transparencies have a psychological advantage. Because they are viewed by transmitted, rather than reflected, light, transparencies do appear "richer" than an otherwise identical print. Nevertheless, the irrefutable fact is that when a transparency is reproduced on paper, whether photographically or photo-mechanically, its brightness range is reduced; it becomes a "print" like any other.

In most circumstances a color negative and a color transparency can record exactly the same degree of detail. In other words, the resolution of a negative and of a transparency can be identical. A print made from either medium loses some detail by virtue of the fact that a print is one generation away from the original image. A well-made transparency, however, may be reproduced directly, which of course eliminates any losses associated with the enlarging process.

Transparencies have another significant technical advantage—they can reproduce delicate highlight details more accurately than prints made from negatives. This subtle superiority is important for very light subjects such as snow, glass, and bright metal.

The arguments in favor of transparency films for reproduction were much stronger several years ago when color negative materials were much less sophisticated. Old habits die hard, however, and the 4x5in transparency is still favored by many publishers. Small transparencies are popular as well, mostly because they are so handy. For example, plastic slide files, 8 1/2x11in sheets with twenty 2x2in pockets, are standard in the magazine business for convenient viewing, shipping and storage of 35mm transparencies. *(See color plates 9–10, 11–14.)*

FILM FOR ARCHITECTURAL PHOTOGRAPHY The definition of a good architectural photograph that I offered earlier encompasses the following technical (as opposed to aesthetic) considerations: the image must have an abundance of detail, and the color must be accurate. When all other variables are controlled, both these requirements are limited by the characteristics of the film, especially when working in 35mm.

A well-paid professional is obligated to select the materials that give the very best results, regardless of the effort which is associated with the proper use of those materials. However, a practical-minded amateur is free to select the tools and materials that adequately serve his or her purpose, while ensuring convenience and economy by consciously choosing some acceptable compromises. I recommend color negatives films as a universal film for architectural photography with this notion of acceptable compromise firmly in mind. My reasoning is straightforward, but please bear with me as I outline the argument in photographic terms.

The advantages of color positive film are real. An excellent transparency will exhibit a wealth of detail (particularly in highlight and very deep shadow areas) as well as rich and natural color. But, there are costs in time, inconvenience, and money, all of which flow from the fact that the final slide is the same piece of film that was exposed in the camera. Unlike a color negative, which may be manipulated during the printing process, a transparency has only one chance at perfection and must consequently be right the first time; there is, for all practical purposes, no margin for error. Such a strict condition means that the exposure and lighting for each shot must be flawless. This is no easy task in architectural work, where there are many photographically imperfect elements. Consider the following: variations of color balance introduced by nonstandard sources such as fluorescent, mercury vapor, or sodium vapor lights must be analyzed by test exposures that will indicate what filters are required when the final shots are made. Exposure is problematic wherever extremes of light and dark are present, as in a daylight shot of an interior view with windows; the narrow exposure "latitude" of color positive films must be accommodated by an expensive and time-consuming procedure called bracketing, in which several additional exposures are made slightly above and below the measured exposure. Graphically speaking, the image must be composed perfectly as well, since the film in the camera is the final product.

The disadvantages of color negative film are real. It is true that some quality is lost whenever a print is made. The additional step, the creation of a "second generation," inevitably involves a measurable degradation of the original image as well as adds to the cost of processing. However, as you will see shortly, the losses in quality and the extra expense are insignificant compared to the tremendous flexibility of the color negative/print process. Tricky problems of exposure, color balance, and composition can be transported from the shooting location into the darkroom, where they can be fixed quite painlessly. As a bonus, excellent materials are available for generating black and white prints as well as color slides from color negatives; if the original color negative is of decent quality its offspring can serve multiple purposes.

PROCESSING

AN OVERVIEW OF THE OPTIONS Processing color materials is not a magical procedure, although it is rather complex. Consistency is the prime consideration and a fair amount of skill and knowledge is required of people who wish to exercise complete control over their work. Only very dedicated professionals and the most fastidious amateurs develop their own color film and prints; everyone else is unavoidably dependent on the work of a variety of photofinishers.

You are likely familiar with the services available at the drugstore or supermarket; film is dropped off and retrieved a few days later after having been shipped to some central plant where development and printing is done by automatic machines. One-hour processing is much the same, except the machines are close at hand and the work is done while you wait. Since the processing is done mechanically there are few choices of print size and no possibility of creative or remedial interventions.

Professional photographers and advanced amateurs need more input into the processing of their work; there are several important manipulations possible only when the process

38

These images illustrate a powerful printing technique. This photo is an unmanipulated, detail shot of a light fixture and part of the ceiling of a heritage building.

This photo is a "paper dodging mask" made by carefully cutting away the overexposed area of the image. The paper mask is placed on top of the photographic paper in the darkroom during an extra exposure. The mask is moved gently in a circular motion in order to make the borders of the darkened area soft-edged.

This photo is the finished product. The chandelier is now properly exposed. Additional burning-in has darkened the highlight around the chandelier's anchor, as well. Camera: Toyo 4x5in, lens 150mm (moderate wide-angle), film Kodak Vericolor III Type S.

is managed by a skilled technician as opposed to a machine. That is not to say that machines do not do the bulk of the work, but simply that the work of the machines can be tailored to suit specific photographic purposes. This expertise will be found only at a professional color laboratory, also known as a custom lab.

THE PROFESSIONAL APPROACH TO PROCESSING You will not be able to buy 35¢ 3x5in machine-made prints at a custom lab. The work done at such places is different from one-hour outlets in the same way that an artisan cabinet-maker is different from a worker in a factory that cranks out furniture on a large scale; the tools may be similar, but they are put to much different use.

The manufacturers of photographic films and chemicals prescribe exactly how their products are to be handled so that results are predictable. Well-tended machines with properly replenished chemistry will satisfy the basic requirements. In fact, a competent one-hour or drugstore processor will be able to do a fine job of film developing and basic printing. Unfortunately, most of these operations are not so consistent that results will be the same from month to month, week to week, or even day to day. Professional labs are always consistent. This uniformity is critical, especially for color transparencies.

In any complex process, alterations in prescribed practice will yield a variety of results. In the development of color film, the list of prescribed practices is very long. Those who are familiar with the work, however, regularly manipulate the process to alter film speed (sensitivity to light), color balance, and contrast (the distance between the darkest and the lightest tones in a photographic image). Interventions of this kind are often required on behalf of photographers shooting with color positive films; tests shots are processed first, then various parameters are modified so that the rest of the film turns out exactly right.

THE VALUE OF A HANDMADE PRINT Those of us who depend on color negative films do not usually require any modifications in the film processing. Instead, the really useful manipulations are performed in the darkroom while the negatives are being printed.

When prints are made by machine, the negative is scanned electronically, analyzed to determine an "average" reading of the variables, and then the exposure times and color controls are set automatically. Machines "assume" that all photographic subjects are sufficiently homogeneous to allow acceptable results using this method.

In the world of architecture, the simple statistical algorithms that animate the machines are inadequate. The full potential of the positive/negative system is realized only when the critical decisions are made by skilled and empathetic human beings. In fact, human intervention in an otherwise implacable and predictable opto-chemical process marks the end of photographic technology and the beginning of art.

A true appreciation of the possibilities requires a thorough examination of a series of examples of machine-made and human-made prints. From the illustrations offered above and in color plates 15–17, it is obvious that the creative input of human beings is an absolutely crucial and powerful ingredient.

My recommendation that color negative film be adopted as a universal medium for architectural work is based on the assumption that all photographs will be printed by professionals in custom labs. Unless you are a professional photographer with a lot of experience and equipment, perfect color transparencies of the subjects in question are basically out of reach. However, a dedicated amateur, without outrageous effort and without wildly expensive tools, can produce truly acceptable color negatives. Unfortunately, those acceptable negatives will look quite ordinary, and sometimes downright bad, when printed by unfeeling machinery. Fortunately, when an enlightened human printer makes intelligent use of the all the controls offered within the printing process, those "ordinary" negatives can be wrought into wonderful enlargements.

I believe that a dedicated amateur, working in 35mm color negative and supported by a skilled color printer, can produce professional-looking results at a fraction of the cost of hiring a professional. Consider the following scenario: a 4x5in transparency of an interior view with several windows during daylight hours could take a professional several hours

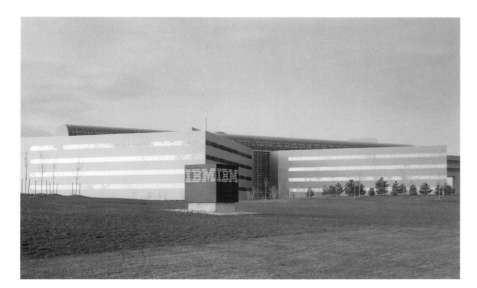

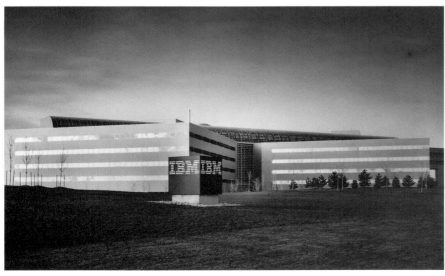

An example of print control. My evening view of IBM Canada's Toronto headquarters was first printed normally. In the final version the whole image was printed quite dark overall, in addition to extra burning-in for the foreground and sky. Camera: Toyo 4x5in, lens 150mm (normal), film Kodak Vericolor III Type S. No perspective controls required.

This line drawing illustrates how a measure of perspective control can be achieved in the darkroom. The top image shows the subject as it appears in real life. The second image shows how the building is pictured by a camera without perspective controls. The diagram to the right shows the negative image being projected by the enlarger onto an easel, which is aligned parallel to the negative plane. The third image shows the effect that is achieved by tilting the easel—the vertical lines of the subject become parallel again, but the whole image is elongated somewhat. In practice, this elongation is fairly mild for small corrections.

to produce. This is because the brightness level in the room must be raised by supplementary photographic lighting (of appropriate color balance) to a level that matches that of the window light, or, conversely, the window light must be attenuated by application of large, expensive, neutral density filters. Total cost for time and material could exceed $500.

The same room could be photographed by an amateur in a few minutes without any special considerations for the windows. The resulting color negative, because of its inherent ability to record a very wide brightness range, will contain adequate detail in the highlight and shadow areas. A machine-made print, however, will look terrible because such a wide brightness range will not read on the print without some extra work. A good printer will burn-in (darken) the bright areas and dodge (lighten) the dark areas; at the same time overall color balance will be corrected and the image will be cropped to the appropriate size and shape. In this way, a ten or fifteen dollar custom-made print will buy the equivalent of one, two, or even three hundred dollars worth of professional photographic expertise. The responsibility of the amateur photographer in this case is to ensure that the color negative is good enough to allow the printmaker sufficient latitude to work his or her magic. The technical instructions in the following chapters are intended to help you do just that.

DESIGNING A PHOTOGRAPH

DOCUMENTARY VERSUS PICTORIAL Photography can be one of the most pragmatic of technical crafts or it can be one of the most ephemeral and subjective of the arts. Even in the seemingly narrow confines of architectural photography there is still room for a variety of approaches, each of which has a different purpose.

As we will see, the maxim "a photograph never lies" is a sentiment that presumes that the camera is a trustworthy recording device, a preserver of facts and conditions as they really exist or as they really existed in the past. Certainly, it can be—so long as the techniques employed in the making of "factual" images are straightforward and unobtrusive. This is documentary photography, and it can only be practiced by people whose intentions are straightforward as well. Such work does not necessarily have an aesthetic component, although there is no reason to exclude it unless the conscious effort to make a picture attractive obscures the original purpose of telling the truth. Some documentary work has an offhand, accidental beauty that flows from the unpretentious nature of the documentary approach.

On the other end of the scale is pictorial photography, an old-fashioned but appropriate phrase, which refers to photographs that try, successfully or not, to elevate the subject into the rarefied world of fine art.

In my experience, many photographs of buildings are commissioned by clients who ask for documentary photographs, but who expect pictorial photographs. The realities of the marketplace dictate that any photograph intended to promote architectural services or sell a particular building will have to do what all other forms of advertising photography do: present reality in the most appealing way possible.

EVALUATING THE POTENTIAL OF SITES Architectural photos are limited aesthetically first by the nature of the structures to be photographed and second by the purpose that the photograph is expected to serve. For example, if the photograph of a building under construction is simply a progress photo, intended to prove that a particular mechanical aspect of the work has been completed, niceties of perspective and lighting are of marginal concern; as long as there is sufficient illumination to record the important details, everyone will be happy. However, if the photo of the same site is to be presented at a meeting of potential investors or tenants, it is much more important to emphasize and exalt the architectural design elements of the structure, the interrelationship of the structure with other buildings nearby, and the quality and texture of the building's material.

There are some basic elements that must be present if the "pictorial" approach is to be successful. First, the building or the room must have some aesthetic qualities. Second, the size of the room or the location of the building must allow for a camera position that yields a photographically pleasing point of view. Third, the light, whether natural or artificial, must be appropriate. The following discussion about the nature of light and lenses will make the significance of all these factors very clear.

LIGHT

PHOTOGRAPHIC SEEING Literally translated, "photography" means "drawing with light." Any real understanding of photography begins with an appreciation of the technically variable qualities of light itself: color, intensity, direction, and specularity. Of these four qualities, specularity is of critical importance.

Specularity is a function of the size of the light source in relation to whatever is being illuminated. For example, the sun on a cloudless day is a highly specular light source, while an overcast sky is non-specular, or highly diffused. Among photographers, specular light is referred to as "hard" and non-specular light is "soft." An object illuminated by a hard light throws a shadow with hard, precisely defined edges; the shadows from a soft light source are fuzzy and undefined.

The first step in learning to previsualize a photographic effect, to predict what something will look like after the whole photographic process has been completed, is to learn to see and appreciate exactly how the infinite manifestations of light affect the appearance of things.

Nature's basic palette evolves from the specularity of light, together with its direction (angle of incidence). What we actually see, what evokes that which we automatically hold to be real, is nothing more than organized energy—energy in the form of photons of light. The manner in which this light strikes a particular object and the way in which the surfaces of the object alter the characteristics of the light trigger intense emotional reactions in our highly conditioned brains. For example, harsh, direct sunlight strongly emphasizes certain patterns and textures that can suggest boldness or power, while the diffused light of an early morning sky just before sunrise softens and embellishes whatever it illuminates. All the great photographers have intuitively cataloged a phenomenal range of natural light conditions and their subjective effects; unlike other visual artists who are free to create whatever "light" they need with paint or pencil, photographers must "collect" light from nature. Since nature cannot be easily manipulated or controlled, much of the skill involved in photography has to do with the patient observation of changing conditions, good timing, and good luck.

There is no mystery to all of this; the only requirement is a willingness to pay attention. Your own responses will guide you.

THE SKY, THE SEASONS, AND TIME OF DAY Since daylight is the primary light source for most exterior architectural views (as well as many interior views), the factors that determine the characteristics of sunlight are fundamentally important.

The exact location of the sun in relation to an architectural subject is a function of the position of the building on the surface of the planet (longitude and latitude), the orientation of its main facade (direction), the rotation of the earth about its axis (time of day), and the location of the earth in its yearly progression around the sun (the season). Astronomical considerations might seem somewhat grand, but the object of the exercise is to produce a strong photograph; consequently, the angle of incidence of sunlight is of critical importance. In fact, the photographic evaluation of a particular site is a parallel effort to the sun study that an architect does when designing a building.

The design and texture of a given building will dictate the sun angle best suited for a powerful image. Since the position of the sun is dependent on the natural variables listed above, the role of the photographer is a passive one and usually involves a couple of visits to the site at different times of day; if the photograph is required quickly, the time of day will be the only variable, insofar as the angle of the sun is concerned. When the need is less urgent, it is quite sensible to wait until the sun comes round to some optimum location. (In the northern latitudes where I work, north-facing buildings are illuminated by direct sunlight for only a few weeks in the summertime, and even then the light shines down from more or less directly overhead for much of the day. Since this condition is very unflattering for most structures, early morning and late evening shots are favored.)

In the studio the commercial photographer works with special tools that modify light in order to achieve certain visual effects. Outdoors, light is modified by serendipitous natural phenomena that the photographer must recognize, anticipate, and use to advantage. The range of choices begins with naked sunlight at high noon and extends virtually forever. Weather, particularly the presence or absence of clouds, is perhaps the most significant manipulator of sunlight. Pictorially, clouds in many forms are often welcome elements and are included within an image for dramatic effect. In terms of the current discussion, clouds are important simply because they are modifiers of sunlight; they cannot alter the direction from which the sun shines, but they can alter the specularity of sunlight by varying degrees. The accompanying sketches illustrate this principle.

Many other natural events and phenomena have an impact on outdoor photography. For several months after the eruption of the Mount Saint Helens volcano, the sky over North America was dulled by the many tons of light ash that were suspended in the upper atmosphere. Air pollution and smoke from forest fires also affect the characteristics of daylight, particularly around sunrise and sunset. During winter, snow on the ground modifies sunlight by reflection, while ice particles in the air contribute some very subtle diffusion effects.

It is important to recognize that none of the profoundly important aspects of architectural photography just described are even remotely related to film or equipment. On the contrary, they demand aesthetic choices that have to do with one's personal appreciation of the delightfully abundant manifestations of natural light. *(See color plates 18–21.)*

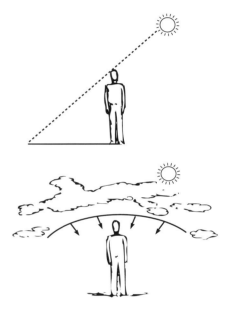

These sketches illustrate how a highly specular light source, like the sun, is converted into a highly diffuse light source. The top image shows direct sunlight and the precise shadow it creates. The bottom image shows how a layer of cloud effectively spreads out the sunlight—the clouds themselves become the light source, as far as the subject is concerned. Since light is coming from many directions at once, the subject is softly illuminated and thus casts a very indistinct shadow.

This Winnipeg apartment building by Akman & Sons was shot in the fall to add a little color to what would have otherwise been a rather monochromatic image. The camera angle was chosen to show the complete facade while allowing the tree on the right to partially obscure the large rental sign in the lower foreground.
Camera: Toyo 4x5in, lens: 90mm (moderate wide-angle), film: Kodak Vericolor III Type S. Perspective controls were necessary for this shot.

INTENSITY AND COLOR So far we have dealt with the qualities of direction and specularity in relation to natural light, but there are two other important considerations, namely color and intensity. Of these two, intensity (the quantity of light) is the least significant. Generally the absolute degree of brightness is not a worrisome factor, except in very dim conditions such as those encountered during night photography. Within a particular image, however, the relative brightness levels of various elements (contrast) is quite significant. The next chapter will deal with the technical restraints imposed by excessive or insufficient image contrast, but for now let us consider the aesthetic implications.

Both direction and specularity of light have a bearing on image contrast, and image contrast, in turn, has an emotional impact. For example, hard sunlight falling from an elevated angle upon a starkly fashioned stone facade results in a deeply chiseled image with dark shadows and brash highlights; the monumental constructions favored by the Nazis were always portrayed in this way. The same structures illuminated by softened, diffused light coming from a low angle lose some of their garish, authoritarian overtones and take on a more spiritual (albeit Wagnerian) flavor.

The color of light complements and enhances the mood evoked by the sculptural influences of sun angle and specularity. It is measured precisely according to the Kelvin color temperature scale. So-called "photographic" daylight is 5500° Kelvin, but this actually varies according to time of day, time of year, geographical location, and air purity. A sunset at the end of a dusty prairie day would radiate very warm light, perhaps as low as 2500° Kelvin, while high noon up in the Rocky Mountains could register a very cool 20,000° Kelvin. "Daylight" color films are balanced for 5500° K.

The way photographic film and paper render color is different than the way human minds and memory do. The brain expects to see the world in a certain light; there is in each of us an unconscious impulse to impose a "natural" color balance upon everything we look at. In fact, we seek out familiar visual "clues" such as skin tones, blue sky, or leaf green, and automatically rearrange the images we perceive so that these color markers fall within a normal, or comfortable, range. This phenomenon is called "color constancy" and is easily demonstrated: a room lit by warm tungsten light seems natural enough, but outside at dusk we quickly become acclimatized to the ambient light condition, which is typically much cooler than the artificial light. The same room, viewed from the outside in, now looks extremely yellow. This phenomenon is not simply a matter of relative color, it is an actual shift or tilt in perception.

The emotional power of color comes into play whenever the ability of the brain to correct color balance is exercised; slight corrections alter one's mood very subtly while gross discrepancies, beyond the capability of the brain to compensate, result in a very strong response. Even the vocabulary we use to describe color conditions (warm, cool, neutral) attributes an emotional weight to this physical property. Since the recording mechanisms of photographic materials are predictable and subject to manipulation by the photographer, the color balance of a photograph can either accurately track what is offered in nature or embellish it.

AESTHETIC CONSIDERATIONS IN LIGHTING Everything that has been discussed in relation to natural light applies to artificial light; however, the modifiers of photographic lighting are manipulated by the photographer rather than by nature. Since it is a major undertaking to illuminate an entire building, full scale photographic lighting is usually considered for interior views only; outside at night photographers must rely on whatever street or flood lighting is available.

Color balance becomes a very important consideration when artificial light sources are encountered. Each type of manmade light—be it tungsten, fluorescent, mercury-vapor, sodium-vapor, or electronic flash—has a characteristic spectrum that must be matched to the natural ambient light and to the characteristics of the film. These technical matters will be discussed in detail in the next chapter.

AESTHETICS AND FORMAT

LIMITATIONS AND POTENTIALS OF VARIOUS FORMATS The notion that format affects the appearance of a photographic image begins very simply with the shape of the frame. Since medium-format systems generally lack perspective controls and are priced at the same level or higher than 4x5in systems, I will limit my comments to a comparison between the very rectangular 35mm image and the much squarer image produced by the larger format cameras.

The standard sizes for photographic enlargements (5x7in, 8x10in, 11x14in, 16x20in, etc.) evolved from the view-camera technology of over one hundred years ago. It is a testament to the strength of these traditions that the original dimensions have remained intact despite the onslaught of the 35mm usurper and despite extensive metrication. In fact, most enlargements from 35mm negatives are cropped to fit the 8x10in format, resulting in a loss of about 20% of the actual image area. For black-and-white photographs, 8x10in is the industry standard for most printing and publishing.

Photographers are naturally inclined to fill the frame; it is an instinctive desire not to waste film, in order to keep cropping to a minimum, and thus preserve image quality. This desire must be thwarted when shooting 35mm simply to conform to the established norms of publishing and photofinishing. Those wishing to take advantage of the elongated format must find a custom lab that will preserve the whole 35mm image by producing 6x10in prints rather than the standard 8x10in prints. The same approach would be necessary for the large-format user who wishes to eliminate unnecessary foreground or background details in photographs of very tall or very horizontal buildings or interiors.

Transparencies cannot be cropped during processing since the actual film exposed in the camera becomes the final product; cropping must be done by mechanically masking the slides with opaque materials such as tape or cardboard. This is not impossible for the larger formats, but it is extremely difficult for 35mm.

In the magazine business, color 35mm slides or 4x5in transparencies have been preferred over color prints for many years. Cropping is usually the prerogative of the editor or art director of the publication, so the aesthetic considerations related to the shape of the image are largely out of the hands of the photographer. New negative films and improved photographic enlarging paper have increased the quality of the negative/positive process, and the publishing industry is slowly coming around to accept well-made color prints. Of course, when enlargements are submitted for publication, the photographer working with a custom printer has much more control over the final image shape. Nevertheless, nothing prevents the editor or art director from extracting a smaller image from whatever is submitted.

The aesthetics of any particular format are influenced as much by the mechanical nature of the equipment as by the shape of the frame. At a basic level, tripod-bound large-format equipment is much slower to use. The cumbersome mechanical process of camera setup and adjustment encourages a deliberate and contemplative approach to picture-making; the positive manifestation of an extended time frame might be insightful

These similar photos illustrate the effects of cropping. They were made for historian Gwen Dowsett and show details of a barn built by Mennonite settlers. Cropping the first photo to eliminate the cast metal pump and corrugated well casing on the left "ages" the image considerably—the only clue that the second photo was made in the twentieth century is the metal roof, which could be eliminated by further cropping if desired. Camera: Hassleblad ELX (medium format), lens: 100mm (normal), film: Kodak Vericolor III Type S. No perspective controls.

and thought-provoking photographs, while the negative implications (boredom induced by the slow pace) might yield exactly opposite results. The highly mobile 35mm user must fight the tendency to produce facile snapshots. Producing first-class photography with small cameras, although mechanically easier than with larger formats, demands both a technical and an artistic self-discipline, a requirement that flies in the face of the rapid-fire stereotype promoted by the manufactures of "automatic" miniature cameras.

Finally, the cost of operating a particular format has an undeniable impact on the characteristics of the photographs. We have seen that the mechanical limitations of large format machines force photographers to work at a steady (and hopefully dignified) pace. There is no choice. The relatively high cost of the film and processing further inhibit the photographer by discouraging experimentation and risk-taking: every image must count. On the other hand, small cameras encourage experimentation and risk-taking. Unlike professionals, who are able to evaluate photographic situations and make decisions intellectually without the need for trial-and-error learning on real film, beginners, or even advanced amateurs, must study the results of their efforts in order to progress. With thirty-six inexpensive pictures per role, the 35mm photographer can afford the few minutes and the few dollars it takes to photographically explore a fleeting light condition or record several subtle variations of composition.

TOWARD A PERFECT 35MM IMAGE In terms of detail and color, carefully made images of different "parentage" can barely be distinguished. The technical degradation associated with the process of reproduction for the printed page is partly responsible; the nuances of the superior large-format photos and the minor faults of the 35mm photos are somewhat submerged by the limitations of ink and printing press. Still, this only reinforces the argument that for all practical purposes the two formats are very competitive.

More noticeable are the differences associated with the opto-mechanical capabilities of each system. Of main concern here is limited 35mm perspective control. Nevertheless, the photos in this book clearly show that a surprising variety of photographs can be made without perspective controls of any sort, and that the control available with 35mm PC lenses, although less than that available with 4x5in technology, is still considerable.

I could, I suppose, provide a chart that would spell out all these observations in quantitative scientific terms, but photographs are virtually never examined in such a fastidious manner. Look carefully at the samples provided, and I believe that you will agree that 35mm systems are capable of producing fine results.

ROLE OF THE RETOUCH ARTIST There is a limit to what can be done with even the most sophisticated photographic technology regardless of format. When these limits are exceeded, photographs can be saved by the work of the retouch artist. Like the view camera itself, retouching has been an invaluable element of photography since the beginning. Although it is no longer necessary to hand color monochromatic images, it is still sometimes necessary to airbrush a pleasant blue over a dull gray overcast sky. In the city where I work, the public works department will remove and replace an offensive street lamp for $800; my retoucher will do it (at my convenience) for around $150. He regularly removes "for lease" signs and straightens crooked blinds, as well as cleans up oil-stained driveways, odd reflections, and overlooked litter *(see color plates 26–27)*. Power lines are his specialty. Certain strictly photographic problems can be repaired as well; "washed-out" over-exposed windows within available-light interior shots and off-color patches due to incompatible light sources can both be retouched. My particular favorite is the restoration of skies that have been eliminated when extreme perspective corrections force the image to the very edge of the lens's coverage. Very compelling presentations result when the retoucher skillfully grafts a photograph of an architectural model onto the image of an existing skyline.

Even more sophisticated work can be done using powerful computers that enhance and manipulate photographs that have been electronically scanned and encoded. However, the costs of such interventions are extremely high ($500 or more), and the degree of precision is rarely necessary in the normal course of architectural work. It is interesting to note that the cost of personal computers with retouching capabilities is decreasing while their speed and convenience of operation is increasing. This means that it may soon be possible to make useful alterations without leaving the office.

48

These images were chosen to show the skills of my retoucher, Ray Phillips of Phillips Advertising Art Ltd. in Winnipeg. A modest office building in downtown Calgary by IKOY Architects was photographed through a grouping of sculpted figures located in a park across the street. The otherwise perfect camera angle left an unfortunately positioned pole clearly visible between the legs of the figure on the right—Ray made it go away.
Camera: Toyo 4x5in, lens: 90mm (moderate wide-angle), film: Kodak Vericolor III Type S. Modest perspective controls.

LENSES FOR 35MM SYSTEMS

THE BIOLOGICAL OPTICAL SYSTEM Human vision is nature's almost perfect response to the visible portion of the electromagnetic spectrum. I say almost perfect because as spectacular as the system might be, there is a flaw: the lens is not interchangeable.

The eye itself is a truly amazing creation. A biological automatic diaphragm, the iris, changes the effective f-stop from about f5.6 in dim light to approximately f22 in bright light. Quick corrections are made according to relative brightness of different objects within a scene, thus allowing us to see a tonal range much wider than even present-day photographic technology can accommodate. More amazing still is the fact that focusing is accomplished by actually changing the shape of the lens itself. This very useful mechanical process goes on continually and quickly, yielding the illusion of almost infinite depth of field. Focus corrections are made spontaneously as one's attention shifts between different objects within the field of view. Overall angle of acceptance is very nearly 180° with an area of critical sharpness of approximately 40°.

NORMAL LENSES (45–58MM) We have all heard the expression "through the camera's eye." The phrase is a simple expression of the realization that the camera's eye is not at all like our own. Learning about lenses is the real beginning of a mastery of photography.

The brain, like the NASA computers that generate a full-color map of Jupiter from a few electronic clues, processes the data relayed along the optic nerve from the eye and then reconstructs an image (the image we see mentally) so that everything looks all right. We are conditioned from childhood to expect the visual world to follow certain rules of perspective, and it is one of the brain's main functions to enforce these rules. That is why optical illusions are possible; the brain, attempting to keep things in some kind of order, may be tricked. This was demonstrated in a dramatic experiment in which the participants wore special glasses that made everything appear upside-down. Within a couple of weeks of constantly wearing these glasses, the subjects of the experiment reported that the world had righted itself and everything appeared normal. Upon removal of the reversing spectacles, everything looked upside-down. It took another couple of weeks without the lenses for things to come right side up again. The phenomenon is not unlike the games our minds play with color balance. *(See color plates 22–23.)*

I have made an effort to illustrate some of the properties of human vision because the selection and use of various focal length lenses in photography is profoundly influenced by our conditioned physiological and psychological seeing. Some optics, like perspective control lenses, are used to "put the world right" according to our innate expectations.

Other lenses, such as the extremely wide-angle "fish-eye," are used to shock and surprise; they can do this because the images they yield are so very different from what our poor brains keep trying to see. These days we have access to a fantastic range of 35mm optics with which to satisfy or tease our visual programming.

WIDE-ANGLE LENSES (8–40MM) It is easy to think of a wide-angle lens as a device to cram more stuff into the frame without having to move back and a telephoto (tele) lens as a device for getting close to the subject without moving forward. I will not deny that the mechanics of lens selection are significant, but I wish to emphasize that various focal lengths offer more than just a different angle of view. In fact, they each offer a different point of view, mechanically and aesthetically.

So-called perspective distortion is both the curse and the blessing of wide-angle work. The term "perspective distortion," however, has very little meaning apart from the brain's response to the optical phenomena of nature. The eye actually sees parallel vertical lines of a building converging just as the camera does. The eye sees nearby small objects as large and faraway large objects as small, just as the camera does. Yet, unlike film, which simply records what the lens presents, our brains interpret and reconstruct the images streaming in from outside. The brain wants to see verticals that do not converge and objects that appear their correct size.

By using photographic lenses to project the light reflected off three-dimensional objects onto a two-dimensional surface (film) and then presenting the flat image (photograph) out of context, we bypass our image-processing capabilities. In real-life situations the brain tries to correct apparent visual anomalies and, up to a point, succeeds; a photograph, being a fixed representation of a three-dimensional object, can only look how it looks. The power of lenses, and consequently the power of photography, derives from this ability to tease our optical preconditioning.

The perspective offered by very-wide to ultra-wide lenses (8–24mm for 35mm cameras) can push visual tension to the limits of tolerance. We will accept a rather odd-looking photograph when there is no choice in the matter—a fish-eye picture of the inside of a space capsule, for example. In fact, wide-angle effects are appreciated as spectacular tools for rendering dramatic views of buildings or urban landscapes. Like all good things in life however, this technique suffers when used in excess; continued reliance on wide-angle effects means that the photographer has surrendered the content of his or her images in favor of form. When the design of the photograph is a consequence of the lens's characteristics alone, the power of the imagery will decrease over time. Just like the folks with the upside-down glasses, we get used to sensational points of view. When this happens, our collective visual consciousness cries out for more natural perspectives and photographs in which form and content strike a harmonious balance. I will have more to say about the distortion associated with wide-angle lenses shortly.

MEDIUM TELEPHOTO LENSES (85–200MM) Short focal length of lenses emphasize details closest to the camera and give them an appearance of exaggerated size compared to similar objects farther away from the camera. The greater shooting distances required to picture the same objects with long lenses tend to flatten perspective and yield images with a less noticeable sense of depth; this "undistorted" presentation will enhance the innate elegance of the pictured objects.

Since 35mm systems have a very limited choice of lenses offering perspective control, sometimes long focal length lenses used at a distance are necessary to help render parallel vertical and horizontal lines properly. Things appear correctly rectilinear only when photographed dead-on by shorter lenses. Without perspective control, objects photographed from below appear to be tilted away from the camera, while objects photographed from above appear to be tilted toward the camera. For example, at a short distance, with the camera positioned below the geometric center of an object, the bottom of the object is closer to the lens than the top. The bottom, therefore, is rendered larger on the negative and the print looks bottom heavy. This is the typical ground level image of a tall building.

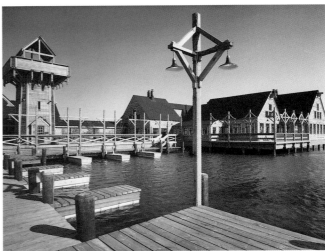

50

I have included this comprehensive portfo-
lio to fully illustrate the use of the various
types of lenses in the effective practice of
architectural photography. The images are
rendered in black-and-white so that
graphic composition of each is presented
clearly and simply. Sun angles were care-
fully predetermined so as to accent par-
ticular features of the structures. All
photos were made with my Toyo 4x5in
view camera on Kodak Vericolor III Type S
color negative film, printed on Kodak
Panalure black and white paper. The sub-
ject is IKOY Architects' Harborview Lei-
sure Center, a municipal recreation facility
built on a rehabilitated landfill site on the
outskirts of Winnipeg. These photos were
published in color in several well-known
journals, including *Architectural Record*,
Canadian Architect Magazine, and *Archi-
tecture Minnesota*.

Top left, top right, bottom left: These
wide views establish the scale and con-
text of the site from the west, east, and
southeast, respectively. The first photo
was shot with a normal lens from the top
of a small hill. The other two photos were
shot from low vantage points with moder-
ate wide-angle lenses.

Bottom right: A moderate wide-angle
lens and an eye-level vantage point al-
lowed this well-balanced view of the whole
complex, which includes boat docks, look-
out tower, golf pro-shop, restaurants, and
a small-scale convention center. A small
aperture was used to preserve great depth
of field.

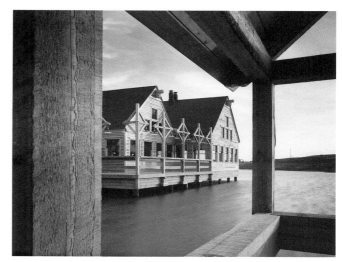

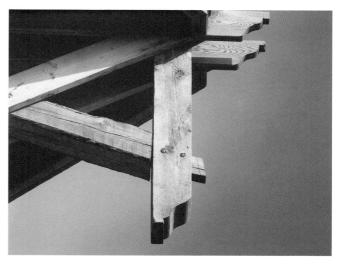

Top left: This moderate wide-angle view looks out from beneath a wooden canopy at a patio area. Reflected light from the paving stones illuminates the detail beneath the canopy—an effect that was strengthened by some judicious dodging during printmaking. Framing like this establishes the modest, comfortable scale of this project, while allowing the viewer to appreciate some of the smaller details of the construction. The wooden deck chairs in the middle distance were placed precisely so as to not overly complicate the view through the wooden posts.

Top right: This photo is an extreme wide-angle view taken from within a small shelter at the very end of the boat dock. The rough timbers seen close up are used to frame the restaurant and convention center situated across the water.

Bottom left, bottom right: By selecting moderate (bl) and long (br) telephoto lenses, I was able to focus in on relatively small details from a distance. In this approach very basic geometrical configurations within the subject determine the composition of the images. Lighting is important, as well, since the surface textures of objects shot close up become very significant.

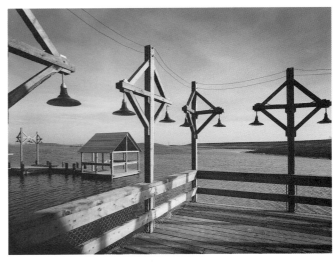

Top left, bottom left: The two croppings change the emphasis and graphic impact of the images—the wider view has a more documentary flavor, while the closer view is more geometrically interesting because of the interaction of the various planes and lines.

Top right, bottom right: In the second photo, construction and wiring details of the lamp standards are clearly visible, as is the relative position and design of the small shelter across the water. In the first photo small detail is sacrificed, but the wider view yields a clearer understanding of the context, the landscaping, and the relationship between the light standards.

A long lens, however, puts the camera far enough away to make the difference between the top of the object and the camera and between the bottom of the object and the camera insignificant. This balances the perspective and makes the picture feel right.

Aside from aesthetic considerations, there are many circumstances in which the factor of image magnification alone is the basis for choosing a long lens. If mechanical or geographical barriers separate photographer and subject, telephotos will pull in a decent image size even from a very distant vantage point. The degree of magnification is directly proportional to the increase in focal length. Thus at the same camera-to-subject distance, a 200mm lens yields an image four times the size of a 50mm lens' image.

The inevitable limiting factor is that as image size increases, so does the significance of focusing error and camera movement, making a sturdy tripod a necessary accessory for this type of shooting. (As focal lengths stretch, it becomes increasingly difficult to hand-hold tele lenses without a loss of sharpness due to the magnification of camera motion. A rule of thumb is to never hand-hold at a shutter speed slower that the reciprocal of the focal length of the lens being used, e.g., for a 500mm use 1/500sec, for a 135mm use 1/125sec—the closest shutter speed to the reciprocal.) Depth of field is a function of aperture size, which in turn is a function of focal length. The longer the focal length the shallower the depth of field at a given f-stop, all else being equal. At wide apertures and close distances this may be a matter of inches or even fractions of inches.

LONG TELEPHOTO LENSES (250-1000MM) As we move up the scale of focal length past the medium teles, compression of natural perspective begins to dominate in a way that is opposite and complementary to the expansion of perspective yielded by short lenses. To encompass a given object we must move farther and farther away; the scene visible in the finder starts to bunch up and a view of fields, foothills, and mountains seems to grow out of one plane. Similarly, blocks of city skyscrapers begin to look like pancake-thin copies of themselves pasted onto poster board. Sports fans and voyeurs simply accept this fact of super-tele life; creative photographers make the most of it by watching for striking juxtapositions of objects normally seen as greatly separated. Sometimes the combination of extremely long lenses and air pollution or thermally induced turbulence will introduce odd distortions or color shifts. Like the compression effect, such optical mutations can be photographically interesting; if not, they may be reduced somewhat by polarizing, ultraviolet (UV), or appropriate color-correcting filters.

FIXED FOCAL LENGTH VERSUS ZOOM LENSES Mechanical and optical consid-erations have resulted in two families of lenses: fixed-focal-length lenses and zoom lenses.

Zoom lenses have adjustable focal lengths. In other words, their focal length is user-variable over a particular range (for example, 28–90mm or 80–200mm). Zoom lenses are extremely handy for fast work. Unfortunately, all the very best lenses (optically speaking), very long and very short focal length lenses (8–21mm and 1000+mm), and most specialty lenses (PC lenses, for example) are available only in the fixed focal length configuration.

The reasons for the above situation are related directly to the complications and compromises associated with the additional optical and mechanical elements required to make focal length a variable property. For my own work I prefer fixed-focal-length lenses for all critical work, but I do own several zoom lenses that I use for assignments such as audio-visual slide shows, where speed of operation is more important than technical excellence. However, I do believe that for the dedicated amateur architectural photogra-pher it is best to stick with lenses of the fixed focal length variety. My advice is based on the assumption that most readers of this book have a great need for a modest number of high quality prints for portfolios, presentations, or publications and are not required to produce a large number of images (particularly 35mm slides) under pressure of time.

PERSPECTIVE CONTROL LENSES Perspective control lenses are in a class of their own, as far as architectural work is concerned. They are available only in a very limited range of focal lengths, but their application in this work is so universal that they warrant detailed study.

Basically they are specialized wide-angle lenses with exceptionally broad coverage. The large image circle is necessary because PC lenses are mounted in a mechanism that allows the lens axis to be shifted both horizontally and vertically; the perspective control feature

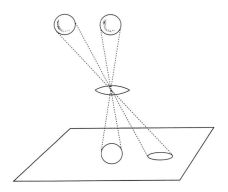

This drawing shows the results of displacing a spherical subject away from the lens axis perpendicular to the middle of the film plane. The image of the well-centered sphere is projected as a circle on the flat film but the image of the off-center sphere is projected by the lens as an ellipse.

WIDE-ANGLE DIFFICULTIES Photographers have a love-hate relationship with short focal length lenses. Although the commonly held belief that wide-angle lenses distort reality is not true, this does not imply that wide-angle photography is easy to do well. There are certain precautions that must be taken to produce tasteful images.

The above mentioned alteration of perspective is the main concern. Architectural photography is often carried out in functionally confined spaces such as heavily furnished rooms or crowded city streets. The subjects are large, and comfortable points of view are hard to come by. We must resort to wide-angle lenses because there really is no choice. In such situations the way in which the sizes of foreground and background objects are rendered in two dimensions is not a welcome design element, but instead an unavoidable anomaly to be dealt with as discreetly as possible. It can be a real eye-stopper when the ashtray on the coffee table looks as big as the fireplace.

To further complicate matters, there actually is a type of distortion that is unavoidably associated with wide-angle work. The line drawing to the left illustrates what happens to the image of a sphere projected onto a flat surface. As you can see, at the center of the frame the sphere appears perfectly round. As the spherical object is shifted away from the axis of the lens, its image becomes more and more elliptical. The effect is exaggerated as focal lengths get shorter.

In the next chapter I will offer some advice on how to cope with both apparent distortion of perspective and real distortion of shape.

BUYING EQUIPMENT AND SUPPLIES

If you are serious about producing first-quality architectural photography, you will not be able to buy your equipment at K Mart. This is not because the equipment available from department or discount outlets is not sufficiently sophisticated, but rather that it is, surprisingly, too sophisticated and too specialized. Photographic technology has become very user specific, and the cameras sold to the general public these days are finely tuned to serve that public. Automatic everything (auto-exposure, focus, film advance, film speed selection, etc.) cameras are not toys; in fact they are extremely well-made and exquisitely engineered. But they are just not for us; most of the currently available automatic features are unnecessary and sometimes confusing.

THE TRUTH ABOUT AUTOMATION I have made several rather disparaging remarks about the recent trend of giving over important photographic variables to electronic control. My opinion is based on the unfortunate fact that architectural photography does not benefit from this development.

Three principal automatic features are being pitched to a willing, and, for the most part, well-served public: auto-exposure, auto-focus, and auto-flash. These are helpful options for the ordinary amateur photographer since they largely guarantee freedom from the technical decisions that stand in the way of spontaneous shooting. The automatic functions are governed by logical algorithms programmed into computerlike microprocessors in the camera. These algorithms fail when confronted with typical architectural situations.

Auto-focus sensors determine subject-to-camera distance by measuring image contrast or by bouncing infrared or ultrasonic radiation off whatever is centered in the viewfinder. Either method will set the focus precisely on the closest solid object the system detects. A problem arises when the subject is not an identifiable object like a person or a tree, but is instead a space such as a room, or a building set within a landscaped environment. In these cases, depth of field is critical. According to the laws of optics, the true depth of field associated with a particular aperture extends from approximately one-third of the distance ahead of the exact point of focus to approximately two-thirds of the distance behind it. An auto-focus camera cannot know this without some fancy intervention by the photographer, yet it is a simple matter to set the proper focus manually.

Auto-exposure systems are similarly baffled by certain situations common to buildings and interiors. For example, bright patches within the image area, such as windows, light fixtures, and reflections from glass curtain walls, will bias the camera towards underexposure. Again, intervention by the photographer will be required, thus short-circuiting the benefits of exposure automation.

Auto-flash circuits trigger small electronic flash tubes when the level of ambient illumination is too low to allow reliable hand-held exposures. Since most of our work will involve small apertures and long shake-inducing exposures, this feature will often be invoked by the cameras that are so equipped. In practical terms, the light provided by such units is too weak to be of much use beyond a few feet, and, in addition, may well create unwanted reflections, highlights, or flare.

WHERE AND HOW TO BUY Cameras suited to the kind of work in which we are interested are rather difficult to come by. As I mentioned earlier, what is required is mechanical reliability and precision, coupled with a built-in, manually operated light meter. Motorized film advance is a definite convenience, but automatic focus, film loading, and film speed indexing is superfluous and sometimes even an obstacle to the work at hand. Cameras without these options are difficult to find brand new because so many electronic bells and whistles have become standard equipment.

The most direct route to these cameras is an industrial photographic supply house that services working professionals. You can find one by checking the yellow pages under "photography supplies, industrial" or "photography supplies, commercial." Any professional photographer can point you in the right direction as well. Professionals prefer simple but well-made equipment, so the sales staff at such a store will be familiar with whatever new cameras are available that fit that description. Also, there is no reason to avoid reconditioned equipment if it is recommended by knowledgeable people. Many classic cameras made five, ten, or even fifteen years ago fulfill the criteria for our particular work

quite admirably. Since camera manufacturers, unlike car manufacturers, have managed to maintain the integrity of their basic designs over the last couple of decades, most of today's lenses will fit on older camera bodies, so optical obsolescence is not a worry.

For the bolder among you, particularly those with photographically minded friends, the newspaper want-ads are always a source of "pre-owned" cameras, lenses, and accessories. People rarely mistreat quality photographic equipment, but it is still a good idea to have a repair technician check out any machine you are seriously considering. Ask a professional photographer to recommend a reliable service person, or look in the yellow pages under "camera repair."

A less convenient but highly competitive source of both new and used professional level equipment can be found through advertisements in the back of the larger photography magazines. Mail order houses in New York, Los Angeles, and other major centers are usually trustworthy and relatively speedy. There may be some problems with local warranty service, but if shipping a broken or damaged camera across the country for repair does not bother you, then do not hesitate to take advantage of the deeply discounted prices.

If the price of the very best equipment should give you pause, consider leasing as an alternative to buying. Almost any company engaged in leasing cars, computers, or office technology will be happy to lease high-end camera gear. In the bigger cities, occasional users can also rent. A final option might be for your specific professional association to purchase some decent equipment that could be shared by its members.

Film can be bought just about anywhere, but professionally oriented products such as Ektar 25 will be easier to obtain through industrial suppliers. Some custom processing labs sell professional films, as well.

ONE CAMERA/ONE LENS ($300–$500)

It is, of course, impossible to recommend a list of standardized equipment for in-house architectural documentation, as every practice will have its own particular needs and resources. Nevertheless, even the most basic efforts will require, at the very least, a camera and a lens. There are several cameras from the major manufacturers that would be appropriate. Canon, Nikon, Pentax, Olympus, and Minolta all have produced no-frills, non-automatic cameras, and a wide range of quality lenses are available for them. I have always owned Nikon equipment and depend on Nikon lenses exclusively for my 35mm work. However, you will have to rely on professional photographer friends or trustworthy camera salespeople to help with the choice.

Whatever the brand of camera you select, the "normal" lens (typically 45–58mm), will not do for most architectural work. It is possible to buy both new and used camera bodies without a normal lens, so when budget restrictions limit equipment choices to one lens only, it should be a moderate wide-angle to moderate telephoto zoom of approximately 28–90mm.

Earlier I indicated that zoom lenses cannot compete with the technical performance of fixed-focal-length lenses. The deficiencies are the inevitable consequences of the additional elements and the mechanical complexity that allows alteration of focal length. Here is a list of the zoom-related problems:

1. Smaller maximum apertures and dimmer, harder to focus viewfinder image.
2. Lower optical performance.
3. Higher susceptibility to flare (spurious non-image-forming light).
4. Tendency toward certain kinds of distortion.
5. Heavier and bulkier construction.

For a number of reasons these performance deficiencies are not sufficiently important to forgo the flexibility of "many lenses in one" that zooms offer to those with limited funds.

To begin with, smaller maximum apertures are not a major obstacle, since most architectural work will be done slowly enough to permit careful focusing. Also, wide maximum apertures have limited value in shooting "deep" subjects like buildings and rooms; in such cases very small apertures are required in order to achieve the depth of field necessary to maintain focus throughout. Happily, image resolution and image contrast improve significantly at smaller apertures.

Increased vulnerability to flare is a fact of life with zooms because all the additional glass tends to aggravate internal reflections. However, some simple precautions will minimize image degradation—for example, avoiding extra-bright sources such as windows or exposed lights within or just outside the frame.

Camera want ads, *Winnipeg Free Press*, July 12, 1992. Prices are in Canadian dollars. Used prices in the U.S. will be 30%–50% lower.

If you were to follow up the "Camera For Sale" classified advertisement for the Canon A-1 this is what you might get.
Top row: Canon lens shade for 28mm lens, Canon A-1 camera with BTL light meter, normal lens.
Bottom row: wide-angle lens, power winder (a low-budget, slightly slower speed version of a motor drive), and a general purpose lens shade.

V

59

A certain kind of distortion that plagues some zoom lenses is more problematic than simple flare—barrel or pincushion distortion is a non-linear response to straight lines. Properly called curvilinear distortion, this problem occurs as a result of the introduction of an aperture. Retrofocus wide-angle and telephoto lenses also exhibit this deficiency to some degree due to their asymmetrical designs. In the "barrel" mode straight lines are bent slightly outward, away from the center of the image, while in the "pincushion" mode the deformation is inward. The change from barrel to pincushion occurs as the focal length is varied. Non-linear distortion is becoming less and less of a problem with every new generation of zoom lenses; therefore I recommend that the newest lens possible be selected. Such lenses do not necessarily have to be made by the same manufacturer as the camera body: Tamron, Vivitar, and others make fine after-market accessories.

The size and weight of most zooms is not really a concern for architectural jobs since the use of small apertures dictates long exposure times, which in turn demand a tripod; the use of a sturdy stand negates problems associated with poor "hand-holdability."

A MODEST 35MM SYSTEM ($500–$800) If the cash is available to start with more equipment, I suggest that zoom lenses be avoided in favor of three fixed focal length optics, namely a 20mm or 24mm extreme wide-angle, a 35mm moderate wide-angle, and a 90 or 105mm moderate telephoto. This group will cover most jobs easily, and the absence of zoom convenience will be balanced by improved technical performance.

A COMPREHENSIVE 35MM SYSTEM ($1000–$2500) Any truly complete outfit will include a perspective control lens. These useful devices are offered in various manifestations by several manufacturers, but I prefer the Nikon 28mm version because its edge to edge sharpness is very good, and its movements are generous. In fact, the Nikkor 28PC will take the place of a conventional 24 or 28mm wide-angle. I therefore suggest the following line-up: 20mm extreme wide-angle, 28mm PC, 35mm moderate wide-angle, 55mm Macro (a macro lens is a specially formulated "normal" lens intended for close-up and copy work, as well as more common tasks—short telephoto macro lenses are also available), 90 or 105mm moderate telephoto, 200 or 300mm extreme telephoto. Well-heeled and/or conscientious photographers would do well to include a second camera body in their collection of tools for emergency back-up in the field and for those times when both B&W and color must be shot.

INDISPENSABLE ACCESSORIES Regardless of how sophisticated or how simple a system you work with there are some accessories that you cannot do without.

First, a sturdy tripod is essential. As I have indicated, architectural photography usually requires great depth of field. Depth of field is a function of aperture (f-stop). Since aperture and exposure time are inversely related, exposure times are usually long, particularly with relatively insensitive, fine-grain, high-resolution films. Image quality is profoundly degraded by camera movement, so the easiest (and by far the cheapest) way to preserve good resolution is to mount the camera on a reliable stand. Choose a tripod with an easy-to-use but positive-acting locking system for both legs and head. Mechanical strength is important; tripods that use extra reinforcing connectors to join the legs and the center column are less prone to vibration. High-quality tripods are fairly expensive and possibly a touch heavier than you might expect, but, believe me, a good one is well worth the expense and the extra weight. Virtually any tripod will vibrate slightly when touched, so it is wise to use a cable release (a mechanically flexible remote-control trigger) rather than one's finger to trip the shutter.

Another modest but important accessory is the lens shade, a shallow cylindrical or rectangular tube that fastens to the front of the lens. As the name implies, a shade protects the lens from any light that originates slightly outside the lens's field of view. Without interference such light can strike the front element at an acute angle and randomly bounce around inside the lens barrel. Ultimately, it forms optical "noise" that causes varying degrees of flare— the result is a lowering of image contrast and an apparent reduction in sharpness. Every lens requires a different size shade for optimum shielding. Unfortunately, even the lens-builders themselves often do not take the time to determine the proper shape and length for each of their products. (This is particularly true for wide-angle and zoom lenses.) Aftermarket lens shades are only a couple of dollars each, so anyone can afford to

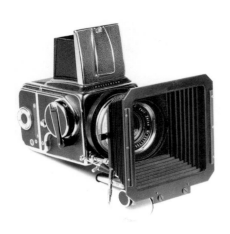

A Hassleblad medium-format SLR with an adjustable lens shade (for precise flare control) attached.

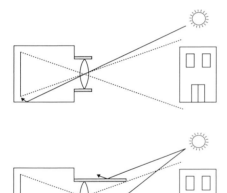

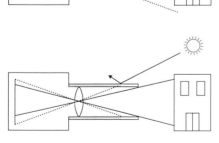

The top drawing shows how a lens shade that is too short permits non-image forming light to enter the camera body and create image-degrading flare. The center drawing shows how a lens shade of proper length diverts or attenuates non-image-forming light. The bottom drawing shows how a lens shade that is too long controls non-image-forming light, but also cuts off parts of the subject.

experiment a bit until the perfect shade is found. The longer (deeper) the better, but do not go so far as to cause image cut-off at the corners of the frame. The diagram on the left show how lens shades work.

To line up the vertical and horizontal elements of rectilinear subjects, most well-stocked photo stores supply simple bubble levels designed to slip into your camera's accessory shoe (the small clip that usually secures a small flash unit). Similarly, these alignments are much easier if the camera viewfinder screen is inscribed with a grid. Some 35mm SLR cameras are designed to accept interchangeable finders, and each manufacturer will have a special screen intended for architectural work. If your camera does not happen to have the interchangeable feature, any competent repairperson can score a grid pattern on the stock screen for about fifty dollars.

The photo on the right shows how I modified a vise to accommodate a spare tripod head. This handy tool allows easy camera mounting when the pyramidal shape of a tripod prevents getting low enough to the ground or near enough to the edge of a stairway, balcony, or parapet. A magazine or a piece of thick cardboard can be used to prevent any damage to decorative railings or the leg of your tripod.

Finally, every camera bag should carry a small selection of basic filters. Filters are flat discs of non-distorting optical glass that have special light-modifying capabilities. They are mounted on the front of the taking lens in the same way as a lens shade. A rationale for specific choices will be given shortly. For now, here are the names of the basic filter categories: polarizing, color-balancing, color-correcting, special-effect, and neutral-density.

This is a photo of a very useful camera clamp fabricated from a tripod head and a Vise-Grip welding clamp. It is particularly handy for low shooting angles when attached to the leg of a tripod. Use a magazine or heavy cardboard to protect the surface finish when attaching to a decorative banister, desk top, table leg, etc.

SHOOTING ECONOMICALLY

PREVISUALIZATION Entire books have been devoted to methods like Ansel Adams's Zone System, a practical application of densitometry by which the enlightened photographer might intellectually previsualize the final results of photographic undertakings. The ability to previsualize a photographic effect before the film is exposed and processed requires a knowledge of exactly how light-sensitive materials respond to light. A first step toward such knowledge is to understand that for every type of film there is a minimum exposure level below which a measurable image density will not be recorded, and that there is also a maximum exposure level beyond which an increase in exposure will not build up any more image density. Between the cutoff points of minimum and maximum exposure levels lies a more or less linear range of sensitivity throughout which an increase in exposure results in a predictable increase in density. Real-life situations are visually rich because they offer a range of brightness, or luminous levels, by which we can distinguish one object from another. (Color plays a role in this process of differentiation, but for now we will consider only brightness levels.) Previsualization, therefore, is an exercise in determining an appropriate combination of camera settings so that the range of acceptance of the film is properly matched to the range of luminances (the brightness ratio) in the scene to be recorded.

SIMPLE EXPOSURE TECHNIQUES The business of matching film response to actual conditions is called exposure control. Unlike the interests of fine artists, who use careful exposure technique to enhance subtleties of expression, our interest is mostly practical; it is necessary to control as many variables as possible in order to guarantee good results with a minimum investment of time and money.

Proper exposure places the subject's brightness range safely within the limits marked by the maximum and minimum levels of sensitivity. This is done by using the film's International Standards Organization (ISO) rating and a measuring instrument called a light meter (or exposure meter).

The ISO designation is a number that represents the sensitivity to light of a given film. The higher the ISO, the more sensitive the film. By today's standards, ISO 1600 is very high while ISO 25 is very low. Sometimes the ISO number is used as part of the film's name; Ektar 25 has an ISO of 25. In real life, there is no such thing as an absolute value for sensitivity. Film speed is a characteristic that changes under various exposure and processing conditions, so many photographers determine a personal effective film speed by experience or testing. An empirically determined film speed is assigned a number called an exposure index (EI) that replaces the ISO rating.

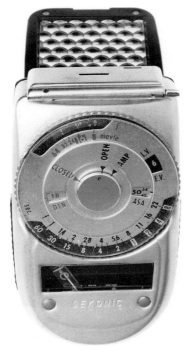

Left: An older model, reflected light meter with "fly's eye" lens array in front of the photo-voltaic photocell (top), exposure dial (middle), and meter readout (bottom). Center: A modern Minolta incident light meter to measure available light and electronic flash. Diffuser dome is at the top. Right: A sophisticated Gossen Spot-Master spotmeter for very precise exposure measurements at a distance. The lens is on the left, the viewfinder on the right, and hand grip on the bottom.

Meters work because of the following rule: a subject of known reflectance, illuminated by a known amount of light, will produce a predictable density on the film when an appropriate combination of aperture and shutter speed is chosen. The meter's job is to measure the amount of light and then recommend appropriate f-stop and shutter speed combinations. For calibration purposes the "subject of known reflectance" is a card painted a shade of gray that reflects 18% of the light that strikes it. When the film's ISO (or EI) is dialed into the light meter, and when the light meter is pointed at an 18%-gray card, the readout will give a combination of f-stop and shutter speed values that will result in an 18%-gray tone on the processed print or slide. The mathematical average of the many brightness levels within a typical subject yields the same reflectance as an 18%-gray card; consequently a light meter pointed at the world automatically gives a reading based on what the meter perceives to be an average light level.

A photo of three 35mm negatives of the same subject, bracketed 1 1/2 f-stops apart. The lighter image is underexposed and lacks detail. The darkest image is overexposed and too dense for proper printing. The middle negative exhibits a full tonal range and will print very well.

For our purposes (with a few exceptions that will be explored later) the light-meter reading can be a reliable starting point for a simple yet efficient procedure to guarantee proper exposure. The procedure is called "bracketing" and involves making a series of additional exposures above and below the measured exposure. For negative films brackets equaling 50% and 200% of the indicated exposure (plus or minus one stop) will generally insure a usable image, while transparency film (which is much more sensitive to exposure error) requires four extra exposures: -1 1/3 stops, -2/3 stop, +2/3 stop, and +1 1/3 stop.

In practical terms, the camera is loaded with a film of a certain ISO (or EI). This number is dialed into the appropriate control on the camera's light meter. The meter will recommend an exposure setting, say f11 at 1/125th of a second. Bracketing exposures of one full

stop on either side of the measured exposure would yield f8 and f16 at 1/125th of a second or alternately f11 at 1/60th and 1/250th of a second, since f-stop and shutter speed are reciprocally related. Half-stop or third-stop brackets are made by selecting settings that fall partway between the f-stop numbers on the aperture control ring of the lens. Some lenses have detentes or painted markings at the half-stops, while others do not, in which case a guess will have to be made. The bracketed exposures are examined after processing and the best ones are retained while the rest are discarded. The people at the lab will assist in making correct choices. The extra film used for the brackets is a small investment compared to the inconvenience and expense of repeating an unsuccessful shoot.

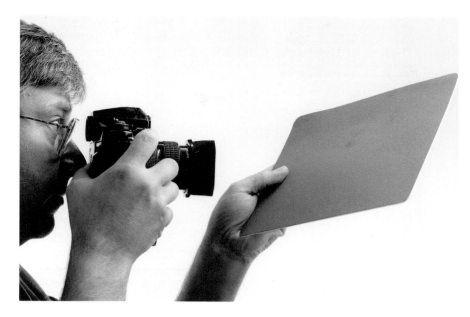

I demonstrate the gray-card exposure method with a BTL metering SLR camera. A gray card is angled to catch the available light. The card should fill the whole frame in the viewfinder, although it need not be in precise focus.

SPECIFIC FILMS AND PROCESSING OPTIONS There are dozens of wonderful films available, but I am intimately familiar with only those I use regularly in my own work. Here is a list of the materials I depend on:

1. Kodak Vericolor III Type S (daylight, general-purpose color negative, ISO 160)
2. Kodak Ektar 25 (daylight, color negative high-resolution, ISO 25)
3. Fuji Reala (daylight, fluorescent-tolerant color negative, ISO 100)
4. Kodak Vericolor VPH (daylight, high-speed color negative, ISO 400)
5. Kodak Ektachrome EPP (daylight, general purpose color transparency)
6. Kodak Ektachrome EPY (tungsten, color transparency, ISO 50)
7. Kodak Ektapress 400 (daylight, high-speed color negative, ISO 400)
8. Kodak Ektapress 1600 (daylight, ultra high-speed color negative, ISO 1600)
9. Ilford Pan F/Kodak Panatomic-X (black-and-white, high resolution, ISO 50)
10. Ilford FP4 Plus/Kodak Plus-X(black-and-white, medium resolution, ISO 125)
11. Ilford HP5/Kodak Tri-X (black-and-white, low resolution/high speed, ISO 400)

Both black-and-white and color negative films benefit from more exposure than their official ISO ratings require; therefore I generally set my exposure meters to an EI of one-half the designated ISO for these films. Transparency films, as a rule, must be exposed at their official ISO ratings.

In Chapter 3, I extolled the print-making services of professional custom processing labs. I believe it is best to depend on these people for film processing, as well. Results will be more consistent and the occasional special service, such as pushing (processing for higher speed and increasing contrast) or pulling (processing for lower speed and reducing contrast), will be available when you need them. Skilled technicians can offer advice regarding exotic darkroom options, exposure technique, and other concerns once a working relationship and a regular flow of work has been established.

POLAROID TESTING A sophisticated approach to exposure (and composition) control commonly used by professionals takes advantage of instant-developing films. All 4x5in and many medium format cameras will accept special Polaroid film backs that allow very precise previews of camera setup and lighting. It is possible to have a 35mm camera body custom-modified for this type of testing, but the image is too small to be really useful and the modification is prohibitively expensive.

Nevertheless, instant-camera testing for 35mm photography is possible with special cameras, as long as those cameras have conventional f-stop and shutter speed adjustments. The cameras are pricey (several hundred dollars) and difficult to locate second-hand, but they are very useful. Polaroid films have stable ISO ratings that are comparable to conventional films, so once a decent exposure has been determined using instant film it can then be transposed to the 35mm camera. This method is for perfectionists with deep pockets only.

KEEPING RECORDS The best technique in the world is rendered useless by a poor memory. Your learning curve will be accelerated and your technical accomplishments safeguarded if you take the time to maintain a written record of film, lens, meter readings, exposure settings, light conditions, and processing details for every roll of film. There are actually dedicated photographic notebooks available through professional supply houses. However, the lack of an official-looking journal is no excuse for not doing one's homework.

FILING AND STORING NEGATIVES AND SLIDES Easy access and worry-free protection of your photographic output is assured if a few simple practices are followed religiously. Edit your negatives and slides as soon as they come back from processing. Those images that are redundant or of no real value (outtakes) should be discarded right away. (Film is susceptible to scratches and attack by skin oils as well as other commonplace contaminants carried on the fingers: handle by the edges only.) All negatives and slides should be kept in vinyl storage sleeves (available at most camera stores) and stored flat, cool, and dry. A large three-ring binder with divider cards or an ordinary letter-size cardboard folder for each job and a regular filing cabinet drawer will go a long way toward keeping things organized and within easy reach. For archival storage, photographic materials should be stored in a freezer. Low temperature and low relative humidity are important for long life.

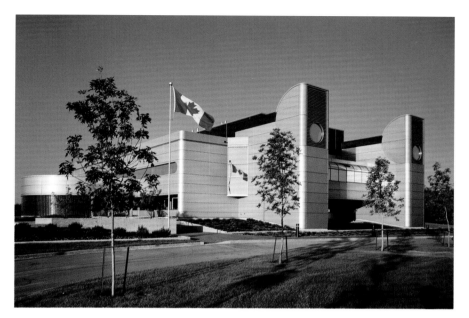

1, 2 These images show how far photographic technology has progressed in the last few years. The top image of the Government of Canada Toxicology Laboratory, Smith-Carter Architects, Winnipeg, was photographed on 4x5in Vericolor film using a view camera and a 90mm moderate wide-angle lens, while the bottom image was made on 35mm Kodak Ektar 25 film with a Nikon single lens reflex camera and a 28mm PC lens. Moderate perspective controls were employed in each instance. I am hard pressed to distinguish between them technically. Careful examination of the original prints show that the 4x5in version has slightly greater resolution—probably due to optics.

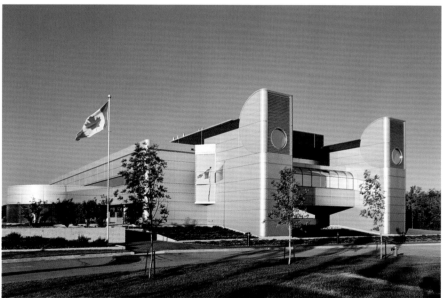

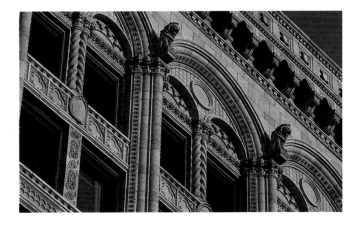

3–8 These 35mm color slides show how quick and easy to use small-format equipment can be. These photos, details of heritage buildings in downtown Winnipeg, were all made during a leisurely two-hour stroll on a warm summer evening. I carried only a camera and a long telephoto lens. In lieu of a tripod, I braced myself against various street-level objects like posts or buildings to avoid camera shake.

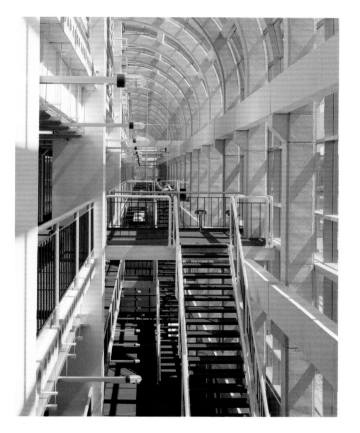

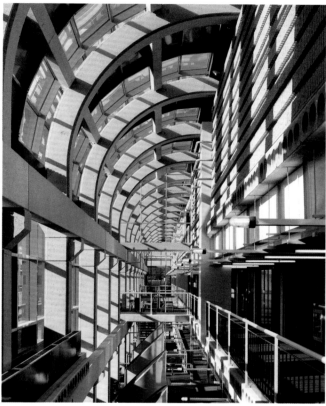

9, 10 These two similar images show how the differences between transparency and color negative films are diminished by the process of non-photographic reproduction. Both images depict aspects of the block-long atrium hallway of IKOY Architects' William Davis Computer Center at the University of Waterloo, Waterloo, Ontario. The first photo was reproduced directly from 4x5in Kodak Ektachrome film; the second photo was made on Kodak Vericolor III negative film and reproduced from an 8x10in print. I think you will agree that they are virtually indistinguishable, technically speaking. Camera: Toyo 4x5in, lens: 90mm (moderate wide-angle). Perspective controls were used.

11–14 This small-format portfolio was shot with a 35mm Nikon SLR and Kodak Ektacolor Gold 200 film by Ron Keenburg, chief of design (the "K") at IKOY Architects. They depict the IKOY hunting/fishing lodge built in northern Manitoba. I processed the film and produced carefully printed enlargements that were used as IKOY's successful entry in the 1990 Governor General's Awards for Architecture competition (Canada's highest honor for design). The sharpness of the Kodak Ektacolor Gold 200 film is noticeably less than that of the much slower Ektar 25, but the photos quite adequately served the purpose for which they were intended. Subjects such as this—fairly simple, bold shapes with clearly defined edges—are the type best suited for 35mm photography.

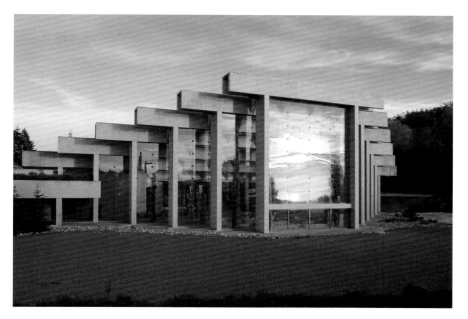

15 These photos, all made from the same negative, show the power of print controls. This is a view of the Museum of Anthropology, University of British Columbia, Arthur Erickson, architect. This is my very first architectural photo. This particular print is completely unmanipulated—just a straight print made at normal color settings and exposure. Camera: Linhof Technica 6x7in (medium format field camera), lens: 65mm (moderate wide-angle), film: Kodak Vericolor II Type S. No perspective controls required.

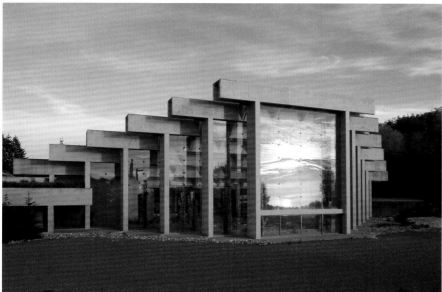

16 The same image printed with a magenta color caste.

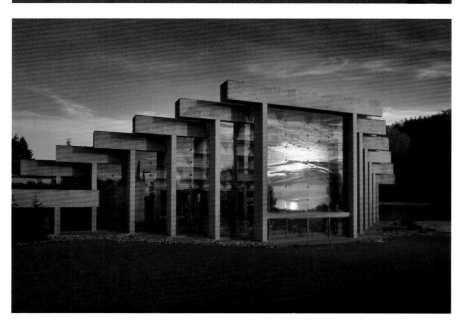

17 The same image printed with several manipulation techniques. First the sky and foreground were "burned in" (darkened) by increasing exposure time to these areas by about 150%—the building was "dodged" (held back, or lightened) during this process. Next, areas of the image to the extreme left and right were burned in by a further 75%. The color settings on the enlarger were adjusted for a very warm color balance, and then the reflection of the sunset was selectively burned in.

18, 19 These two photos—details of a very old handmade door and latch—were made from the same camera position and show how quality of light affects the power of an image. The pictures were part of a documentary shoot for Canadian historian Gwen Dowsett, who was studying the vernacular architecture of Manitoba's early Ukrainian immigrants. The photo above was made while the sun was obscured by a cloud—the light is very soft, and yields a rather dull effect. The photo on the right was made just a minute or two later, just after the cloud passed and permitted the early morning sun to skim the subject. Apparent depth and richness of color were dramatically increased by the direct sunlight. Camera: Hassleblad ELX (medium format), lens: 100mm (normal), film: Kodak Vericolor III Type S. No perspective controls.

20 The vantage point here was chosen to highlight IKOY's imaginative and unorthodox use of conventional materials. Camera: Toyo 4x5in, lens: 150mm (normal), film: Kodak Vericolor III Type S. Perspective controls were not used.

21 Careful camera positioning revealed a pleasing mirror image of the IKOY deck and pool while showing off details of the stair at the same time. The overcast sky makes the shot less confusing by eliminating heavy shadows. Camera: Toyo 4x5in, lens: 75mm (extreme wide-angle), film: Kodak Vericolor III Type S. Perspective controls were required.

22 This ultra-wide-angle view of a re-
stored cathedral in Regina—Clifford
Wiens, architect—was made by available
light from the balcony at the back of the
church. Notice how the blue-magenta
color of the columns and pews in the fore-
ground argues with the warmer tones to-
ward the alter. Stained glass pieces to
each side of the alter are backlit with fluo-
rescent lamps—note the blue-green spill
on the wall around them. Camera: Toyo
4x5in, lens: 47mm (extreme wide-angle),
film: Kodak Vericolor III Type S. No perspec-
tive controls required because of the ele-
vated viewpoint.

23 This view is shot from floor level. Note
how the inclusion of the stained glass win-
dows in the composition makes the blue-
magenta cast of the columns more
acceptable. This is a psychological trick: if
the viewer is shown the reason for a photo-
graphic condition, the viewer becomes
more tolerant of that condition. Also note
that the change in vantage point has
shifted the predominant color balance of
the pews and central carpeting toward a
warmer, more natural tone. From the new
viewing angle the predominant light
source is no longer window light, but tung-
sten. I dodged the fluorescent highlights
to each side of the alter, which made them
lighter and less objectionably blue-green.
The hanging tungsten fixtures were indi-
vidually burned in to yield more detail.
Camera: Toyo 4x5in, lens 75mm (very wide-
angle), film Vericolor III Type S. Extreme per-
spective controls because of the viewpoint.

24, 25 This a close up view of a unique wire and wood-block curtain that architect Clifford Wiens designed to separate the main alter from a smaller chapel directly behind it. Vertical lines were permitted to converge for effect. The print on the right is identical to that on the left, except that the ceiling fixtures have been switched on, enhancing the celestial feeling and increasing the perception of depth by adding detail to the walls and arches. It pays to pay attention to subtle effects. Camera: Toyo 4x5in, lens: 75mm (very wide-angle), film: Vericolor III Type S. Extreme perspective controls required because of the floor-level viewpoint.

26, 27 This elevation of a two-story Akman & Sons suburban office building was shot under pressure of deadline—the windows were supposed to have been tidy. Since the picture was needed for a promotional brochure I asked Ray Phillips to eliminate the signs plus some other unsightly details in the foreground. Camera: Hassleblad ELX (medium format), lens: 60mm (moderate wide-angle), film: Kodak Vericolor III Type S. No perspective controls.

28 These three 35mm Kodak Ektachrome slides of the Air Canada Head Office in Winnipeg, Smith-Carter Architects, show the technical effects of a one-stop bracket around a metered exposure. The differences are small but significant—study the difference in the highlight detail as exposure changes.

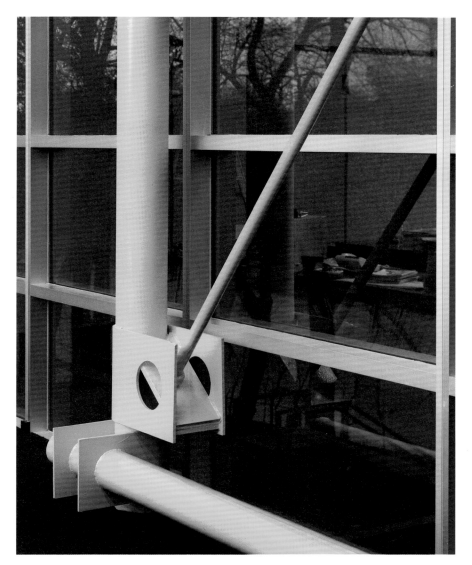

30, 31 I offer this nondescript hallway as a lesson in on-camera filtration. The photo at the top is an unfiltered exposure with daylight-balanced Ektachrome under cool-white fluorescent lighting. The film reacts strongly to the excessively greenish spectrum produced by these lights. A more pleasing neutral color balance is pretty well restored by shooting through a 30M (magenta) Kodak Color Compensating gelatin filter (below). A very similar correction can be achieved in the darkroom when making prints from unfiltered color negatives.

29 This is a closeup view of one corner of a custom-made stress-relief structure. Available fluorescent lighting illuminates the yellow steel tubing and window mullions. The extra magenta filtration required to compensate for the green characteristic of fluorescents renders the twilight sky in extra rich tones. Reflections from inside the building were diminished by using a polarizing filter on the camera lens.
Camera: Toyo 4x5in, lens: 90mm (moderate wide-angle) plus polarizing filter, film: Kodak Vericolor III Type S. Perspective controls were required.

32 In this picture, daylight competes with fluorescent lighting. The overall color balance of the print is set to make the fluorescent-lit areas appear neutral in color. As a result, the areas in which daylight predominates appear somewhat magenta. This effect is minimized, however, by the fact that daylight areas are also overexposed and consequently rather pastel. Camera: Toyo 4x5in, lens: 75mm (extreme wide-angle), film: Kodak Vericolor III Type S. Perspective controls were required.

The photographs on these two pages document the restored turn-of-the-century Bank of Hamilton Building. The renovations were supervised by The Prairie Partnership Architects. All interior views were shot by available light.

33 This view was made from street level and shows how the building fits into the urban landscape. Late afternoon sunlight fully illuminates the main facade and highlights elements of the nearby structures. Camera: Toyo 4x5in, lens: 90mm (moderate wide-angle), film: Kodak Vericolor III Type S. Fairly extreme perspective controls were required to maintain rectilinearity at close quarters.

34 Still at street level, but now much closer, this view of the entrance relies on the steep sun angle to highlight the texture and detailing of the stone and metal work. A moderate telephoto lens was used to compress perspective. I was working to a fairly tight budget, otherwise I would have asked a retoucher to eliminate the wires above the door, and the sign post to the right of the stairs. Camera: Toyo 4x5in, lens: 250mm (moderate telephoto), film: Kodak Vericolor III Type S. No perspective controls required.

35 The main banking hall viewed through the lobby doors. I shot the interior on a different day—I wanted very dull daylight inside to reduce color balance conflicts. I made the prints quite yellow to enhance the warm feel of the original brass fittings and tungsten light fixtures and to minimize the blue of the ambient daylight. Camera: Toyo 4x5in, lens: 90mm (moderate wide-angle), film: Kodak Vericolor III Type S. Moderate perspective controls.

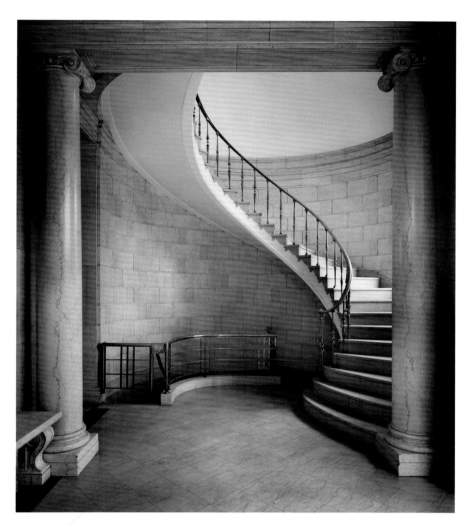

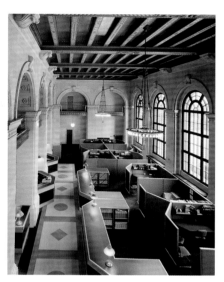

37 This is a shot of the main banking hall from the vantage point of a small mezzanine. Careful burning and dodging of the print was required to maintain detail throughout. It is very clear how the mixture of daylight and tungsten light induces shifts in color balance across the image, but in this case the discrepancy is not objectionable, in fact it adds to the "old world" ambience. Camera: Toyo 4x5in, lens: 90mm (moderate wide-angle), film: Kodak Vericolor III Type S. Extreme perspective controls required.

36 This photo shows the base of the circular stairway in true rectilinear alignment. Color balance is uneven, but as in the shots of the banking hall, the obvious shifts are acceptable because of the age and complexity of subject. Camera: Toyo 4x5in, lens: 90mm (moderate wide-angle), film: Kodak Vericolor III Type S. Moderate perspective controls.

The images on these two pages illustrate color to black-and-white conversions.

38, 39 A magical image made by available light without perspective controls. Careful alignment of the wide-angle-equipped camera captures the graceful curve of this stairway at the Carleton Club, Winnipeg, by Smith-Carter Architects. Small tungsten lamps behind the handrail project interesting shadows on the curved wall to which the individually mounted steps are attached. The conversion from color to black-and-white is successful because the tones and geometry of the image are sufficiently distinct to maintain the graphic impact. Camera: Toyo 4x5in, lens: 47mm (extreme wide-angle), film: Kodak Vericolor II Type L.

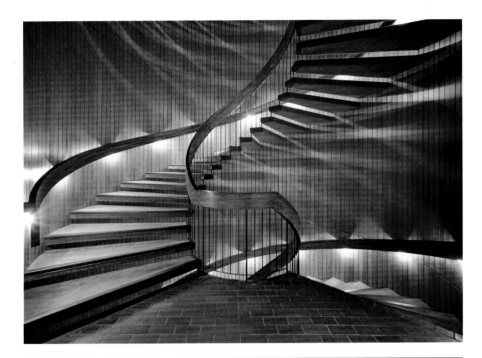

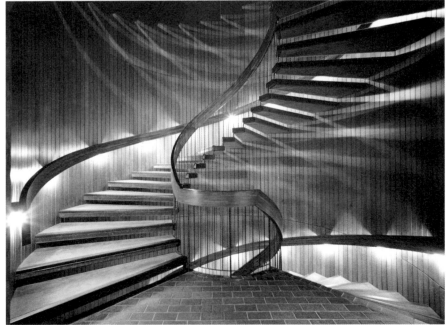

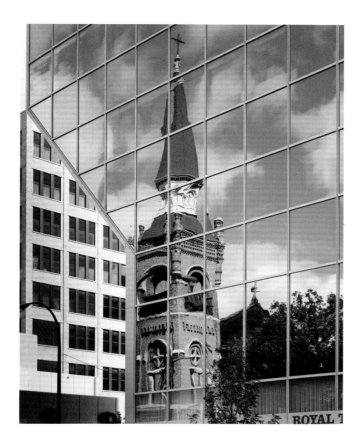

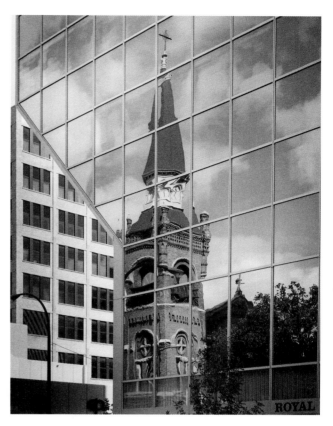

40, 41 This carefully composed image is a photographic pun: it records a very particular point of view and sets up a playful interaction between the main subject—the glass building partially shown in the foreground—and the surrounding structures. The color version is more immediately accessible, simple because the additional information makes the composition less ambiguous. Technically the conversion to black and white is satisfactory, but the monochromatic rendering makes an already complex picture a little confusing. Camera: Toyo 4x5in, lens: 150mm (normal), film: Kodak Vericolor III Type S.

42 This is a 4x5in copy transparency of an IKOY rendering—a proposed Agriculture Canada Research Station and Laboratory, Brandon, Manitoba. The slide was made by Custom Images, a professional color lab in Winnipeg. The original drawing is held flat against a perforated easel by vacuum suction, and photographed together with Kodak Color Control Patches and a Kodak Gray Scale so that densitometric measurements can be used to make accurate prints at a future date.

43, 44 This office building rises near the banks of the Saskatchewan River, in Saskatoon, Saskatchewan. This is the first project I photographed for IKOY Architects. The two photographs show how a little extra effort makes photographs much more interesting. Both images were made from the same vantage point, but twelve hours apart. The second photo was taken at night, with about a 90 second exposure. Arrangements were made to have the building fully illuminated. Serendipitously, nearby buildings were relatively dark, leaving my clients' building (second from the left) shining like a jewel in the winter night. Note how various light sources are each recorded as different colors. Camera: Toyo 4x5in, lens: 150mm (normal), film: Kodak Vericolor III Type S. Perspective controls unnecessary.

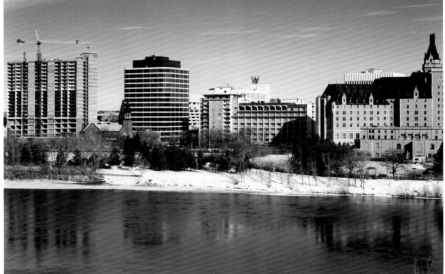

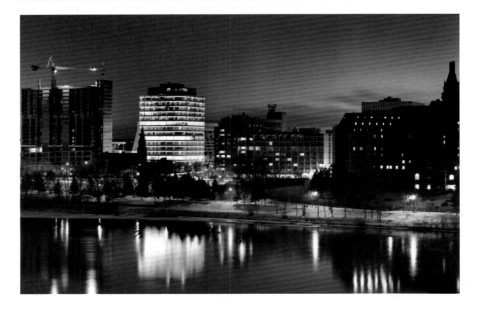

Please note: The advice in this chapter will be based on the assumption that the work will be shot exclusively on 35mm equipment.

A TYPICAL EXTERIOR SHOOT

DEFINING THE JOB First things first: the proper beginning for any photographic project is to gather information and then think. Only professional artists and highly motivated amateurs make photographs for the sheer joy of it. Although there is no monopoly on aesthetic pleasure, most everyone makes photographs for a specific reason. Define your own reasons, and the work will be much more straightforward. Refer to the list of pertinent questions given on pages 15–16.

CHOOSING FILM AND EQUIPMENT In a typical scenario, architectural photography is intended to be a combination of documentary record and selling tool. This means that the images must be clear, comprehensive, and attractive. Technically, they must be versatile, since it may be necessary to generate color prints suitable for inclusion in a portfolio, black-and-white prints for newspaper or photocopy reproduction, and a few color slides for audio-visual presentation. The end use, therefore, dictates some technical choices even before the actual subject of the photos is considered.

The amount of time and the money available further limit technical choices. For example, each of the above mentioned end products (color prints, black-and-white prints, and color slides) will be technically superior if they are produced with films dedicated to that particular medium. In other words, if the very best results are required and if the resources are there, the photographs should be shot on three different films. If time is not a problem but cash is, the alternative would be to use to use Ektar 25, the highest resolution (but least sensitive) color negative film available. With this approach the work tends to go rather slowly because the resulting long exposures keep the camera tripod-bound. To speed things up, albeit at the expense of some quality, a faster film such as Vericolor Type S or Ektar 125 will get the camera off the tripod. I strongly recommend you do some comparative testing. A working familiarity with film performance is essential to the successful visualization of the final image.

Equipment choices and equipment availability are interlocked. After deciding on a format, most professionals will pack a wide selection of lenses, and then base their specific choices on the shooting angles dictated by the accessibility and the size of the subject. The compact nature of 35mm equipment makes this easy to do for amateur work. However, even if you will be using fast film, I suggest carrying a tripod along to each job just in case low light-levels force exposures into the "non-handholdable" range.

SELECTING ANGLES AND TIME OF DAY Determining the best points of view and the best sun angles is the real work of the architectural photographer. In the studio, the commercial photographer creates a scene in which the lighting and the camera position best portray the subject. However, when working outdoors with subjects of monumental scale, virtually all controls, except for the choice of camera position and the time of day, are eliminated. The technique of finding the right angles is a Zen-like process of observation and surrender—surrender to both the workings of nature and the not-quite-invisible hand of the architect who fashioned the building and its surroundings. If the photographer is the architect (or someone involved in the creation of the design), then finding pleasing angles will be easier, although the mechanics of the process will be the same.

A site inspection, preferably in the company of the designer, is essential. The first efforts should be directed to finding suitable views from eye level, from below eye level, and from above eye level. The higher vantage points might be located on nearby buildings or hills, while the lower vantage points might require a bit of crawling around. Glass or metal-clad buildings are tricky because different perspectives invoke different reflections that have to be integrated as second order compositional elements.

The exact point of view (I refer now to fine tuning, which involves very precise camera movements of a few inches to a few feet) depends on small but significant details such as the interaction between foreground objects like trees, lampposts, or street signs, and elements of the building's facade.

Next, decide on what angle of sunlight will be most effective. This is a subjective criterion, and changes according to exactly where on the style-scale of "straightforward documentary" to "high drama" you wish to place your work. (Consideration of style relates to the choice of angles as well, but the range of choices is more limited.) A simple rule

says that coarse-skinned buildings (wood, brick, cement, stucco) are best highlighted by steeply angled, direct sunlight, while smooth-skinned buildings (glass, metal, tile) are enhanced by interesting reflected light, such as that from an unusual sunrise, sunset, or cloud formation. Aside from the predictable progression of the sun's arc through the sky, natural light is capricious. Patience is an asset in this work.

You will note that all preliminary photographic choices can be made without any reference to photographic hardware; the first steps of the previsualization process involve only an aesthetic empathy with the subject, based on careful observation of how the natural and the man-made worlds interact.

OPTICAL CONSIDERATIONS After points of view and sun angle are determined, the capabilities of the lenses at hand must be considered. In the best of all possible worlds every choice of camera position would be easily accessible, but in the real world the laws of optics impose some rather brutal restrictions. Except for recording details and shooting from a distance, most architectural photography depends heavily on wide-angle lenses; therefore, angle of acceptance is critical. Strictly speaking, each different point of view around a given site will demand a lens of different focal length. If perspective correction (parallel vertical lines) is not a major concern, the infinite variability of zoom lenses is a definite advantage. But as we have seen, zooms have problems (there is no such thing as a PC zoom, for example), so those interested in the best optical performance and/or perspective correction must rely on lenses of fixed focal lengths. The corollary of this fact is that some desirable points of view must be sacrificed or modified because the lenses available are not exactly the right focal length.

To preserve the parallel lines of the subject, the film plane and the principal subject-plane must be parallel. When the lens is not positioned on a line perpendicular to the exact center of the subject, either crop the image from an ultra-wide-angle lens or use perspective controls. Unfortunately, PC lenses are available in only a couple of focal lengths, typically 28mm and 35mm, while extreme wide-angle lenses introduce problems of dimensional ambiguity. When the limits of coverage or perspective controls are reached, the camera has to be either moved away from the subject or tilted upwards.

As discussed in Chapter 4, the gratuitous use of "unnatural" perspectives that result in converging vertical lines and odd spatial juxtapositions can get tiresome. Generally

Left: An early morning shot of the rear wall of the IKOY Office. The exposure was made just as the sun reached a position that fully illuminated the structure while leaving the pool and deck in shadow. This leads the eye directly to the stairway entrance and enhances the contrast between the reflections of structural details and the blue of the water. This is an excellent illustration of the effective exploitation of natural lighting conditions. Camera: Toyo 4x5in, lens: 90mm (moderate wide-angle), film: Kodak Vericolor III Type S. Perspective controls were required.

Right: An extreme close-up showing the treatment at the corners of the steel mezzanine supports in IKOY's Winnipeg office. To achieve maximum impact, the photo was made by direct sunlight at a time of the day when the wall behind the joint was not directly illuminated. Camera: Toyo 4x5in, lens: 250mm (moderate telephoto), film: Kodak Vericolor III Type S. Perspective controls were required.

VI

67

speaking, we are most comfortable when that which we know to be upright is rendered as upright in a photograph. Similarly, we are most comfortable when objects that we know to be of a certain relative size are so rendered in a photograph. Bearing these truths in mind, it is not difficult to understand that lenses of different focal lengths have clearly definable comfort zones within which three-dimensional subjects of familiar proportions may be comfortably translated into two dimensions. From experience I can say that moderate wide-angle lenses can be trusted not to exaggerate perspective to a noticeable degree; they have a wide comfort zone and can be used freely all around the compass, both dead-on or from very acute angles. The dimensions of the subject and the angles of acceptance of the lenses in question geometrically predict minimum working distances; extreme wide-angle lenses are real problem-solvers in tight circumstances, but they have a very narrow comfort zone and consequently must be used much more carefully. The following advice regarding low, medium, and high-rise buildings is given with special attention to the eccentricities of wide-angle lenses. Some consolation may be taken in the knowledge that even professional photographers with a full compliment of 4x5in equipment are frequently confounded by the limits of the available technology.

LOW, MEDIUM, AND HIGH-RISE BUILDINGS I use the word "mechanical" to describe those variables in photographic practice that are neither completely aesthetic nor completely technical. The size and shape of the subject are largely mechanical considerations; in photographic terms the geometry of the subject creates problems that, given the

nature of the tools available, have to be dealt with in rather predictable ways.

Eye-level photography from the street is the most common type of architectural work because it yields images that look right (and it is easy on the back). Nevertheless, the mechanical problems associated with this approach escalate according to the size of the structure because larger subjects demand greater camera-to-subject distance. Adversely, skyscrapers are crowded together in congested urban neighborhoods while strip malls are usually surrounded by acres of parking lots.

Low-profile buildings of one or two stories are the least technically demanding to photograph. Generally, moderate wide-angle or even normal lenses will permit rectilinear elevations and angled views to be made without a struggle. The problems in this case are more aesthetic than technical, since many industrial side-by-sides and low-budget suburban strip malls are not highly interesting photographically.

It is possible to add some visual interest to dull low-rise subjects by using their architectural embellishments, however unprepossessing they might be, to advantage. For example, most multi-tenant structures have a stand-alone signpost or marquee; this could be positioned as a foreground element to one side of the frame to break up the horizontality of a suburban/industrial landscape. The front wall of most low-rise buildings have some decorative texturing, such as brick, stained wood, or exposed aggregate. By getting fairly close to the embellished surface and shooting at an angle along its length with a moderate wide-angle lens, detail elements can become the compositional focus. This effect can be enhanced by choosing a "glancing" sun angle that is opposed about

Low camera angle, early morning light, and a big pile of crushed rock were employed to dress up this shot of a suburban cement plant: Tallcrete Building, IKOY Architects, Winnipeg. Camera: Toyo 4x5in, lens: 75mm (extreme wide-angle), film: Kodak Vericolor III Type S. No perspective control necessary.

This photo shows how to deal with low-budget condominiums—clever framing and the right light. Low-angled sunlight and the fall foliage of the modest landscaping elevated these simple wood-frame side-by-sides, shot with a moderate wide-angle lens. (IKOY Architects.) Camera: Toyo 4x5in, lens: 90mm (moderate wide-angle), film: Kodak Vericolor III Type S. With the camera at eye level, perspective controls were unnecessary.

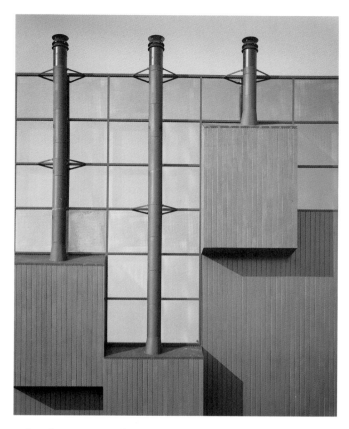 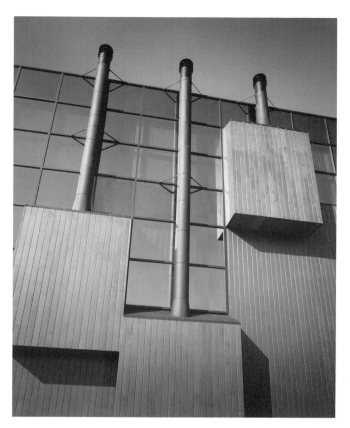

90° to the camera angle. (Such a sun angle is quite dramatic in the right situation, but it is also pitiless in revealing mechanical flaws. Chose a smaller angle when shooting imperfect finishes.) If a PC lens is available, shooting from a lower-than-eye-level camera position can add to the sense of drama.

Since strongly horizontal images allow for a broad expanse of sky, if possible make your photographs on a day when interesting cloud formations are visible from the best camera positions. When shooting black-and-white materials the tone of the sky can be deepened and the textures of the clouds enhanced by shooting with yellow or red filter over the lens. In color, skies can be enriched with a polarizing filter.

What might otherwise be simple documentary-quality images of very plain structures can sometimes be greatly improved by shooting around dusk or dawn when the sky is often particularly pretty. For example, warmly colored reflections will dress up rows of windows that would appear monotonous in broad daylight.

In some circumstances a bird's-eye view of a low-rise building can make an effective photograph. Low-budget structures generally have only tar, gravel, and ventilation equipment on the roof, but some more elaborate structures allow for more attractive finishing. It is not unusual to find a bit of greenery around such buildings as well. From an elevated point of view, possibly a nearby rooftop or balcony, a photo of the whole site might be quite attractive. If no elevated vantage point is available, you might create your own. It is surprising how different things look from the top of an eight or ten foot ladder. Really ambitious photographers might even rent a cherry picker—a truck with a hydraulically operated lift such as those used by power-line workers or window cleaners. They rent out for about $75 an hour with an operator.

Many low buildings are surrounded by oil-stained concrete driveways and parking lots. If the negative visual effects of the dirty paving cannot be eliminated by cropping the image, a couple of clean late-model cars can be included in the composition as camouflage. (For ground-level shots use a slightly elevated camera angle so that the cars do not unduly obstruct the view of the building.) When an unsightly foreground simply cannot be avoided, ask the printer at the color lab to burn-in the offending area so that it attracts less attention. (Burning-in is also effective in deepening the color of a pale or overcast sky.)

Several of the techniques suggested above will work with medium-rise buildings, although without perspective control lenses it will be more difficult to shoot close up and

These pictures were made at about the same time of day, yet the different camera positions yielded strikingly different tonalities. This occurred mainly because of the change in the reflection—from a different angle we see darker or lighter parts of the sky. These photos also illustrate the effect of maintaining or relinquishing rectilinearity. The facade's grid is most powerful when presented dead-on, while the converging view is more playful, and less mechanical. Camera: Toyo 4x5in, lens: 90mm (moderate wide-angle), film: Kodak Vericolor III Type S printed on B&W Kodak Panalure paper. Perspective controls were required.

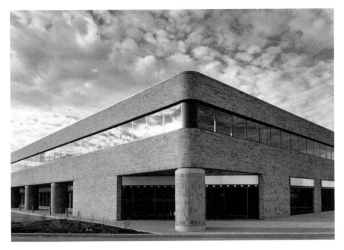

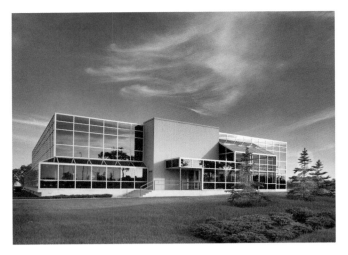

Left: This picture shows how a dramatic sky—and the reflection of a dramatic sky—can dress up a fairly ordinary structure. The partial overcast softened shadows as well, making the windows the brightest part of the image, a condition that leads the eye away from the sparsely landscaped foreground. The soft light retains detail in the darker wall, thus maintaining a fairly balanced look. Camera: Hasselblad ELX (medium format), lens: 60mm (moderate wide-angle), film: Ilford FP4 (ISO 64). No perspective controls required.

Right: This one-story building is the RH Laboratory on the campus of the University of Manitoba. The photo is an example of how reflections can be used to enhance an image. I chose an evening with broken clouds so that the wispy shapes would soften and enrich the black shiny panels. The modest landscaping was used to advantage by selecting a low camera angle. Camera: Toyo 4x5in, lens: 90mm (moderate wide-angle), film: Kodak Vericolor III Type S. Modest perspective controls.

at lower angles. Buildings of several stories are often more expensive than buildings of only one or two stories, so it is likely that finishing and landscaping are superior. Choose angles that highlight these elements to improve your photos. Taller buildings usually have a lot of windows, so reflections of interesting cloud and light conditions can figure prominently in your compositions. If the reflections from particular angles are distracting, a polarizing filter can sometimes attenuate or eliminate them altogether. Whenever windows are prominent, take the time to go from room to room and arrange blinds and drapery so that they appear uniform and tidy from the outside. Actually, this applies to low-rise buildings as well. (High-rise buildings often use highly reflective mirror-like glass, which largely eliminates this problem.)

It may be necessary to get above street level in order to avoid converging verticals. Should the neighboring structures be too tall, however, shooting from a rooftop will cause the same problem, but in reverse (diverging verticals). The solution is to shoot through a window. Results will be best if the windows open, but if the windows are permanently sealed, a few precautions are necessary. First, turn off all the lights in the room; even if you cannot see them the fixtures might cause distracting reflections in your photos. To further reduce the possibility of reflections get as close to the glass as possible, in fact it is best to have the lens actually touching the glass surface; if you use this method, first ensure that the glass does not vibrate with passing traffic or activity within the room (a soft-rubber lens shade will effectively isolate the camera from such vibrations.) Be aware that if the window is tinted it will induce a color-cast in transparency films. This is not a worry with color negative films, which can be color-balanced during the printing stage. Remember to clean the window.

High-rise buildings are difficult to photograph with 35mm equipment. The main task is an exercise in photographic detective work, since a good combination of point of view and sun angle that does not require extreme perspective correction is very tricky to find. The problems associated with this search are as much diplomatic as they are photographic. Since most of the useful viewpoints will be found inside or on top of neighboring high-rise buildings, you will need to negotiate with reluctant building managers, security guards, and maintenance people. Aside from their own good natures these people have no real reason to help you, so be patient. It may be necessary to arrange in advance for written permission to access certain buildings. You may have to pay for a security person to escort you.

Once on location, be prepared for some unusual mechanical obstacles. Vertical metal ladders, narrow walkways, and restricted parapets are typical on top of tall buildings. Some physical contortion and creative clamping may be necessary to secure the camera properly. Extremes of temperature, wind, and vibration are problematic up high, as is air quality. Both urban smog and natural haze can stain or obscure an otherwise decent sight line, although polarizers or ultraviolet filters are sometimes helpful in improving image contrast and color. As a rule, high-rise hopping is very demanding and slow going. A whole day of work might yield only three or four good images.

Aesthetically speaking, photographing tall structures is attended by design difficulties not unlike those presented by very horizontal structures, with the added complication of contextual clutter. Wide but low buildings allow the use of the sky as a compositional

component, but tall buildings are usually found in the company of other tall buildings and there is no guarantee that they will appear side-by-side in harmonious configurations. Skylines are haphazardly arranged in modern cities. Pleasing views will be apparent only after an automobile tour that circumnavigates all the districts surrounding the downtown area. It is a good idea to have a friend do the driving while you do the looking. Real persistence sometimes pays off in the discovery of a location that reveals the building of interest nestled within a sensational framework of other structures or spotlit by a serendipitous shaft of sunlight.

From close by, the facade and the first few floors of skyscrapers can be shot with a reasonable possibility of maintaining parallel verticals, but to capture the whole height on film usually means tilting the camera. The exaggerated views afforded by extreme wide-angle lenses are sometimes welcome in these circumstances, particularly if there is a decent-looking entranceway, corporate logo, or piece of sculpture that can be incorporated in the lower foreground. Should there be a position on the street that is sufficiently distant to allow the building to be photographed in its rectilinear entirety with a 24mm or 28mm PC lens, special care must be taken in order to avoid obstructions like vehicles, street signs, streetlamps, and pedestrians. The exact time of day is critical for this work; the shadows of deep urban canyons

seem to retreat for only minutes at a time. Skyscrapers act like giant sundials and darken each of their neighbors in turn as the daylight hours pass. Since modern buildings are often embellished with sleek metallic surfaces or curtain walls of subtly colored mirror glass, changes in the light conditions will be amplified at certain angles. Be careful to avoid unattractive reflections. Polarizing filters are helpful in emphasizing and de-emphasizing certain reflective phenomena, although they can make some varieties of glass appear distorted or discolored.

Light can be used to isolate and emphasize tall buildings even after the sun has set, assuming the cooperation of the building management can be enlisted in the enterprise. These days many tenants will switch off office lights at the end of the day in order to save energy; if the building you are shooting is completely lit up at three or four o'clock in the morning there is a good chance that it will stand out boldly against a mainly dark field *(see color plates 42–43)*. Later I will offer specific pointers for dealing with the problems of shooting at night.

Features of a small urban park and the inclusion of the Calgary tower place this IKOY Architects' apartment building (the one with the dark circle painted on it) in context. Tall buildings can be seen from quite a distance in uncrowded cities like Calgary, so there are often many choices for a contextual view—it just takes a little effort to find them. Camera: Toyo 4x5in, lens: 90mm (moderate wide-angle), film: Kodak Vericolor III Type S. No perspective controls necessary.

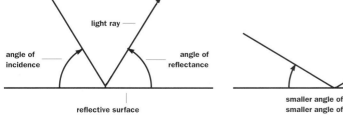

light ray

angle of incidence

angle of reflectance

reflective surface

smaller angle of incidence = smaller angle of reflectance

This drawing shows how the angle of incidence is equal to the angle of reflectance. It is necessary to understand this very basic optical phenomenon in order to successfully photograph reflective materials like glass, metal, or surfaces treated with high-gloss paint.

AERIAL PHOTOGRAPHY There are some buildings that simply cannot be adequately photographed from ground level or from some vantage point on neighboring structures. This can be equally true of tall skyscrapers, sprawling suburban malls, or complicated industrial sites. The solution is to get up high in a helicopter or light plane. This does not have to be an expensive production undertaken by experts only. Like other seemingly intimidating photographic techniques, aerial photography can be straightforward and economical if a few simple guidelines are kept in mind. I will deal with the mechanical aspects first, relevant technical aspects second, and the financial considerations last.

It is prudent to organize an aerial shoot at least a week or two in advance. All air traffic is strictly monitored and controlled so pilots will need a few days to obtain the necessary permission from regulatory bodies in order to fly low over urban areas. In my area flying above one thousand feet is not difficult to arrange. To get lower, a fair amount of red tape has to be dealt with.

A little research with the yellow pages or a few phone calls to local television news producers will yield a list of flyers experienced in working with cameramen. Call ahead and arrange a time to take a look at the plane or helicopter from which you will be working. Generally a door or window can be removed so that there is a relatively unobstructed opening through which photographs can be made. Take your camera along. Sit in the actual passenger seat and familiarize yourself with the restrictions imposed by the structure of the aircraft and the seat belt/safety harness that you will have to wear. Discuss with the pilot how you will communicate while in the air (i.e. headset or hand signs), and what maneuvers can be safely and conveniently executed while airborne.

There are a number of technical decisions to be made. The first is what time of day to shoot. Since dust in the atmosphere and urban smog tend to reduce contrast, strong side light is best for good subject modeling. This means early morning or early evening, depending on the orientation of the building. The air is cleaner in the early morning.

Film, format, and lens selection is necessarily limited. View cameras are, of course, out of the question: aircraft are always moving so there is not time to set up and, even if there were, buffeting would likely shred the bellows. Small- or medium-format SLR cameras are preferable because they permit a good mechanical grip, rapid shooting, and quick lens changes. From a thousand feet up a "normal lens" (50mm in 35mm format, 80-100mm in medium format) will cover a whole city block. This is fine for contextual shots but the most useful lenses for individual structures will be short telephotos (85-135mm in 35mm, 150-250mm in medium format).

Fast shutter speeds are required to counter mechanical vibration and horizontal motion through the air. In fact, it is best to keep to the highest shutter speed available. Since the subject-to-camera distances dictated by aerial work require no focusing (professionals simply tape focusing rings in the "infinity" position), depth of field is not a problem. Select an aperture one or two stops smaller than the maximum for the lens you are using. With ISO 100 film in bright daylight a typical setting might be f4 at 1/1000sec.

Shooting while flying by the subject requires that the photographer "pan" the camera— i.e., keep the subject framed in the viewfinder by shifting in the direction opposite to the movement of the aircraft. This is a tricky activity: fast shutter speeds and the rapid-fire convenience of a motor-driven camera make it easier to get usable images. Although helicopters can hover in mid-air and thus reduce the need for panning, they vibrate rather brutally (photographically speaking), so very high shutter speeds are still required.

All this might sound exotic to the beginner, but it is usually a lot of fun and will yield some very interesting photographs. Costs can be kept reasonably low by good planning. Make certain that your arrangements can be changed at no cost and at short notice as determined by weather. Since your job will likely involve only a short time in the air, this should not be a problem with small operators. Second, plan your flight so that time in the air is minimized—determine the best angles ahead of time and work out a sensible flight pattern with the pilot. Finally, familiarize yourself thoroughly with any equipment you plan to use, and take along spares in case of a breakdown. A lightweight flexible cable connected to the camera's tripod screw and tethered to the plane at the other end will give some peace of mind for the nervous among you. Check with a general insurance agent to make sure that your equipment (and any equipment you rent) is covered for aerial work.

Actual costs vary depending on the amount of time in the air and the size of the aircraft. I prefer working from a small helicopter, which costs $300 per hour. With a cooperative

pilot I can fly from the airport to downtown, shoot half a dozen different angles of a particular building, and get back to the airport in about forty minutes. A small plane is less money—perhaps $75 to $125 per hour—but less flexible in the air. The same assignment might take 1 1/2 hours in a plane.

A way of reducing costs is to split expenses with other interested parties. It will take an extra hour to shoot four to six additional buildings for their owners or designers, but that extra work will pay for your own shoot.

MAKING THE ACTUAL EXPOSURES Working outdoors involves several straight-forward techniques that must be adhered to regardless of the exact nature of the subject:

1. Color film must always be intended for use under daylight conditions, i.e. 5500° Kelvin.
2. The exact position of the sun relative to the front element of the lens must be controlled carefully, particularly with wide-angle lenses and cross-lighting, in order to guard against loss of image contrast due to flare.
3. Camera motion of any sort cannot be tolerated if images of the highest quality are expected. The reduction in sharpness that results from even the tiniest movement is so subtle as to be easily blamed on poor lenses or low film resolution. With small apertures, exposures made in even very bright daylight can be 1/30 of a second or longer. Most people, including professional photographers, cannot reliably hold a camera steady for that length of time. Use a tripod and a cable release. When using the tripod, or when using a hand-held camera, always gently squeeze the shutter release, rather than give it a quick jab.
4. Any image that includes the sun or a reflection of the sun within the frame cannot be expected to "turn out." There is no reason not to try for an unusual effect, but be aware that results will be unpredictable and make sure there are more conventional shots of the same subject as backups. Film is relatively inexpensive, so it is prudent to make backups of all images made with new or experimental techniques.
5. Do not trust the light meter to give you an exact measurement for every condition. Use the technique of bracketing exposures as described on page 62.
6. Keep records of meter readings, film type, lenses used, and bracketing range. Compare the results with your notes in order to foster familiarity with the responses of your film and equipment to a variety of situations.

PROCESSING AND VIEWING THE RESULTS As I mentioned in Chapter 3, there is a valuable pool of photographic expertise available at the custom color lab. The technical people there are constantly dealing with the output of working professionals; consequently they are aware of what picture faults are caused by shortcomings of the film, the equipment, or the photographer. The costs of having your materials processed by a professional lab will be somewhat higher than the drugstore or the one-hour lab, but the investment is well worth it. These days a repeat customer in any service-oriented business is a valuable customer, so once you make it known that you rely on their good work, the people at the lab will have a lot of cogent advice to offer. They do not have the time to be long-winded, but good listeners and quick learners will benefit from their experience.

It is wise to get in the habit of evaluating photographs with the proper light source. Transparencies should be illuminated with a light box made specifically for that purpose rather than the ceiling fluorescents or a handy window. Similarly, color prints should be examined under fairly bright daylight, or simulated daylight, conditions. Color and density are hard to evaluate subjectively if the viewing light is always changing. The people at the color lab will have proper sources set up for examining results immediately after processing and they can suggest suppliers should you decide to buy your own. I recommend it.

WORKING INDOORS

DEFINING THE JOB There is a considerable change in photographic gear necessary when architectural documentation moves inside. First, the generosity of the sun is largely cut off and we must often make do with difficult artificial conditions and/or whatever spills onto the scene from windows that are not necessarily conveniently placed. A parallel burden is the dramatic change of scale and proportion that must be accommodated; the same equipment will be put to quite different use with a new selection of films and

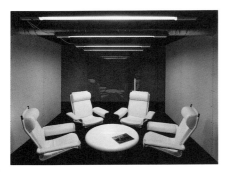

This sparsely furnished space is one of the smallest in the IKOY Office. Shot by the available light of the suspended fluorescent tubes, the meticulously placed furniture is obviously—but not obnoxiously—distorted by the unavoidable use of an extreme wide-angle lens. Camera: Toyo 4x5in, lens: 75mm (extreme wide-angle), film: Kodak Vericolor III Type S. Perspective controls were not required.

techniques. I do not mean to imply that working indoors is an impossible task for amateurs, just that it is necessary to define a few basic principles and approaches before starting in.

To begin with, the apparent distortion introduced by wide-angle lenses becomes much more of a problem at the close distances typical of work indoors. Extravagantly large spaces such as concert halls, arenas, and industrial plants are not too difficult to manage in this regard, but they are encountered less often than offices, private homes, and modestly sized retail storefronts, which are quite difficult.

Second, all the interiors just mentioned will be illuminated, more often than not, by an artificial source. Sometimes a variety of man-made lights, each radiating a different segment of the visible spectrum, are encountered together at a particular location.

Finally, the conditioned expectations of most people will limit the choice of camera position, at least for most modest sized interiors, to those that are exactly at, or very close to, eye-level. This fact, in combination with the more vexatious characteristics of wide-angle lenses, means that, along with moving the camera, it often becomes necessary to carefully rearrange furniture, plants, and other decorative elements in order to maximize the photographic potential of a particular room.

The above listed variables become more troublesome to control according to the degree of visual sophistication required of the final image. A documentary or progress photo does not need the technical fine tuning that a glamorous interior "portrait" does. The amount of work involved varies tremendously according to how the job is defined. My advice will attempt to cover all the technical bases as simply as possible.

RELATIVE COLOR AND RELATIVE BRIGHTNESS Color balance is an important issue of indoor photography. If the artificial light in a room is different in color temperature from 5500°K daylight, various combinations of film, filters, and processing will bring things back to normal. Relative color becomes significant when several sources of different color temperatures are mixed together; some of the areas that the different sources illuminate will appear to be strangely colored in the photographs because film is much more sensitive to relative color balance than our compensative brains. Some technical advice on how to deal with synthetic sources and relative color balance follows shortly.

Relative brightness refers to the contrast, or brightness ratio, within a particular scene. Outside, where the only light source is the sun, we can predict that the ratios will usually fall within a range that can be accommodated by color or black-and-white negative films. (Certain subjects lit by harsh direct sunlight will exceed the capability of transparency films, in which case the exposure brackets that retain some detail in the highlight areas, at the expense of completely black shadows, are preferred.) Indoors, the ratios can stretch well beyond the recording ability of even the most forgiving negative materials. The reason for this unwelcome condition is simply that outdoors, the light source (the sun) is rarely included within the image area, whereas indoors some light source (a light fixture or a window) will almost always be included within the image area.

There are a number of ways to cope with severe contrast. The simplest is to ignore it completely. To do this, take an exposure reading of the most important non-highlight area. Ensure that the meter does not pick up any of the bright spots or the reading will be skewed. The resulting negatives should then be printed normally, which will leave the troublesome bright areas pure white. There may be spiky shafts of flare or diffused "blooms" of brightness around the overexposed areas. If the highlights are tiny (small light fixtures, for example), they will not be particularly intrusive. However, windows are just too big to ignore, so steps must be taken to correct for the disparity in brightness between what is inside and what is outside.

DAYLIGHT INDOORS The first level of coping with available daylight is to compose images that do not include windows. Should this prove to be impossible, turn to a familiar exposure technique: meter the areas of significant interest, excluding the windows as before. This time, however, the processing will not be strictly "normal." Instruct the printer at the color lab to burn-in the windows. Manipulating the print is not a perfect solution, but for relatively large windows the effect is remarkably good.

Professionals balance the window light by lighting up the whole room with an intense dose of electronic flash. This approach requires some heavy-duty equipment and is beyond the capability of most amateurs. Really ambitious amateurs can try a relatively low-budget

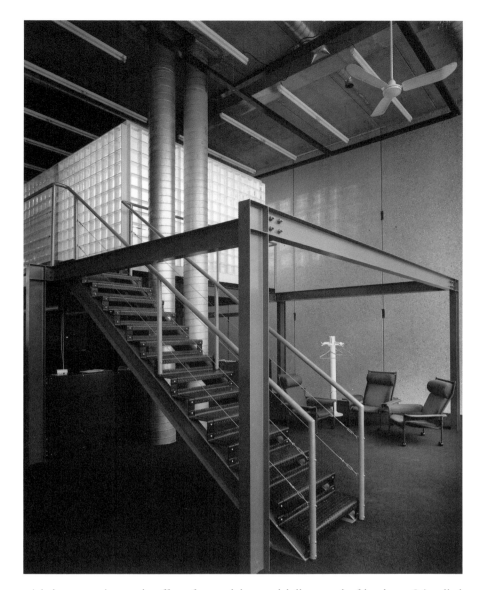

This dramatic view of the interior of the IKOY Office was made in the early morning. The room lights were switched off, and a single tungsten photo lamp without a reflector was placed inside the glass-block washroom/sauna that is situated on the mezzanine platform. The stairs, the galvanized ducts, and the green steel supports are illuminated by the weak ambient daylight coming through the windows. Camera: Toyo 4x5in, lens: 90mm (moderate wide-angle), film: Kodak Vericolor III Type S. Perspective controls were required.

trick that approximates the effect of several thousand dollars worth of hardware. It is called painting with light and requires only one 500 or 1000 watt photographic tungsten light equipped with a daylight blue filter gel. (This combination can be purchased for $150–$300 from a camera store or a theatrical lighting supply house.) Take the picture during the early morning or in the evening so that the daylight level is low. Select a slow film and a small aperture. Extinguish the room's lights and lock the tripod-mounted camera's shutter open. During the exposure, stand just behind the camera and sweep the scene with the beam of the tungsten light. The "strokes" should be as uniform as possible, although darker areas can be hit with two or three passes. The final image will be a seamless composite. As a starting point, try Ektar 25 film at f22 and an exposure time of three minutes. The color lab will help determine the optimum exposure time and sweeping motion after examining the negatives from a test or two.

TUNGSTEN LIGHT Incandescent lights of all shapes and sizes depend on the visible radiation produced when a small coil of tungsten metal, called a filament, is heated. The exact color temperature of the light produced is a function of the degree of heating. Photo floods glow at 3400°K, tungsten halogen lights at 3200°K, while ordinary household bulbs are somewhat warmer, typically 2500°K. For all practical purposes, however, photographic and "ordinary" tungsten lights can be mixed without any ill effects; both sources produce similar results when used with tungsten-balanced film.

It is not uncommon for interiors, particularly those in private homes, to be lit entirely with incandescent bulbs. Two problems arise when shooting interiors lit in this way. First,

contrast (brightness range) is often too extreme since typically arranged household or office lighting is not always sufficiently evenly distributed for pleasant photographic effects. This may be remedied by painting with light, without the blue filter. Another approach requires a clever printer and a labor-intensive combination of selective burning-in and dodging. Color labs offer an even more sophisticated solution to excessive negative contrast called contrast-control masking. The tonal scale of difficult color negatives may be compressed by sandwiching the original image together with a same size, black-and-white positive called a mask. The areas of maximum density in the mask coincide with the areas of least density in the color negative; when the two are printed in perfect registration, the exposure in those areas is reduced. (The reverse is true for low contrast color negatives printed together with a negative black-and-white mask.) Well-done color-masking can produce prints of exceptional quality; the technique is useful for correcting contrast problems in negatives made under a variety of circumstances, both indoors and outdoors.

A second problem arises when the tungsten lights inside have to compete with daylight from outside. If the daylight predominates it is often possible to ignore the blue/yellow disparity; the prints are balanced to render the daylight areas properly, while the tungsten lights (plus a small patch of "territory" around each of them) are allowed to go yellow. The overall look is not always perfectly natural, but the effect can be quite acceptable, even cozy. The professional way of balancing tungsten to daylight is to cover the outside of the windows with large daylight-to-tungsten filter gels. This is an expensive and unwieldy solution. The alternative, a two-part exposure, is not much easier. The camera is set up and an exposure on daylight balanced film is made with the room lights off. The camera is then left until night when a second exposure is made with the lights on and a blue filter over the lens. (Simply shooting at night solves the color balance problem altogether at the expense of the natural, day-lit look.)

Difference in color temperature can be used to advantage to produce exaggerated twilight effects as the daylight levels outside fall below the tungsten levels inside. If the prints are color balanced to the now predominant tungsten illumination, the view through the windows will vary from very blue to richly magenta.

Note: Absolute light levels indoors are ordinarily substantially less than those outside. This means exposure times that can range upwards of one minute with slow films and small apertures. Bracketing around such long times can try one's patience.

SODIUM-VAPOR AND MERCURY-VAPOR LIGHT Gas-discharge lights work by evaporating and electrically exciting materials in a vacuum. The resulting light falls within a narrow spectral range that is characteristic of the particular material. Sodium-vapor lamps emit a very yellow light, while mercury-vapor lamps shine green-blue.

It is not possible to achieve totally accurate color when these types of sources are involved. This is true because narrow spectrum light is not a linear source, so even very careful filtration will give only an approximate correction. Nevertheless, these lamps are common, particularly in industrial settings, and we have to do what we can with them.

As it happens, sodium-vapor lights work best without any filtration at all when using tungsten-balanced films. Mercury-vapor lights come in a number of tough-to-measure frequencies, but I have found that a 30M CC filter (magenta color-correction filter) or a 30R (red) CC filter works best with daylight-type transparency films. Daylight-balanced color negative films work well without filtration.

FLUORESCENT LIGHT The familiar fluorescent tube uses a high-voltage electrical discharge to excite special materials called phosphors to glow with visible light. The phosphors, not unlike those that are coated on the inside of television tubes, can have any number of characteristic colors. The typical choice for office, small-scale industrial, and institutional lighting is called cool-white: such fluorescent tubes are photographically recorded as strongly green compared to daylight, so they require a 30M CC filter over the lens for use with daylight-balanced color slide films. There are many different color fluorescent tubes, even some that simulate daylight. It is always best to shoot a test roll to guarantee correct filtration. Happily, color negative films work satisfactorily without filtration under all kinds of fluorescent lights since any required color correction can be done during printing. *(See color plates 29–32.)*

Since the shot is taken at night and the office is lit by a single source—fluorescent light—the color balance of the print was easily normalized in the original color print. Camera: Toyo 4x5in, lens: 75mm (extreme wide-angle), film: Kodak Vericolor III Type S. Very precise perspective controls required.

 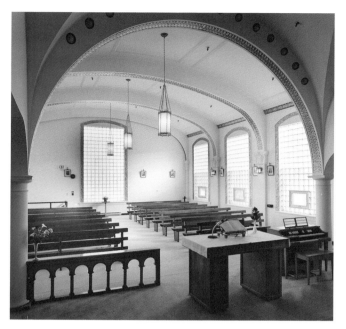

PROBLEMS WITH MIXED SOURCES The preceding discussion on tungsten light-ing has already touched on a few of the basic techniques for coping with conflicting colors from mixed sources. Here is a quick review of what has been mentioned already, plus some additional tricks:

1. The most direct method of dealing with multiple sources is to eliminate all but the most important one. Shooting at night with artificial light as the only source is one approach, shooting during daylight hours with all man-made sources switched off is another. Those spaces with a combination of sources always have separate electrical circuits for each type of light. A little experimentation with the switches will reveal which light source is most appealing. Simply leave the least desirable light turned off.

2. When the lighting is distributed in such a way that none of the different sources can be eliminated, photographs can still be made, providing the final results do not need to look absolutely natural. Color slide films are most dramatically affected by mixed lighting, so it is best to avoid them altogether. Among color negative films Kodak Ektapress and Fuji Reala seem to be most tolerant. Really bizarre color distortion can be sidestepped completely with black-and-white materials.

3. When a natural-looking photograph is absolutely necessary some form of filtration will have to be used. The most obvious way is to filter one of the offending sources to match the other. For example, a common problem is a fluorescent-lit office or retail space in combination with daylight from large windows. In this case the fluorescent fixtures can be filtered with magenta gels. Filter material is available in large sheets for use behind the fixtures' diffusers or as preformed sleeves that can be slipped over each tube individually; either way it is a big effort. Still, taping jumbo-size green gels over the windows is no easier.

4. Tungsten/daylight or tungsten/fluorescent problems can be solved by cutting up appropriately colored gels (green-blue to match tungsten with fluorescent, plain blue to match tungsten with daylight) and stapling together little filter-cones that can be placed over the individual incandescent lamps. Alternately, ordinary screw-base bulbs can be replaced by blue-tinted lamps available at photo shops.

Considering the effort required to filter all the lights, shooting a double exposure with color-balancing filtration on the camera looks rather appealing. The catch for the 35mm photographer is that most small-format equipment does not allow multiple exposure. However, a less sophisticated method goes part of the way toward making mixed sources less bothersome. There are some situations where the scene is adequately lit by one of two available sources, but where the final photo will look dead because the switched-off fixtures need to be included in the image for reasons related to composition. In these cases, an accomplice should be enlisted who can turn the fixtures on during part of the exposure. For example, if a corporate boardroom is predominantly lit with fluorescent lights but has

These images show how turning on light fixtures during part of an exposure can make a more appealing shot in some inte-rior situations. The pictures show the restored chapel in a local convent photo-graphed by available daylight. On the left, the tungsten fixtures were left off during the thirty-second exposure, while on the right the lights were left on for ten sec-onds. The shot with the lights on is much more inviting because of the warmth of the tungsten lamps. Detail in the glass block windows was retained by burning in during printing. Camera: Hassleblad ELX (medium format), lens: 40mm (extreme wide-angle), film: Fuji Reala. The shot was made without perspective controls by plac-ing the camera on top of a tripod extended to six feet.

VI

some elaborate incandescent fixtures that are important to the design, a thirty-second exposure could be made with the incandescent lights on for only five of those thirty seconds. This would be enough to photographically animate the fixtures, but not enough to disturb the overall color balance of the room.

WHEN SUPPLEMENTARY LIGHTING IS REQUIRED Earlier I described the technique of "painting with light" that may be used whenever brightness ratios get out of hand. This method of supplementary lighting is handy and inexpensive, but it lacks a degree of finesse that is required for sophisticated results. In Chapter 4, I discussed an aspect of previsualization that involves studying and appreciating the infinite variety of natural lighting conditions. Indoors this process must sometimes be extended to the creative addition of artificial sources in order to achieve a special look. Truly sensitive application of artificial sources might be called "sculpting with light" as opposed to "painting with light." This aspect of interior photography is only for the very ambitious and the very patient. It requires some photographic lights, which may be purchased or rented, plus a fair amount of time to properly arrange them. Powerful electronic flash units are commonly used by professionals to match room levels with available daylight, but such exotic equipment is too delicate, too expensive, too heavy, and possibly too dangerous for amateurs. I recommend that tungsten lights be used instead. Color requirements will limit their use since they lose a fair amount of power when filtered. Nevertheless, they are lightweight, relatively inexpensive to buy or rent, and, because they are continuous sources, their effects on the subject are easy to see. A few words of warning: tungsten lights are extremely hot and consequently pose a fire risk. Also, take care to avoid damage to heat-sensitive subjects.

Lights can illuminate photographic subjects directly or indirectly. Direct lighting yields harsh shadows but also gives an easily controlled, sharp, and penetrating effect, which is advantageous for certain textures of subject. Indirect light, or bounce light, is softer, broader, and more natural in appearance. To achieve indirect lighting, some sort of reflector is required. Light, neutral-colored walls or ceilings may suffice, or silver or white reflector cards or umbrellas may be used.

A good quality photographic light may cost upwards of $150, and several may be required to light a large or complicated space. Umbrella reflectors cost from $50–$150,

Left: This detail in the IKOY Office was lit by electronic flash both inside and outside the glass block room. I needed to take control of the lighting in order to clearly contrast the texture of the glass with the steel and concrete. Camera: Toyo 4x5in, lens: 90mm (moderate wide-angle), film: Kodak Vericolor III Type S. Perspective controls were required.

Right: This image was chosen as the cover shot of several architectural journals, including Architectural Technology Magazine, that included IKOY Architects work. The photo was made with electronic flash illumination—the metal detail was isolated for dramatic effect by a sheet of gray paper taped to the wall behind it. Camera: Toyo 4x5in, lens: 150mm (normal), film: Kodak Vericolor III Type S. Perspective controls were required.

depending on size and construction. A 36in umbrella is considered small in size and casts a much harsher light than a 72in umbrella, which is considered large. Reflector cards can be made from white 4ft x 8in foam board, available at art supply stores. A complete system consisting of several lights, stands, extension cords, reflectors, and filters might cost $150 a day to rent.

The proper use of photographic lighting is easily the subject of an entire book. At the risk of being simplistic, I will say that the best way of learning lighting technique is to study well-lit images in the better publications, and to mentally visualize the size and placement of the lights. Surprisingly, the set-up for modest-sized interiors often consists of only two or three lamps bounced off the walls and ceiling just left, right, or slightly behind the camera so that the light evenly fills the area of the room being photographed. Sometimes a few direct sources are cleverly placed to subtly outline or highlight certain areas or objects of interest within the scene.

CONSIDERATIONS FOR LONG EXPOSURES Working indoors inevitably requires much longer exposures than those typical of exterior photography. There are two categories of concern: the first is basically mechanical and has to do with such things as camera and/or subject movement, while the second is more technological and has to do with the nonlinear changes in film sensitivity as shutter speeds are extended past five or ten seconds.

Small negatives are capable of outstanding performance when all the variables in the photographic process are well controlled. Unfortunately, the best films and lenses in the world are wasted when the camera or the subject moves during the time when the shutter is open. I have already recommended a tripod be used for exposures that are longer than 1/30 second. Such times are not uncommon even outdoors. Ektar 25, for example, requires an exposure of about 1/15 second at f11 under mildly overcast, daylight conditions. Indoor light levels can be a couple of orders of magnitude less than light levels outdoors. Exposures can stretch to two or three minutes. It is critically important to keep the camera absolutely still.

The key to a rock-steady camera is a quality tripod. Because 35mm cameras are compact and lightweight, many novices and too many camera-store salespeople think that a compact and lightweight tripod will do. This logic is faulty. In fact, the heavier the camera the steadier it tends to be on a tripod, since a three-legged support tends to stiffen as it is loaded. Some professionals actually hang weights or a packed camera bag on their tripods in order to add to their stability. If the camera is not very heavy to begin with, the tripod itself must have a bit of weight and reasonable rigidity in order to perform well.

Any tripod you consider purchasing should be examined with its legs fully extended and the center column raised. There should be very little flexing or twisting and all locks should be positive acting and easy to operate. Tripods with additional supports linking the center column to the legs are preferred. Make certain that the tripod head (the articulated support that allows the camera to be tilted and rotated) is absolutely vibration-free when positioned both vertically and horizontally. Tripods and tripod heads may be purchased separately. Choose a combination that is both strong and easy to use. I strongly recommend heads that have separate locks for horizontal and vertical movement, as opposed to ball-and-socket heads, which have only one lock. Ball heads are very tempting because they are so compact; however, they are maddeningly tricky to level precisely.

Steadiness is such an important issue that I recommend testing the rigidity of the camera's own tripod socket (the threaded hole on the baseplate) as well as the rigidity of the tripod. Long or heavy lenses often come equipped with their own tripod sockets that are positioned to shift the mounting point closer to the center of gravity of the lens-camera combination; use these sockets whenever such lenses are fitted in order to relieve undue strain on the lens mount as well as to increase system rigidity.

There is a simple but effective technique that applies to the use of cameras on tripods. First, never release the shutter button with your finger. Even the most rigid tripod will permit some motion in response to direct physical pressure, no matter how slight, so use a flexible cable release. Next, be aware of the stability of the surface upon which the tripod is sitting. Even modern buildings sometimes have floors that vibrate with indoor pedestrian traffic or outdoor vehicular traffic. Select those moments when the floor is not moving to make your exposures. Similarly, avoid jarring the camera or flexing the floorboards by shifting your own position relative to the tripod when the shutter is open. Finally, most

quality tripods have rubber feet that can be screwed upwards to expose pointed metal tips: pay attention to the floor or ground surface texture and adjust the tripod's feet so that they will not slip. Rubber is good for tile, marble, concrete, and wooden floors while the steel tips work well for carpet, grass, gravel, bare earth, and ice.

Subject motion is not a big problem in architectural work, although there are some circumstances when it has to be considered. For example, trees, foliage, and water move around in response to the wind, as do flags and fabric awnings. When outdoor exposures hover around 1 1/15 second, such motion can degrade sharpness or distract the viewer. On the other hand, sometimes a little blur adds a bit of life to the scene.

Indoors, subject motion can be a problem as well. During long exposures, drapes, blinds, and plants can be shifted around by moving air. Hanging lamps and other decorative elements can be disturbed this way also. It is a good idea to turn off ventilation system fans and close windows while shooting long exposures.

People in pictures are more of a subject-movement problem indoors than outdoors. This is because outdoors the shutter speeds rarely exceed one second. I have found one second to be the maximum time a cooperative person can remain photographically still. Any longer, and even cooperative subjects move involuntarily. Photographs made at exposures in the range of one to five seconds will show people, or parts of people, as blurred.

It is interesting to note how photographic fashions change. Only a few years ago, any blurry figure in an architectural photo was considered either a technical flaw or an affectation. Recently, however, the same effect is more readily perceived as "natural." I believe this has occurred because pictures of buildings devoid of people may appear cold and lifeless—a few warm bodies make imposing structures look less forbidding. Following this logic, perfectly sharp images of people can look posed and stilted. A little blur implies normal human activity.

Very long exposures, on the order of thirty seconds or more, can make people disappear. For example, consider a camera set up on a tripod to photograph an interior corridor of a retail mall lit by dim artificial light. If the hallway is filled with moving people and the exposure is perhaps ninety seconds long, none of the people will be in one place long enough to register on the film. In other words, the mall will appear to be empty after the film is developed. This effect is somewhat unnerving the first time it is encountered, but it is actually quite a handy technique for simplifying some complex subjects.

The nonmechanical considerations of long exposures involve a quirk of film behavior called the reciprocity effect. Earlier I mentioned that shutter speed and aperture are inversely related. When the size of the aperture is increased to admit more light, the shutter speed must be shortened to compensate, and vice versa. Unfortunately, this reciprocal relationship holds true for only part of a given film's characteristic curve (range of sensitivity). At the extremes of the characteristic curve linearity breaks down—at one end increasing the brightness of the light no longer induces a proportional increase in density, while at the other increasing the exposure time no longer induces a proportional increase in density.

Reciprocity failure has two negative effects if no corrective measures are taken: significant underexposure and color shift. There are two ways around these problems. The most direct approach is to chose a film that has been specially formulated to behave well at long exposure times, such as Vericolor Type L (L for long) or Ektachrome EPY. Since the variety of reciprocity-failure-proof films is limited, from time to time the second method of control will be necessary: obtain a current copy of the *Kodak Color Data Guide*, which lists exposure corrections and compensating filtration for all Kodak color films. It is a simple matter to increase the measured exposure by the recommended factor, or to introduce the recommended color-correction filter. (I have found that color-correction filters are only necessary for transparency films; negative films can usually be properly balanced when prints are being made.) Expect corrective increases in exposure time on the order of 33% to 300% when daylight-type films are used in dim, artificially lit situations. It pays to experiment with your favorite materials in order to become familiar with their eccentricities under extreme conditions.

CONSIDERATIONS FOR WIDE-ANGLE LENSES Outdoor architectural subjects are typically one of three basic geometrical shapes: wide, square, or tall. Indoors, the subject

The furniture of this staff lounge area was arranged to minimize wide-angle effects. The wedge-shaped reflection of the lighting array is used as a design element in the photo. Camera: Toyo 4x5in, lens: 90mm (moderate wide-angle), film: Kodak Vericolor III Type S. Perspective controls were required.

is typically a space that is occupied by a variety of objects. Wide-angle lenses make the photography of interiors possible, but they demand some special attention in return. The main problem is one of relative proportion associated with the limited points of view available when working in tight spaces. Wide-angle lenses permit photographs to be made in such circumstances, but at a cost. Normal vision does not allow for entire rooms to be "swallowed" in one glance. In fact, our visual impression of a space is composed of a series of visual surveys that our minds integrate into a geometrically balanced whole; the shapes and relative proportions of individual objects and architectural embellishments are mentally preserved in a comfortable, natural way. The process of visual integration breaks down when we are constrained to record the same scene in two dimensions from a single vantage point—this is exactly what happens when we use wide-angle lenses indoors.

There are three problems that arise from the use of wide-angle lenses. The first two complications are dimensional in nature. You will recall that the process of rendering a three-dimensional object in two dimensions introduces some geometrical distortion. This is inevitable, and unavoidable. Also, wide-angle lenses create spatial or proportional distortions that cause the apparent relative sizes of familiar objects to be strangely altered. The only solution to these difficulties is very careful placement of the camera and very careful rearrangement of the movable objects in the room. You will have to learn which alterations in perspective and proportion are photographically acceptable and which are perceived as outlandish. This work is an exercise in damage control, and the results depend on the good taste of the photographer rather than on technical expertise.

The third problem associated with wide-angle lenses, edge falloff, is more optical in nature. Simply stated, wide-angle lenses, particularly extreme wide-angle lenses, project less light at the edge of the frame than in the center. Outdoors this is often not a major problem, since it is natural and effective for the sky and the foreground to appear a little darker than the main subject. However, with interiors we are less tolerant of density changes, especially since changes of density often induce slight color shifts as well. A deep blue photographic sky that picks up a bit of magenta as it shifts in density is much more acceptable than a sandy colored ceiling that slides toward pink at the top of the frame. Some of these problems can be minimized by simple cropping, burning-in, or dodging during printing, but with certain lenses under certain circumstances, more heavy-handed measures must be taken. Should you find edge falloff to be an intrusive defect in your work, consider obtaining a center-weighted neutral-density filter. This device is a disc of clear optical glass with a fuzzy gray spot in the middle. The spot is lighter at the edges than at its center. When placed over a wide-angle lens the filter compensates for the edge-falloff effect. Unfortunately there is not a big demand for this item, so its price is high ($250–$400)

and it is tricky to find. No 35mm lens-maker sells a center-weighted filter, so one intended for view-camera lenses will have to be located and adapted.

THE JOYS OF COLOR NEGATIVE FILM Here is a list that recaps the many advantages of color negative films:

1. Wide exposure latitude.
2. Wide tolerance for variations in absolute and relative color balance.
3. Effectively immune to reciprocity-effect color shifts.
4. Relatively insensitive to reciprocity-effect underexposure problems.
5. Permits the balancing of densities within a scene during printing.
6. Allows the production of color or black-and-white prints and slides from a single exposure.
7. Allows easy cropping at the printing stage.
8. Competitive with transparency films for color saturation and resolution.
9. Available in a wide range of sensitivities.

WHAT A GOOD COLOR PRINTER CAN DO The technical flexibility of color negative materials can only be realized when the photographer works in harmonious partnership with a competent printer. The person who does the darkroom work must be sensitive to the desires of the photographer, the nature of the subject, and the potential of the medium. A successful exploitation of the points above depend on the experience, expertise, and taste of the processor/printer.

Any valuable working relationship depends on reliable communication between the partners. You will be expected to be able to tell your printer what kind of prints you like. Personal tastes vary and the negative/positive system is extremely flexible. After some experimentation you should know whether you want prints that are warm, cool, or neutral in color, and light, medium, or heavy in density. Similarly, you will have to decide on what is appropriate cropping, burning-in, and dodging for particular negatives. All custom labs will produce test prints to help you decide on the level of manipulation required. The printer or a competent go-between will view the tests with you and offer specific advice. If limitations in the negative will prevent a given shot from looking a certain way, you will be informed at this point. Assuming a realistic notion of the capabilities of the technology, the final prints should meet your approval in every way. In certain cases a final print might have to be remade once or twice in order to match the specifications promised at the test print stage. This should be done cheerfully and free-of-charge, unless the specifications have been unilaterally changed by the photographer after the test print was discussed.

Here is a review of the services you a can expect from a competent lab:

1. Prints of decent color balance regardless of the original color of the light sources.
2. Precise control of local density in areas of the print larger than 1.5x1.5in.
3. Cropping to specification.
4. Contrast control for difficult negatives using masking techniques.
5. Routine spotting (removing dust marks with a small brush and retouching colors).
6. Easily readable proofs and test prints.
7. Push/pull processing of film when necessary.
8. Personal contact with the printer when necessary.
9. Good black-and-white prints and color slides from good color negatives.
10. Sensible recommendations on improving your technique.
11. All promises regarding delivery times and deadlines meticulously maintained.
12. Professional discretion (no gossiping about other clients' business).

FINE TUNING If you follow my recommendations, your pictures will always turn out. That is to say there will always be something visible on the film, at the very least a recognizable approximation of what you intended to produce. The nice thing about shooting buildings is that they are relatively permanent, photographically speaking, so images that fall short of your expectations can be attempted again and again. I can say quite unashamedly that, even at my "advanced" stage of development, certain tricky shots must sometimes be tried two or three times to get exactly what I had in mind.

It will take several months of weekly photographic activity to become truly comfortable with film and equipment behaviors. A guarantee of quick progress is an orderly filing system and a religious adherence to note taking. There is no point, with finished images in hand, in having to guess what you did or did not do correctly a couple of days or weeks ago. When you appeal to experts at the lab or at the camera shop for advice, a written record of your technical choices will facilitate the delivery of pertinent counsel.

It is a good idea to keep on hand a collection of fine images culled from magazines, books, or your own best work so that they may be referred to for comparison with those photos you feel are lacking in some undefined way. Eventually the qualities of outstanding work will become internalized, and the analysis of faults and deficiencies in your current project will come quickly and automatically.

Here is a list of variables that must be kept in mind when studying your photos:
1. The nature of the site, the building, or the room.
2. Quality and color of the available natural or man-made light.
3. The quality and quantity of any supplementary photographic lighting.
4. Film choice.
5. Equipment availability, selection, and use.
6. Point of view and the arrangement of any movable subject elements.
7. Ultimate use of the image.
8. Time and money available to do the work.
9. Degree of print manipulation required at the color lab.

Being unhappy with what you have produced is a good sign. High standards inspire good work. To make disappointment valuable, it is necessary to analyze the exact failings of the particular unsatisfactory images, postulate an improved technique or aesthetic approach, and then reshoot and reevaluate the results.

At first you may have to enlist the help of the good people at the processing lab to assist in a dispassionate analysis. After a bit of practice it will be a simple matter to divide photographic problems into the general headings we have just discussed, reread the pertinent chapters, and apply the recommended techniques more carefully or more imaginatively. When a specific fault of an aesthetic or technical nature is discovered, make a note to yourself on the back of the offending photo and bring it with you to the reshoot. This is a fail-safe way of correcting errors the second time out.

It is important to identify which of the above elements are under the complete or partial control of the photographer as opposed to those elements that are uncontrollable. There is no point in suffering over those thing one cannot change, but it is only sensible to maximize those things that one can change. It will always be possible to find the reason for a photographic fiasco but it is a personal matter whether or not the necessary effort can be mustered to put things right.

PHOTOGRAPHING ARCHITECTURAL DETAILS

DEFINING THE JOB Shooting details of texture or mechanical design demands a different approach than that which I have outlined for overall exterior or interior views. Exactly what constitutes a "detail" is somewhat flexible, but for the purpose of this discussion I will simply say that an architectural detail is any discrete component or group of components, forming part of a building or an interior, that can be isolated photographically. Details are photographed to emphasize the small-scale aspects of architectural design and construction. The general approach can be lavishly artistic, employing sophisticated lighting and unusual points of view, or it can be simple, unpretentious, and profoundly prosaic.

EQUIPMENT Since small-scale documentation involves a visual amplification of important fragments within a larger structure, the optics that are most effective have longer focal lengths. Wide-angle lenses are eschewed in favor of normal or short teles, with really long telephotos called into service when small areas of interest are separated from the camera by significant horizontal or vertical distances. It makes sense for an active architectural photographer to own one or two moderate teles or a telephoto zoom in the range of 90–200mm. Longer lenses, up to 1000mm, are easy to rent since they are favorites of both nature and sports photographers. Teles magnify camera motion and focus errors along with image size, so a sturdy tripod and a cable release are necessary.

FILM AND LIGHTING The form and texture of architectural details are equal in importance to their function. Light fixtures, doors and door frames, windows and window frames, roof and siding materials, and other visible structural components have a dual function that embraces both practicality and visual appeal. The practical aspects are best shown contextually in the larger views. Aspects of visual appeal are best shown via well-lit and well-composed "still-life" imagery, in much the same way that fine artists or commercial photographers elevate the objects and products upon which they focus. Unless grain or diffused focus are desired for some special purpose (perhaps as a motif in an exotic brochure), the sharpest and most accurate films are also the most desirable when shooting architectural details.

Lighting is a matter of taste, although the nature of the specific subject will suggest the most effective approach to take. For example, chrome, glass, and polished stone generally look best when illuminated by soft, indirect lighting from broad windows, an overcast sky, or nearby walls or other large reflectors while coarse stone, wood, and heavily textured fabric look best under harder, more angular light from direct sun or photographic lamps. Much can be done with available light, provided some thought goes into selecting the proper time of day and camera angles that capture the best ambient lighting effects.

TECHNIQUE The same technical "good housekeeping" applies to shooting details as to shooting larger views. It is important to keep the camera still while the shutter is open, and it is important to focus carefully on the most important subject plane. Because details are usually compact subjects, the camera's exposure meter can usually be trusted to give a reliable starting point for the exposure brackets. Appropriate accommodations must be made for reciprocity effects when working in low light. Great depth of field is not usually a concern. In fact, shallow depth of field is an effective tool for separating a sharply rendered detail from an out-of-focus background.

If photographs of architectural details are required for documentary purposes only, no special attention need be paid to aesthetic matters. If, however, the intent is to make an artistic statement, some thought must be given to image composition. All embellishments to buildings exist because someone designed them into the structure. To do justice to the original designer's intentions requires an appreciation of why and how the particular feature came to exist. Light conditions and point of view are then optimized in order to best present this knowledge with an empathetic visual. The correct approach is a celebration of the form of function.

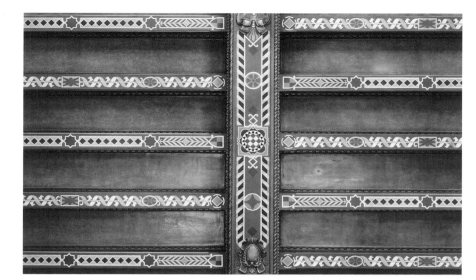

Even the most ordinary architectural detail can be enhanced by careful composition and the right light. This image was part of a promotional brochure for a Spanish-style condominium development. The geometrical arrangement of the elements and the steeply raked sun angle combine to make an attractive picture. Camera: Toyo 4x5in, lens: 250mm (moderate telephoto), film: Kodak Vericolor III Type S. Perspective controls were used to insure perfect alignment of all the verticals.

A detail of the ceiling of the Bank of Hamilton Building. The original paint work with gold leaf embellishments was painstakingly restored by conservers from the Manitoba Museum of Man and Nature, who worked—on their backs—from scaffolds. They applied special solvents with toothbrushes! Camera: Toyo 4x5in, lens: 150mm (normal), film: Kodak Vericolor III Type S. No perspective controls.

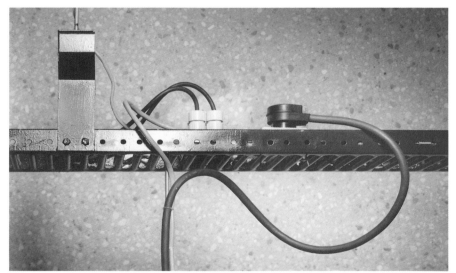

Cool light from the window illuminates the wall and ceiling, while the warm light from the fixture illuminates the bottom of the stair—the resulting contrast defines the graceful curve of the steps and banister. Existing conditions can be used to advantage whenever additional photographic lighting is impossible. Camera: Toyo 4x5in, lens: 75mm (wide-angle), film: Kodak Vericolor III Type S.

IKOY uses all mechanical and electrical systems as design elements in their buildings. Here is a closeup detail of an electrical track that is suspended from the ceiling and runs the length of the building. This picture was lit by electronic flash in a large umbrella reflector. Camera: Toyo 4x5in, lens: 250mm (moderate telephoto), film: Kodak Vericolor III Type S. Perspective controls were required.

COPYING DRAWINGS, RENDERINGS, AND PERSPECTIVES

DEFINING THE JOB Some types of photography are not very glamorous, and copy work is a good example; the skills required are very simple, the time involved is negligible, and the necessary equipment is inexpensive. Copy work (flat work) is the reproduction of some existing two-dimensional image through photographic means. The copy might end up as a 35mm slide, an 8x10in print, or a wall-size mural. The basic criteria are sharpness, color fidelity, and contrast control. *(See color plate 42.)*

LIGHTING I prefer tungsten light for copy work because a bright, continuous source speeds up camera alignment and focusing. A little care must be taken with heat-sensitive originals, but normally there is no problem.

To arrange flat work, place the camera exactly perpendicular to the material being copied. Position lights at 45° on either side of the camera in order to project an even field of illumination. A single light is perfectly acceptable for copy work as long it can be adjusted for uniform brightness over the whole image area.

When the material to be photographed is not perfectly flat, changing the angle of the light will sometimes eliminate unwanted reflections and hot spots (small areas of excessive brightness), but some shiny, irregular surfaces (an oil-painting, for example) cannot be accommodated in this way. In such difficult cases the only remedy is polarization. Consider light as composed of energized particles, called photons, that vibrate as they travel along an otherwise straight path. The frequency (number of vibrations per second) determines the color of the light. The plane of the vibrations relative to the direction of travel determines the polarity of the light. Generally, the polarization of light is more or less random; the photons vibrate in any and all directions. A polarizing filter has a wonderful ability to transmit only those photons that are vibrating in one particular plane. The particular plane is called the axis of polarization. Two polarizing filters placed so that their respective axes of polarization are oriented at 90° to one another will be perfectly opaque to all light. (This property may be invoked electrically in certain materials. Liquid crystal displays [LCD's] operate on this principle.)

Many materials reflect or absorb light of only one polarity. For photographic purposes the reflectivity of such materials may be reduced by controlling the polarity of the illumination. Polarizing filters for lights are available in heat resistant sheets through suppliers of theatrical lighting equipment. Polarizing filters suitable for use with photographic lenses are made of optical quality glass and are available at any camera store. Virtually all troublesome reflections may be removed when both the copy camera and the copy lights are polarized.

LENSES There is no such thing as a perfect optical system, and each photographic lens will excel at some particular task. Most lenses for general shooting, including wide-angle, normal, and telephoto types, are designed to be used in situations where the size of the subject exceeds the size of the image at the film plane by a factor of approximately ten to one. In addition, their performance is optimized for distant subjects. This means that for precise copying of small images a special-purpose lens is required. Lenses specifically designed for copy work are designated as process lenses or apochromatic (apo) lenses. They are usually quite expensive. In most circumstances, however, any good quality lens will do a reasonable job if the image being copied is 8x10in or larger, and if the aperture is set two or three stops smaller than maximum. "Stopping down" in this way reduces aberrations (optical deficiencies) that exist at maximum aperture, while avoiding the image degradation that occurs as a result of diffraction at the very small apertures.

MECHANICAL CONSIDERATIONS As I mentioned, the camera must always be positioned exactly perpendicular to the surface of the material being copied. Of course it must be held very still for maximum definition. The most reliable method of achieving this precise condition is to use a copy stand, which, in it is simplest form, has a baseboard with a vertical column to which the camera is attached by way of an adjustable mounting plate. Two (sometimes four) lights are permanently attached to the baseboard at the prescribed 45° angle. Such a setup works fine for most copy work, but when shooting a lot of different size originals the constant variation of camera height can be hard on the back. I prefer to

have the camera at a fixed level, which allows me to keep my back straight, so I built a copy stand with a baseboard that may be adjusted for height with an electric motor. For really big drawings and posters I find it is convenient to put the camera on a tripod and tape the material to be copied to a wall.

FILM AND TECHNIQUE To copy artwork or graphics that will end up as large display panels or posters, use a fine grain color negative film such as Ektar 25. Very presentable copy slides from color prints and drawings can be made with Kodak EPY tungsten-balanced Ektachrome. In this case I use an 18% gray-card (available at photographic supply stores) in combination with the camera's built-in meter to determine the starting exposure. Extreme closeup work, with an image to subject ratio of 1:2 or less, will require auxiliary closeup lenses, an extension tube (a carefully made cylinder that fits between the lens and the camera body to permit close focusing) or else a lens specially designed for high magnification, such as the Micro-Nikkor series made by Nikon. Extreme magnification will require some exposure compensation, but this is automatically taken into account with BTL (behind-the-lens) meters.

COLOR FIDELITY Sharpness is a photomechanical problem that is resolved by keeping the camera properly aligned and very steady, by focusing accurately, and by using a fine grain film. Maintaining color fidelity, however, is a matter of understanding the spectral response of photographic materials, rather than something that can be accomplished by a particular technique.

It is necessary to understand that color fidelity is not the same as color balance. Correct color balance is a rather subjective and imprecise term describing a print or slide that has no overall color bias; when grays are gray, and skies are blue, and grass is green, and skin looks "normal," color balance is said to be "neutral." On the other hand, color fidelity has to do with accuracy and implies that the film and film processing, as well as the enlarging paper and paper processing, will respond in a linear and predictable manner to a full palette of color. In other words, true color fidelity is achieved only when all colors are reproduced on photographic materials exactly as they appear in reality. Unfortunately, this serendipitous state of affairs will never happen because the color we see in prints and slides is generated by organic dyes that are physically limited in their ability to imitate the real world. An extreme but cogent example: a fluorescent yellow tennis ball will never look anything but a dull yellow-green when photographed because the colors in a print or a slide can only be a chemical approximation of real colors. Ektachrome will never glow in the dark.

All this can be expressed in numbers with graphs of spectral sensitivities, but the bottom line is simply that photographic materials are not honest about some colors. This can be very bothersome for precision copy work, particularly architectural renderings, where color fidelity is extremely important. Problems arise when certain paints and inks trigger the wrong response. One type of green used by a certain manufacturer of popular felt-pens reads as yellow with Ektachrome and lavender with Vericolor Type L. Sometimes the solution is to switch films. For example, Fujichrome Professional handles some blues and greens much better than Ektachrome or Vericolor.

Anyone who expects copy prints to closely match their originals should study the limitations of the medium. Comprehensive testing is the only way to achieve totally predictable results. Once educated to the value of color testing, the artists who produce renderings and perspectives that will be copied can select their colors according to how well they photograph.

For most reliable results, position a Kodak Color Control Patch so that it appears at the edge of every copy negative. The patch is a 1x4in strip of cardboard that has been imprinted with a series of neutral color patches of different densities. It costs only a few dollars, but its inclusion in the frame allows the color lab to quickly determine the exact color balance with a densitometer and color analyzer. For black-and-white copy work, use a Kodak Gray Scale.

CONTRAST CONTROL Every copy photo will pick up a little contrast, and in the case of some soft, pastel-like originals (such as old faded photographs), this is not a problem. Originals with high contrast may pose a problem.

Controlled flare is an easy method of reducing contrast. When the copy negative is being made, position the original on a large white card. If the exposed edges of the card are lit, some non-image-forming light (flare) will spill over and effectively lower the overall brightness range. A deep black surround works best with low-contrast originals.

Although conventional practice officially precludes the manipulation of contrast in color materials by chemical means, I have found that both Ektachrome and Vericolor films respond well to slight changes in processing. Check with the color lab for details on what they can do.

In Chapter 6, I described the value of contrast-control masking for difficult negatives. This technique may also be used for controlling excessive contrast in copy work, although such an inconvenient and expensive approach should be considered only as a last resort.

ARCHITECTURAL MODELS

DEFINING THE JOB There are three interrelated factors that determine the photographic approach to architectural models: scale, point of view, and the degree to which real-life conditions are simulated. The most sophisticated models cost several thousand dollars and are large, highly detailed, and meant to be examined at every angle, from street-level to bird's-eye. Miniature cars, trees, people, and even Plexiglas "water" contribute to a very realistic appearance. At the other end of the scale are unpainted and unadorned assemblies made of foam-core or cardboard that are intended to represent only a building's basic shape.

LIGHTING AND TECHNIQUE As a rule architectural models are expected to be lit in a way that mimics sunlight; this is easy to do with a single tungsten light and some large white reflector cards positioned to brighten up the shadows. The general direction of the "sunshine" can be determined from the site-plan specifications. Any glass, metal, or plastic surface may be highlighted by carefully placing an additional light or a card of an appropriate color or texture so that its reflection is pleasingly visible from the camera position.

Several different vantage points or points of view may be required. The street-level view is the trickiest to carry off convincingly. The center of the lens will be just a fraction of an inch off the "ground" in order to duplicate an eye-level perspective, and miniature obstacles, such as elements of the landscape and other buildings, are sometimes more difficult to deal with than their real-life equivalents. Nevertheless, the same camera movements are required to maintain the parallelism of vertical and horizontal lines, so PC lenses are handy for this work.

Depth of field is inversely related to magnification, so overall focus becomes a problem with small subjects. When shooting architectural models, very small apertures are required to hold the focus all the way from front to back. Unfortunately, some loss in resolution is inevitable as diffraction tends to degrade image quality when small f-stops are used. This happens because light is bent, or diffracted, as it passes by a sharp edge such as the metal leaves that comprise the diaphragm of a lens. As the aperture is reduced, the ratio of glass area and the exposed length of the diaphragm's edge changes so that the diffraction effect becomes more noticeable. The correct photographic response to this condition is to choose the widest aperture that still permits the necessary depth of field. This choice is facilitated by a control called a depth-of-field preview button, which is standard on most SLR cameras. Depressing this button overrides the automatic diaphragm control that keeps the aperture wide open for easy focusing. Although the viewfinder image will appear darker with the preview button pressed, it is just possible to see the exact depth of field at the working aperture. The depth of field scale etched on the lens barrel is helpful in making this determination without having to struggle with a dark viewfinder.

BACKGROUNDS A technique that adds credibility to color photos of models is the creation of an artificial sky. This is easily done by taping a length of blue seamless paper (available in 9ft x 36ft rolls from photographic suppliers) to the wall behind the model. A tone that is slightly denser than the real sky works well if it is lit from the bottom to give a graduated effect. An alternate solution is to instruct the printer to burn-in the sky during processing. Clouds can be added by having an artist airbrush directly onto the seamless or

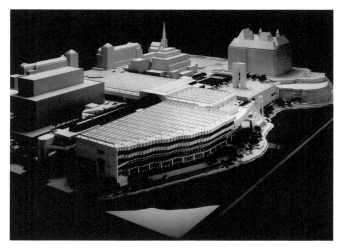

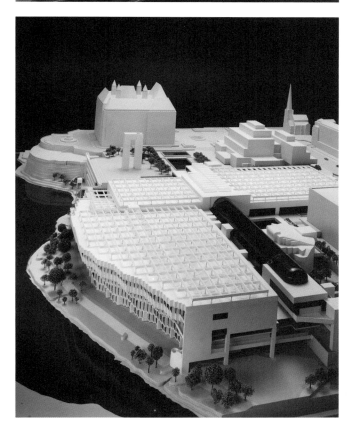

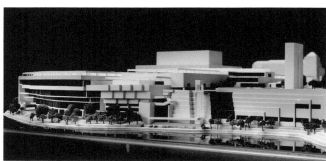

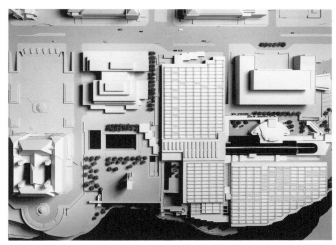

onto the final print. Once or twice I have glued tufts of cotton batten to sky-blue seamless; it makes a surprisingly natural sky when lit softly from above and photographed slightly out of focus.

To achieve a highly dramatic ambience project a slide of an exotic sky condition, such as a sunset, onto a white backdrop behind the model. For this technique the brightness of the artificial sun must be reduced to balance the brightness of the projected image. The projector can be mounted underneath the model, and a wide-angle projection lens can be rented to give a broad enough image to cover the background.

Whatever the type of sky used as a backdrop, it cannot be a continuous dome like the sky outside. It is therefore necessary to rotate the model itself, rather than reposition the camera, in order to shoot several views from different angles. When the model is moved, the artificial sun will have to be moved as well, or else the sun angles will be inaccurate. Since proper focus and camera position are both critical and relatively difficult to achieve with small subjects, it makes sense to plan the camera angles ahead of time so that the movement of the model can be kept to a minimum and performed in a logical way.

Views of Clifford Wiens's model of a new National Gallery of Canada. The cardboard and plastic miniature was shot at night in Wiens's Regina office. The room lights were extinguished, and a single photoflood was reflected off a large foam-core card mounted on a boom-arm for exact control over the card's position. View-camera controls were used to properly manage focus and perspective, but similar results are possible with less sophisticated equipment. Camera: Toyo 4x5in, lens: 150mm (normal), film: Kodak Vericolor III Type S, printed on Kodak black-and-white Panalure paper. Some perspective controls were used.

A typical progress photo, in this case photographed from ground level. Camera: Toyo 4x5in, lens: 90mm (moderate wide-angle), Film Kodak Vericolor III Type S. Perspective controls were used to give a rectilinear look, but are not really necessary to serve documentary purposes.

PROGRESS AND CONSTRUCTION PHOTOS

DEFINING THE JOB Making a visual record of a building under construction or documenting engineering details of existing structures is not necessarily the most creative photographic activity; like copy work, it is quite straightforward.

Progress photos may be requested by architects, engineers, contractors, developers, building owners, or even the bank that is financing the project. (On very large projects funds may be advanced to contractors and suppliers in stages based on the periodic presentation of photographic proof of work completed.) The main requirement for documentary shooting is accuracy.

The degree of detail to be recorded depends on the final use of the photos. A construction company may want to show the installation of structural elements of a steel and glass skyscraper, something easily photographed from a distance. An architect might be involved in a lawsuit with a contractor over some improperly installed materials, in which case closeup photos showing the exact condition of the defects would be necessary.

EQUIPMENT AND TECHNIQUE Color is not always required, but all prints must exhibit very high resolution. Therefore, film and equipment choices will be similar to other more exalted kinds of architectural work. Prints must be dated, and all negatives filed for easy access. If a series of images are needed to show the progress of construction over time, return to the exact same camera positions at approximately the same time of day for each visit to the site. This will ensure that the photos make immediate visual sense when viewed either in pairs or all together.

Photographs of mechanical details in dark locations require some supplementary lighting. Tungsten lights would be clumsy to use on construction sites, but less so in finished buildings. The painting-with-light technique described earlier is handy for covering large areas. When freedom of movement is essential the appropriate tool is a battery-powered portable flash. Small units are available quite cheaply, and bigger, more powerful versions can be rented. With a single, powerful flash, big spaces can be illuminated, but only at a documentary level. A short extension cord may be used to get the flash-head off the camera; if the flash is separated from the camera, even by an arm's length, the subject will be better defined by the texture of shadows and highlights.

Note: Some flash units have built-in sensors to determine correct exposure while others use sensors incorporated in the camera. In the first case exposure bracketing may be achieved by altering the diaphragm settings, but the second case will require the ISO setting on the flash to be adjusted between exposures.

Although most progress and documentary photographs will never be coveted for their aesthetic qualities, it is never a waste of time to try for harmony and balance in any photographs you make. Well-composed images are more appealing and more effective, if only on a subconscious level. Similarly, if parallel verticals can be preserved, your work will have a more professional look.

CONSIDERATIONS FOR DIRTY OR HAZARDOUS LOCATIONS Construction is a messy business. Exposure to dust and grime are hard on photographic equipment. (Cement dust is particularly insidious.) It is only prudent to protect delicate cameras and lenses from harmful exposure to the detritus of building sites by observing a few simple precautions.

Avoid windy and rainy days. On large projects things do not change all that much within twenty-four or forty-eight hours, so there is some leeway to pick weather conditions that are calm. When dusty or wet conditions are unavoidable, put your camera in a plastic bag. Cut out holes slightly smaller than the lens and the viewfinder eyepiece (thus insuring a snug, waterproof fit) and secure the plastic at these locations with elastic bands; you will find that the controls may be easily manipulated through the polyethylene. Use your car or some other sheltered space when changing film or lenses. Store the exposed film in plastic while on the site. Keep camera bags closed and/or encased in plastic, as well.

A number of hazards exist on construction sites. If the camera must be placed on a tripod, chose a position that is stable (the edges of deep excavations can be unpredictable, especially when wet) and well out of the path of machinery or busy laborers. It is easy to become absorbed in the photographic process, so try to stay alert to the surroundings. Keep an ear open for invisible hazards such as workers drilling through nearby walls or ceilings.

Watch your step. Empty stairwells may be hidden or poorly covered and there may be dangerous obstacles on the floor. Wear a hard hat and proper protective footwear. Cement dust is carcinogenic, so a filter mask is not excessive wherever concrete is being mixed, drilled, or cut up.

After leaving a construction area, use a soft brush, compressed air, or a vacuum to dust-off your equipment inside and out. (Camera stores sell canned compressed air that is handy on location, but avoid ozone-eating freon if possible.)

JOB-SITE ETIQUETTE It is in your own best interest to find out who is the construction foreman on large projects and inform him or her whenever you are on the site. You will be advised of any dangerous locations or procedures (blasting, for example), and the construction workers will be informed of your presence. The foreman has a legal responsibility for everyone's safety, so do not argue. Hard hat signs should be obeyed, as should warnings that call for protective goggles or earplugs. Never interfere with the flow of workers, machinery, or materials unless prior arrangements have been made.

It is highly likely you will encounter the same construction companies over and over again during several years of shooting construction sites, so it is both prudent and kind to supply a print or two for free as a professional courtesy.

WEATHER CONSIDERATIONS: WIND, RAIN, LOW TEMPERATURES

We have considered how weather makes variations in light and sky that are both essential and welcome as visual excitement in architectural photographs. The side effects of such variability form a set of mechanical problems that have to be scrupulously managed if that visual excitement is to be effectively captured.

Wind introduces mechanical energy that causes movement of elements of the subject as well as the equipment. In the earlier section on tripod technique, I discussed how subject movement affects the look of architectural photos. To recap briefly, let me say that a certain degree of blur in foliage or flags can actually enhance the "reality quotient" of an image. By that I mean that "perfect" photographs of buildings tend to look like reproductions of elaborate architectural models rather than real views. Wind-induced movement can counteract this feeling of unreality.

Wind can interfere with what you are trying to do when it induces camera motion that degrades overall resolution. Yet wind is only rarely a continuous force, so by paying attention it is possible to chose moments of relative calm to make a photo. After all, you only need a few seconds or less. When this approach is impossible, camera motion can be dealt with by securing the camera to an immovable support or by using high shutter speeds. In my experience hand-held cameras need to be set at 1/250sec or above to prevent loss of sharpness due to noticeably buffeting gusts. To detect camera motion that might not be readily apparent when the camera is mounted on a tripod or clamped to some other anchor, attach a bubble-level and see if the bubble settles down completely. If it does not, avoid shutter speeds of longer than 1/30sec.

Wind introduces both visual and mechanical contaminants. Dust and other particulate debris in the atmosphere will reduce sharpness and create off-color skies. This is not always visually objectionable but grit in the air will eventually work its way into cameras and lenses. Professional equipment is designed to resist this sort of invasion to some degree, but protective measures, like the plastic bag trick described earlier, should always be taken when conditions become extreme. Remember that even though 35mm film is capable of wonderful results, all negatives or slides made by small-format equipment must be highly magnified to be useful; dust in the camera results in difficult-to-retouch black spots or scratch-induced black lines on the final images. The best approach is simply to avoid shooting on really windy days.

A plastic bag in combination with a lens shade will ensure that rain water stays off the front surface of the lens. Rain in the air will reduce sharpness but water on the streets often looks great. Grass and other foliage looks nicer when wet, as well. Although I do not recommend working in the rain, shooting just after a downpour is sometimes the only way to de-emphasize the grime of some urban centers.

Where I live winter lasts eight months of the year and low temperatures are a fact of life. Most modern equipment uses lubricants that permit normal mechanical operation in

the cold. Nevertheless, do not force any control that becomes stiff at low temperatures. Avoid breathing directly on cold cameras since moisture from the breath will condense on lens elements and reduce performance. Equipment that has been outside in the cold should be protected from condensation with plastic before being brought back indoors. It is not too inconvenient to seal up the whole camera case inside a garbage bag.

Cameras with electronically governed functions may shut down in the cold due to reduced battery power. In these circumstances it is necessary to keep batteries warm by either shielding the whole camera beneath warm clothing or by using a custom-made extension cord to separate the battery from the camera. An alternative might be to keep the battery in a warm pocket until just before use.

Modern films are mechanically very tough, but they may become brittle at low temperatures. Avoid sharp bends when loading. Cold, dry conditions can induce static electric discharges inside a camera, so turn off motor drives and instead advance film manually with a slow, even motion.

I have found that thin cotton gardening gloves are great for protecting hands from the cold; if this proves too clumsy, you might try cutting away the cloth at the fingertips.

HOW TO TAKE GOOD PHOTOS AT NIGHT

INTRODUCTION We are compelled to shoot at night by bad sun angles, the need to eliminate intrusive urban clutter, or the simple desire to show off a building in a novel way. Several problems are encountered in this work. Low light levels, high image contrast, reciprocity failure due to long exposures, and odd color balance due to mixed artificial light sources have been thoroughly examined in Chapter 6.

Just like other photographic challenges, the special inconveniences of working in the dark will be made easier by thinking and planning ahead. It is sensible to select camera locations and arrange for access to private property well ahead of time. Confirm any arrangements with a phone call just before the end of the business day so that chances for confusion in the evening are minimized. Carry identification. Your own business card, your client's business card, and the business card of whoever gave permission for you to be wherever you need to be will prove helpful in certain circumstances. High security locations will require a formal letter and/or a security person as escort. Be prepared to explain what you are doing to the police, as well. And remember, working in the dark is easier with a flashlight.

VERY LONG EXPOSURES Normal interior shooting involves exposures of usually no more than one or two minutes with even the slowest films; outdoors at night, exposures for faster films will be about the same. However, a combination of low light and slow films will yield exposure times of five minutes or more, and bracketing becomes a real chore. Many BTL exposure meters will not even show a reading at such dim levels.

A professional quality hand-held exposure meter will help, but experimentation and record keeping will also make working at night a lot easier. Many street-lighting situations are similar in color and brightness, so what works in one place will often work again in another. For a typical, urban, street scene you might try f8 at one minute for ISO 100 film with plus or minus two stop brackets (i.e., 15sec, 30sec, 1min, 2min, and 4min). Evaluate the processed film with the help of the lab staff, and adjust the exposure accordingly. After a bit of experience only plus or minus one stop brackets will be needed. Reciprocity failure due to long exposures leads to nonlinear color responses in most films. However, a good printer can usually establish an approximate color correction that will be acceptable.

SUPPLEMENTARY LIGHTING Very long exposures allow time for some fairly easy photographic manipulation. Raising light levels way above the existing ambient conditions is virtually impossible, but with a little effort important details can be reinforced and dark areas opened up with some cleverly applied artificial light. If a source of electricity is available, one hand-held photographic light of 500 or 1000 watts can highlight specific areas using the painting-with-light method introduced earlier. Portable battery-operated video lights or multiple flashes from battery-operated electronic flash units will work in locations without a source of A.C. power. It is important to keep the light moving smoothly to avoid hot spots. Watch out for direct reflections from windows or other shiny surfaces.

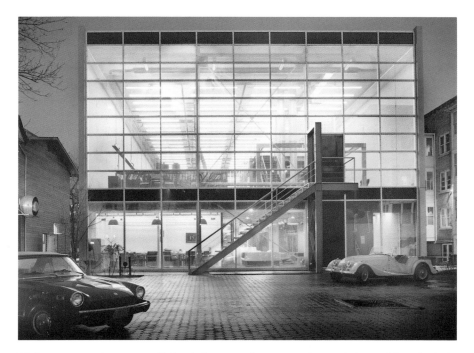

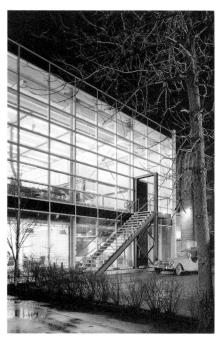

If the exposure times are sufficiently long, say five or ten minutes, it is possible to lock the camera shutter open and walk right up to the target building with the light in hand. As long as you keep moving and do not shine the light directly at the camera you can cover a very large area with light and still not be seen in the photograph. Strange, but true.

TOWARD PHOTOGRAPHIC PERFECTION

SMALL-FORMAT LIMITATIONS Having followed my arguments to this point, you should have a fairly clear understanding of how far one can go with small cameras. In this day and age it is certainly quite far. Fine-grained color negative films like Ektar 25 and Fuji Reala permit outstandingly detailed enlargements. Moving to the more temperamental color transparency films will enhance color fidelity and highlight detail: new films like Fuji Velvia, Ektachrome 50, and Agfachrome 50 are approaching the exalted technical plateau occupied for many years by the venerable Kodachrome 25 (still available, and still the standard for 35mm resolution and color-fidelity).

All of the films mentioned above are capable of results that will satisfy many photo editors and most critically-minded architects. We now know, however, that good results are dependent on a painstaking methodology: slow films (ISO 25-64) require tripod-bound cameras for the small-aperture/wide-depth-of-field work so typical of exterior and interior photography. Exposure is critical too, since slow films, particularly slow slide films, exaggerate subject contrast compared to their higher-speed relatives. Careful management of basic exposure is mandatory. Bracketing is essential. In many cases supplemental artificial lighting will be required to bring the tonal range of interior views that include unshaded windows or bright light-fixtures within recordable limits. Exterior views of high-contrast subjects (such as buildings with shiny metal mullions or highly reflective glass) may have to be shot under partially cloudy conditions so as to avoid the technical extremes associated with direct sunlight.

Even when exposure or contrast buildup is under control, high resolution films push the technological limits of 35mm photography in another, less manageable way. In those circumstances where one has calculated a perfect exposure, has ensured that the camera was steady and carefully focused, and has selected the depth of field appropriate to the depth of the subject, the final results may be limited not by the film stock but by the optical properties of the lens used to take the picture. I must add to this disturbing fact yet another disturbing fact: perspective control lenses (the architectural photography workhorses) exhibit more optical flaws than conventional lenses.

You will recall that PC lenses mimic the rise/fall/shift movements of the large-format view camera in order to allow small-format workers a measure of perspective control. Like

The office of IKOY Architects, Winnipeg—nighttime shots of the front exterior. The parking lot was dampened with a garden hose to make the images more interesting with reflections. The "painting with light" technique was used to add some detail to the tree, the car on the right, and the painted steel stairway support.
Camera: Toyo 4x5in, lens: 90mm (moderate wide-angle), film: Kodak Vericolor III Type S. Perspective controls were required.

the lenses of view cameras, PC lenses have a much wider image circle than the actual size of the film format: the property allows movements without image cutoff. Such extreme coverage comes at a price—an inevitable decrease in resolution at the edges of the field. This degeneration is exaggerated in small-format lenses intended for use with SLR cameras because of a further limitation on their construction: such lenses must allow sufficient room for the swinging mirror between the back of the lens and the film plane. This room can be provided only by retrofocus lenses. Unfortunately, perfection in ultra-wide-angle retrofocus lenses is much more difficult to achieve than in conventionally designed ultra-wide-angle lenses. This is why PC lenses are so expensive.

Perspective control lenses are undeniably useful tools. However, the fact remains that they—and, to a more moderate degree, all small-format ultra-wide-angle lenses—are increasingly unsharp toward the outer edges of the image field. Consequently, even when every photographer-controlled variable has been carefully managed to achieve high-quality results, the 35mm image will still be limited by hardware.

RESPONSES TO SMALL-FORMAT LIMITATIONS There is some consolation in knowing that understanding the shortcomings outlined above demands a high level of insight into photographic technology. Nevertheless, those who find the limitations of the medium upsetting must find some remedy.

There are three approaches: the first is psychological. It is a fairly straightforward process to say to oneself, "enough is enough." After all, the uses to which most practitioners will put their photos are adequately served by work produced with currently available 35mm technology. Publications, portfolios, and presentations can be reasonably accommodated using the methods already outlined.

The second approach, for those infrequent situations where there is a real need for a higher level of photographic perfection, is to obtain the services of a professional photographer. It is usually time to retain a professional when a high-profile architectural journal demands a set of original 4x5in transparencies, or when the degree of perspective control required for a particular shot may be beyond the capabilities of your small-format equipment.

A little experience will help determine whether or not the first two options will serve over the long term. If you feel that your photographic needs are met by regular use of small-format equipment in combination with the occasional professional assignment, then there is no problem. However, if even well-made 35mm images regularly seem inadequate, and if the available professional photographers are too expensive or too obtuse, you may wish to consider moving up in format.

BEYOND 35MM There is a wide range of photographic technology beyond miniature format. Fortunately, the skills required to operate bigger cameras are virtually the same as those required for excellent 35mm work. I have emphasized that most of the effort involved in excellent photography has nothing to do with cameras; rather, it is an intellectual/emotional process of observation, appreciation, and previsualization. Still, having made the decision to explore another technology, some new information is required.

MEDIUM-FORMAT SLR Medium-format single lens reflex cameras produce the benefits of a 4x5in within a "miniature" body. The luscious medium-format image is indeed a technical equivalent to a 4x5in image, yet the tremendous mechanical flexibility of a large-format view cameras is generally unavailable in medium-format systems. A well-made medium-format image is virtually equivalent to a well-made 4x5in so long as the capability of the film is the *only* consideration—there is no doubt that either medium transcends the possibilities of 35mm in terms of resolution, tonal gradation, and even color saturation, simply because of image size. In addition, larger images and lower magnifications permit the use of faster films of lower inherent contrast, a valuable attribute in this work since many architectural subjects exhibit very wide tonal ranges.

Some exotic (and brutally expensive) medium-format designs such as the Fuji 6x9cm system or the Linhof Technica 6x7 do incorporate a flexible bellows and a limited range of movements, but in general medium-format SLR cameras are really elaborated 35mm cameras. Although their advantages rest mainly with large film size, there are some other appealing aspects to medium-format cameras. For example, some have interchangeable

A medium-format flatbed camera ("press camera") showing movements. This camera by Linhof features a coupled range finder/viewfinder. To focus the camera when movements are used, a ground-glass back must be substituted for the roll-film back shown in the photo.

An Asahi Pentax medium-format SLR that looks and operates like a giant 35mm SLR.

film backs, which means that they can accommodate several different film stocks by simply switching backs (usually a quick, one-handed operation). Such cameras will accept special Polaroid film backs, as well. This allows more or less instant testing/confirmation of composition and exposure: a real advantage in tricky situations. Since medium-format images need not be enlarged to the same degree as 35mm images, and since all good medium-format lenses are made to the same high standards used for small-format lenses, optical performance tends to be relatively better overall. Some disadvantages: extreme wide-angle lenses are not easy to obtain and PC lenses intended for medium format do not cover as wide an image field (and are therefore less useful) as those available for miniature format. Medium-format machines are relatively awkward to hold, they are vibration-prone even when mounted on a tripod, they consume film at an alarming rate, and they are usually bulky, heavy, and very expensive.

To recap, medium-format SLR systems will improve the technical quality of photographic images, but at a cost in convenience of operation, physical bulk, and degree of perspective control.

NON-SLR MEDIUM-FORMAT CAMERAS Single lens reflex cameras are popular because they permit easy lens interchangeability. The mirror and prism viewfinder system always relays to the photographer exactly what the taking lens sees, so framing and focusing are straightforward operations. Unfortunately, the SLR systems are heavy (solid glass prisms big enough for medium format are fairly weighty), they introduce vibration due to the additional moving parts (mirror, automatic diaphragm), and they suffer from the

restrictions in lens performance associated with retrofocus designs. (Theoretically retro-focus lenses can perform very well but they are hard to design and construct, so the best ones are quite costly.) Dispensing with the SLR concept allows cameras to be sized down and optical performance to be upgraded with the use of less expensive non-retrofocus lenses. This is achieved by incorporating a separate optical viewfinder with or without a coupled range finder (a device for determining camera-to-subject distance by a system of optical triangulation). Optical finders are less accurate when used with long focal length lenses, therefore some of the most interesting non-SLR roll film cameras are offered with non-interchangeable wide-angle lenses.

There are several cameras worth considering by those who wish to integrate the advantages of miniature cameras with the advantages of a larger format. I think that it would be quite reasonable to own a comprehensive 35mm system in addition to one of the wide-angle/optical finder type medium-format cameras. Such equipment would combine the ability to produce detail shots, medium views, long telephoto shots, copy work, and the ubiquitous 35mm slide while allowing the production of highly detailed wide views where precise reproduction of a myriad of small details is important. Fuji, Mamiya, Linhof, and others all offer such cameras, some of which include a rise/fall/shift capability (monitored by moving frame lines in the optical viewfinder). Dedicated wide-angle roll film cameras are available with extended image sizes such as 6x9cm, 6x12cm, or even 6x17cm for truly panoramic wide-angle views.

A 4X5 PRIMER For those not interested in half measures, a 4x5in view camera is the only option. Some economies are possible by selecting a basic camera with less-than-laboratory-grade controls and a modest array of lenses, but, any way you look at it, moving up to large format is a costly step.

I will make the assumption that the serious worker will acquire a monorail-based view camera and at least three or possibly four lenses, namely an extreme wide-angle (65–75mm), a moderate wide-angle (90mm), and a lens of "normal" focal length (135–150mm). Moderate or long telephoto lenses (250–450mm) will be required for details or working at a distance. One may expect to spend $2500–$3500 for this equipment new, about one third less for used. Sometimes these items are advertised in the want ads of the local paper—they are more easily located through the large mail-order suppliers that advertise in photography magazines.

A comprehensive 4x5in system.
Top row: front standard, clock timer, rear standard, bellows above monorail.
Middle row: 150mm and 250mm lenses, ground-glass back, two polarizing filters, center-graduated neutral density filter.
Bottom row: 47mm, 75mm, and 90mm lenses, roll-film back above Polaroid back.

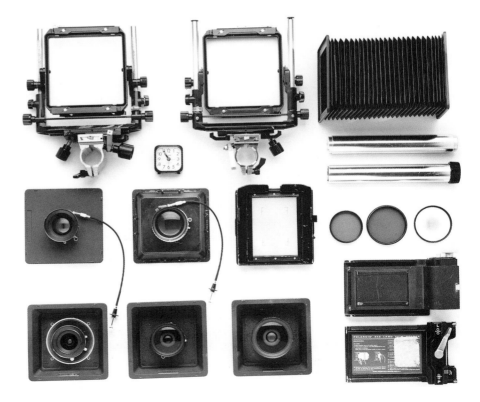

Large-format cameras are less convenient to use than SLRs because they do not have viewfinders. Instead, the image projected by the taking lens must be evaluated on a ground-glass screen in the film back. Lenses of relatively small maximum aperture (f8) may have the same resolution as lenses with wide maximum aperture (f4-f5.6), but they will be difficult to work with due to the dim image they project on the ground-glass. The diameter of the projected image circle will likely be smaller with smaller aperture lenses, so the range of corrective movements will also be restricted. For this reason lenses of wide maximum aperture are preferred by those who must use view cameras often. Smaller aperture lenses are significantly less expensive, however, so greater care in focusing will yield economic benefits.

Monorail view cameras intended for use with 6cm roll film or 6x7cm sheet film are available—I do not recommend them simply because a ground-glass image smaller than 4x5in is just too difficult to evaluate without eye strain.

A number of 4x5in film holders and a light-tight changing bag for loading them will be required. A Polaroid film back is both a luxury and a necessity. (It is a luxury because 4x5in Polaroid film costs about $2.00 a shot and generates an inordinate amount of garbage; it is a necessity because you will waste a lot of time and money without the guarantees provided by on-site previews of your work.) Typical films to use are Kodak Vericolor III Type S (ISO 160) for daylight color negatives, Kodak Vericolor II Type L (ISO 80) for tungsten artificial light color negatives, Kodak Ektachrome EPP (ISO 100) for daylight transparencies, and Kodak Ektachrome Type 6118 (ISO 64) for tungsten artificial light transparencies. My standard test film is Polaroid type 54 (ISO 100)—a coaterless black-and-white material that produces highly detailed test prints in forty-five seconds at room temperature. Type 58 (ISO 75) is useful for evaluating color balance under both daylight and tungsten conditions: when exposure times are shorter than five seconds the film is correctly balanced for 5500K, at exposures longer than thirty seconds built-in reciprocity effects alter response to match 3200K sources. (Polaroid recommends a processing time of one minute for Type 58, but I have found that ninety seconds is better.)

In addition to the camera, lenses, and film backs the following accessories will be required: a bag bellows (a soft, extraordinarily flexible bellows usually made of leather, required for use with wide-angle lenses), a dark cloth (an opaque cloth to drape over one's head and the back of the camera to permit viewing the dim ground-glass image), a sturdy tripod, cable releases for all lenses, a loupe to magnify the ground-glass image for precise focus, and an incident light meter.

Until now we have depended on the BTL/TTL light meter and bracketing for exposure control. With the higher cost of large-format sheet film, extensive bracketing becomes prohibitively expensive—an incident light meter reading confirmed by a Polaroid test is more reliable. Behind-the-lens meters measure the light reflected by the surface of the subject. Incident meters circumvent the vagaries of subject tonality by measuring the light that impinges on the subject, rather than the light that the subject reflects. It does this by way of a translucent diffuser—a plastic dome about one inch in diameter that sits on top of a photocell (a crystalline device that converts light energy into electrical energy). Light striking the dome from different directions is mixed together by the diffuser and measured by the photocell, which then activates the light meter's readout. To take an incident light reading, hold the meter at the position of the subject and point it at the camera or at the main light source. Use the setting suggested by the meter for a Polaroid test exposure. Visually evaluate any deviation from the ideal and then correct for it in the exposure of the real film. With a reliable lab, a familiar film stock, a well-calibrated incident meter, and accurate shutters, economy-minded photographers can dispense with brackets altogether. Nevertheless, when I work in 4x5in format, I always shoot two color negatives at the same exposure as insurance against mechanical or chemical damage during processing. When I shoot big color transparencies I bracket two or three stops as insurance against slight variations in film speed or processing conditions.

The large-format learning curve is very quick, particularly when the process is expedited on the job with Polaroid tests. Anyone who has done good work in small format should do well with big cameras under the same conditions. It will quickly become apparent that the various controls available on the view camera are invaluable tools that greatly facilitate image management. Those accustomed to the right-side-up image in the viewfinder of an SLR will at first find it a little odd to be evaluating an inverted and left-to-right reversed

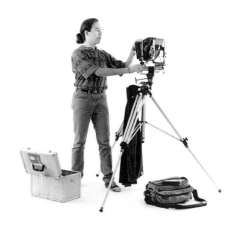

Leo Kopelow levels the view camera before lining up a shot.

image on the view camera's ground glass. This disorientation will soon pass. After all, it is common practice for graphic artists to turn their work upside down in order to better evaluate balance and composition.

REASONABLE EXPECTATIONS Substantial investments of cash and patience will be rewarded—carefully made large-format images will take your breath away. It is possible to subvert the potential of the medium by inappropriate choices of lenses, film, and point of view, but such errors are rare simply because the deliberate pace of view camera work encourages precision.

Examine your large-format negatives or transparencies with a loupe and a light table. When evaluating your work be certain to distinguish between camera movement, imprecise focus, and optical deficiencies. There will inevitably be some loss of sharpness toward the outer edge of the image projected by even the very best lenses. Cheap or damaged lenses will exhibit an exaggerated edge softness. Keep in mind that at moderate apertures (typically f11-f22), virtually all view-camera lenses will be critically sharp in the central image area. If this is not the case it is most likely that you have either focused poorly or you have allowed the camera, or a part of the camera, to move during the exposure. Sometimes lack of sharpness is a result of film slipping slightly within the film holder or of misalignment of the film holder within the film back. Other culprits might be a small movement of the front standard, back standard, or tripod due to a malfunctioning or improperly actuated lock. Even a fingerprint on the lens will degrade sharpness noticeably. A bellow can act like a sail outdoors: a slight breeze may move the whole camera enough to degenerate an otherwise perfectly sharp image.

Good, repeatable results are only possible with a fastidious routine of careful camera setup, precise focus, secure locking of all movement, and correct exposures.

YOU DON'T HAVE TO WORK ALONE It will become evident that working by oneself, particularly with large-format cameras, can sometimes be an overwhelming proposition. Why not follow the example of the majority of professional photographers who—when confronted with a big job—take on some extra help?

The costs of large-format equipment and film make the expense of hiring an assistant seem relatively small. If the helper is a colleague or an employee, the only real cost will be the time lost from other work. Such people need not be highly skilled in a photographic sense, since carrying equipment, helping to rearrange furniture, or cleaning up an outdoor site is not very complicated.

Keep in mind that more sophisticated helpers will improve picture making in the same way that sophisticated technicians at the color lab can improve print making. Every city supports some people who specialize in assisting photographers on a free-lance basis. They may be located by asking professional photographers or industrial photographic suppliers. Technical schools or universities that teach photography are also good sources. Remuneration varies from minimum wage up to $25 per hour, depending on experience.

A skilled assistant will accelerate the photographic process by anticipating what equipment is required for a particular shot, how the equipment should be set up, and where the equipment will be moved for the next shot. They will offer advice about lighting, lens selection, and point of view based on their experience with other professional photographers' methods. Some assistants intend to be professional photographers themselves, so their enthusiasm on location can be quite inspirational both technically and aesthetically.

Those jobs that demand supplementary lighting can be facilitated using the expertise of theatrical or cinematographic lighting specialists. This need not be as imposing an undertaking as it might sound. Consider that in almost any urban center there will be at least one business that specializes in supplying a variety of lighting equipment to those who produce television, film, or theater. Their staff will know about color balance and contrast control and they will be able to suggest which instruments and accessories are appropriate for your problem shots. Very likely they will be able to "rent" a technician to set up and operate the lights as well. Since still photographers work on a much more flexible schedule and on a much smaller scale than the other users of rental lighting, rates will be manageable. Similarly, independent film and theater production companies often have their own lighting and lighting technicians; the possibility of a little extra income between projects is often very attractive to them.

MAGAZINES AND NEWSPAPERS

TECHNICAL REQUIREMENTS FOR PUBLICATION I cannot say what makes an architectural project suitable for publication, but the technical criteria for architectural photos intended for publication are fairly straightforward. I have already commented on the ancient argument between transparencies and prints. The following specifications apply to both:

1. The image must be clear, with an abundance of detail and consistent focus.
2. The color must appear natural and appropriate for the scene.
3. Perspective and point of view should be natural and pleasing.
4. Sun angle, sky conditions, and seasonal variations should be appropriate.
5. The subject must be portrayed in its proper context relative to the site.
6. The scale of the subject must be properly established.

Look familiar? These same characteristics of quality architectural photographs were listed in Chapter 1. Hopefully, the nuances of what goes into such images are now familiar, as well. Here are a few more tips:

7. Prints should be carefully produced and 8x10in in size.
8. 35mm transparencies of exceptional quality are okay, but larger is better.
9. A self-addressed stamped envelope should accompany all submissions.
10. Do not send away material that cannot be replaced. (Another argument in favor of prints!)

These are pages from *Architectural Record*, April 1983, featuring the IKOY Office. A comprehensive submission results in a comprehensive publication if both the project and the photography are regarded as worthwhile by the editors of architectural journals.

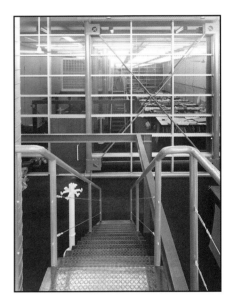
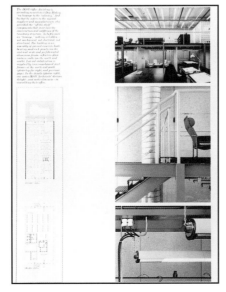

Two covers: *Architecture Magazine*, March 1987, *Architectural Technology Magazine*, Fall 1987.

HOW TO DEAL WITH AN EDITOR Successful interactions with photo editors begin with an understanding of what it is they do for a living: they are charged with assembling the visuals that illustrate and support the written editorial material. Piles of pictures of all sorts must be evaluated. Generally, professional offerings are not dealt with any differently from those of advanced amateurs, but all too often a sow's ear must be made into a reasonable facsimile of a silk purse. Those images that are ultimately selected to accompany the written editorial material must be carefully cropped and captioned.

The way to warm the heart of a photo editor, and consequently the way to maximize the use of your images in the magazine, is to attend to all the above mentioned details yourself. Thus, make certain that the images you submit are logically appropriate illustrations for the text, aesthetically as well as technically excellent, and clearly captioned. (Easily removed stick-on labels are best for prints, since pen or pencil markings may cause stains or mechanical damage. Use stick-on numbers and a separate clearly printed list for 35mm slides.) Captions should indicate who the photographer was, when the image was made, and why the image is significant.

Dealing with an editor is not always a one-way operation. If the level of work submitted is acceptable but incomplete in some way, you can expect to be asked to supply whatever additional images are necessary. It is at this point that many amateurs (and some professionals) get tripped up. Magazines have highly developed editorial policies. These policies are reinforced by methods that vary from the very subtle to the very heavy-handed. Selection, cropping, sizing, placement, and the use of color are methods of manipulating the significance of particular images to serve the editorial policy of the magazine. These methods do not directly involve the photographer who has made an unsolicited submission, but a call for additional specific material does. A personal decision must be made about how such requests will be handled; arguments over style, technical approach, and the value of particular images are profoundly unwelcome by most magazine editors. Professional photographers are sometimes threatened by detailed requests, which they may interpret as criticism. Amateurs are sometimes threatened by specific requests since they have a personal stake in the way the building or interior will be represented in the magazine. For example, a request for a closeup picture of a structural defect may irritate the photographer/architect whose building is being subjected to a critical review.

It is necessary to understand that editorial exposure in a publication is not always a straightforward public relations vehicle. Any magazine exists to serve its readers and its advertisers; their welfare will usually be considered ahead of the welfare of contributors. When everyone's needs coincide, relations with editors can be wonderfully peaceful. In the event of a dispute, the contributor should understand that he or she will inevitably have to defer to the wishes of the editor or else withdraw the entire submission. To establish a working rapport, it is best to query the editor with a detailed proposal letter before submitting a comprehensive body of work.

Canadian Architect Magazine **chose this
shot as the cover of the issue that fea-
tured the IKOY Office. A large sheet of
seamless paper was used to isolate the
elements in which I was interested from
the rest of the room. Available light was
sufficient here.** Camera: Toyo 4x5in,
lens: 150mm (normal), film: Kodak Veri-
color III Type S. Perspective controls were
not required.

SHIPPING AND HANDLING Earlier I mentioned that all submitted materials should
be accompanied by a stamped, self-addressed envelope and that irreplaceable materials
should never be sent as part of an unsolicited submission—these are the basic rules. In
addition, it is only sensible to pack photographs carefully. Usually two sheets of stiff
corrugated cardboard or foam board will protect prints and slides sandwiched between
them. Heavy duty envelopes or padded shipping pouches are preferred over craft enve-
lopes, as well. Never ship glass-mounted slides. Always sleeve large-format transparencies.
Photographic suppliers that cater to professionals often stock very attractive transparency-
mounting systems that consist of a black cardboard frame enclosed by a specially made
sleeve with a clear plastic front and a frosted plastic back. These mounts handle several
35mm or medium-format transparencies, or one large-format transparency. At one or two
dollars each, they are a good investment since they protect slides from fingerprints and
provide a diffused viewing light at the same time.

Deadlines are critical, so never trust the postal system. Independent couriers such as
Federal Express are expensive but quick; they keep track of shipments via way-bill
numbers and computers so shipments seldom go astray. If material is requested by a
magazine, you will usually be able to ship collect via their favored courier. Don't be
shy—ask for an account number.

WHEN YOU PAY THEM, WHEN THEY PAY YOU You will never really have to pay a
magazine directly to get a photograph published. However, all photos produced and
submitted on speculation will of course be produced at your own cost. It is extremely
unlikely that these costs will ever be recovered should the material eventually be accepted

for publication. A query letter that outlines the proposed article and the photography that would be required to support it will sometimes result in the offer of some money for professional photography or for the materials needed to produce the work in-house. The exact amount will depend on the practices and size of the publication in question. Although there is no question that any publication will happily accept quality photographs if offered for free, they are quite used to paying for good work produced on assignment by professional photographers. The remuneration for amateur work will have to be diplomatically negotiated, with actual costs for materials as a starting point.

WHAT TO SEND Earlier I mentioned that editors have considerable power over the effect and importance of the images they choose to publish, while the creation and selection of images for submission is the first and sometimes the only control that rests with the contributor.

Sending images on speculation is a form of advocacy since there are professional benefits that accrue from publication of one's architectural or interior design projects. The natural impulse is to make certain that whatever is published will be a positive and flattering representation of your work. The preceding chapters are all dedicated to the acquisition of the skills necessary to do this, but the last (and sometimes the most difficult) task is to ruthlessly edit one's own photographs.

Editing is an exercise in minimalism; it is necessary to eliminate all but the most essential images. The very best photographers do this as they shoot, so that both time and materials are conserved at once. Some professionals and advanced amateurs as well as most beginners tend to shoot prodigious amounts of film with the intention of weeding out the inferior pictures after processing. Working this way exposes the photographer to the sometimes irresistible temptation to retain images that are less than excellent. When using 35mm, a shooting ratio of 20:1 (twenty mediocre shots for each good one) is not at all unreasonable. A magazine submission should be composed of pictures that have been culled from your first rough edit. Sending a small number of wonderful pictures that you have carefully preselected will ensure that the photo editor's work begins with a visual record that accurately reflects your personal interpretation of the subject. Assuming the original submission was first-class, you will not be unduly compromised should the editor request additional images; the quality of the photos will earn a measure of professional respect and your views will be considered seriously.

A GOOD BLACK-AND-WHITE PRINT Although most national magazines publish in full color, there will always be a need for high quality black-and-white photographs for use in press releases, technical and legal documentation, and newspapers. Standards of reproduction vary, but it is important to be able to recognize the characteristics of a reproducible print, if only to ensure that your lab produces satisfactory work. It is incumbent on the contributor to submit excellent prints. While the published result may end up noticeably worse than a good original, it will certainly never be any better than a poor original.

This photo of a dilapidated prairie farmhouse shows the wealth of detail that can be preserved on carefully made small-format negatives. This photo was made on slow speed black-and-white film with a tripod-mounted camera. A yellow filter was used to enhance the contrast between the sky and the clouds. Camera: Leica M4 (35mm range finder), lens: 35mm (moderate wide-angle) with yellow filter, film: Kodak Panatomic-X (ISO 50).

VIII

A superior print will exhibit a range of tones from pure white to deep black, with an abundance of intermediate values where appropriate. Both highlight and shadow areas should retain some modulation of tone, and fine details should be rendered clearly.

BLACK-AND-WHITE CONVERSIONS Part of the convenience of working with color negative materials is the relative ease with which black-and-white prints may be produced from them. Kodak has introduced three black-and-white printing papers for this purpose: Panalure L, M, and H—low, medium, and high contrast, respectively. These excellent materials will render images of great detail and natural tonality from a wide range of color negatives *(see color plates 38–41)*. Any lab that is capable of producing ordinary black-and-white enlargements can produce Panalure prints using the same chemistry and equipment. In a pinch, ordinary black-and-white paper may be used with color negatives, but the tonal range will be noticeably altered and the image, particularly with 35mm color negatives, will appear very grainy. Such a print would be only barely adequate for reproduction in the newspaper or by photocopier.

Slanting early morning sunlight skims the sculptured detail of the facade of the Manitoba Law Courts Building in this black-and-white photograph. A perfectly symmetrical view, combined with the purposely converging verticals, provides a sense of power and drama. Careful printing maintained detail in the carved crest shadowed by the overhanging canopy.
Camera: Hassleblad ELX (medium format), lens: 40mm (extreme wide-angle), film: Fuji Reala, printed on Kodak B&W Panalure paper.

Where black-and-white services are not available, there is a handy alternative that can produce very pleasing results. Ilford makes a black-and-white film called XP-2, which is quite widely available in camera stores. This material does not require special processing, but can be developed in the same way as ordinary color negative films. The resulting monochrome image is not composed of metallic silver as it would be in a conventional black-and-white film; rather its made up of a chemical dye. When printed on the same machines as ordinary color prints, a little care by the operator will result in very useful

black-and-white prints. Conservatively rated at ISO 400, this material is quite sensitive to light, and has the very wide exposure latitude characteristics of color negative film, to which it is closely related in structure. Excellent enlargements may be easily made with conventional black-and-white printing papers. I recommend XP-2 as the most convenient route to high-quality black-and-white photographs, particularly when a reliable lab cannot be located.

Monochrome conversions of color slides require a bit more technology since there are no black-and-white papers that will produce a positive image from a positive original. Your processing lab will have to make a black-and-white internegative by copying the slide with black-and-white film. This may be done with a slide-duplicating camera or by contact printing. The latter is inconvenient but technically superior since it bypasses the losses associated with any opto-mechanical system. Assuming a very high-quality original slide, you can expect good to fair results with either method. Nevertheless, if you know in advance that good monochromatic prints will be required, I strongly recommend that you shoot in fine-grain color negative, XP-2, or conventional black-and-white film (in ascending order of technical quality) rather than rely on converting color slides.

A final word: if your color work is to be published in black-and-white, never allow the magazine or newspaper to make the conversion in-house. You will always be much better served by supervising the conversion at your own color lab. This does not have to be a point of conflict if you simply say that you wish to maintain high standards without having to impose on the publisher's staff.

DEADLINES All publishing deadlines must be scrupulously respected if you expect to be taken seriously by the photo editors of magazines, newspapers, and in-house newsletters. It is important, therefore, to allow sufficient time to shoot, process, edit, and print whatever photographs are required.

Every photographer will have a characteristic speed of operation; just how long it takes to analyze the photographic possibilities of a site, decide on equipment and film, pick the appropriate time of day, and arrange for access where necessary, will be different for everyone. Weather and traffic conditions must be taken into account, since these unpredictable variables may delay even the most carefully planned shoot.

Processing film of any kind will usually take less then a day in any large urban center. Photographers in smaller communities may have to wait two to three days. Machine-made prints in color are commonly available at one-hour processors or within a day from conventional color labs. Machine-made enlargements may take anywhere from two to five days. Custom color labs can turn around excellent hand-made prints in one day by special request (usually with a rush fee tacked on), but two to four days is generally regarded as "normal" service. Special processes, such as black-and-white conversions, duplicate transparencies, or outsize prints, may take anywhere from a week to ten days. It is a good idea to get quotes on delivery time (as well as price) when planning time-sensitive projects.

From time to time circumstances may arise that demand virtually instant or overnight results. At these moments the history of your relationship with the color lab will be crucial. Have you regularly bypassed the more expensive lab in favor of the inferior, but cheaper, one-hour photo store? Have you neglected to recommend the lab to professional colleagues? Have you disputed invoices that included rush fees for previous special services? If you have, you cannot expect experienced professionals to cheerfully stay up all night to save your reputation.

A PROFESSIONAL'S PORTFOLIO

PRESENTATION FORMAT A collection of excellent photographs of your work is a premium selling tool for your professional services. In general there are two methods of presenting the material: prints and slides. I have always preferred prints, simply because I dislike the hassle of arranging for a projector and a darkened room, and because I value the personal contact that results when people physically handle and discuss carefully crafted photographs. My own portfolio consists of about thirty-six 11x14in color enlargements that have been laminated with plastic on both sides. The image area is smaller by three or four inches than the full paper size, so the pictures float serenely in a pure white field. Laminating makes the prints durable, but also gives the prints a pleasing weight and

strength. These mechanical characteristics are inevitably appreciated at subtle psychological levels as well. The prints fit handily into a typical attache case. Before any presentation I select the ten or twelve images that seem most appropriate to show.

A large number of prints is better managed by making laminated 8 1/2x11in prints, which can be punched to fit a variety of attractive three-ring binders. For crucial presentations, slick-looking suede or leather-bound binders can be suitably embossed.

Logos, technical data, and captions can be added to prints in a couple of different ways. If someone in your office has a good "hand" the most direct method is to do the lettering manually with a fine-line permanent marker directly on the surface of the print. The more painstaking among you may chose to use pressure-release type, such as Letraset, instead. Those with deep pockets can have captions professionally typeset and then photographically burned-in on the prints by the lab. Typesetting, a high-contrast negative, and burning-in may cost ten to twenty dollars per photo. Prints with titles prepared by any of the above techniques may be laminated afterwards without any special precautions.

WHEN TO USE SLIDES When visual information has to be delivered to a large group of people, 35mm transparencies are the undisputed winner. The big, bright, rich-looking image on the screen tends to focus the viewers' attention on the material being offered. If the commentary that accompanies the slides is interesting the overall effectiveness of the presentation can be very high. Some proposal calls and competitions ask specifically for slides as a means of standardizing entries for the convenience of the adjudicators.

The slide in the projector is the same piece of film that was exposed in the camera, thus the potential exists for really wonderful image-quality since the losses associated with a second-generation print are absent. On the other hand, the manipulations and corrections that may be incorporated during printing are also absent, so problem images can be painfully obvious. There are two ways of dealing with this dilemma: the first involves careful application of photographic technique in association with ruthless editing, while the second involves making copy slides of prints derived from conventional color negatives. Method one is preferable if the ultimate in technical quality is desired. However, method two integrates well with an existing body of color negative work and still allows for the beneficial interventions possible with the negative/positive system. Several sets of duplicate slides can be circulated around the city or the country while the originals remain safe at home. The copies may be made at the color lab or they may be made in-house using a closeup lens and the techniques discussed in Chapter 7. The slides that result will never be as good as perfect first-generation slides, but they are quite satisfactory for presentation purposes. My own architectural clients have used such slides for years without any problems. Copy slides should never be used for reproduction purposes, however; color separations should always be made from first-generation slides or directly from color prints made from color negatives.

These pages are from the 1986 Royal Architectural Institute of Canada Governor General Award Catalog. They include IKOY Architects' winning entry for that year— The Red River Community College Auto/Diesel Shops. All the photographs are reproduced from 35mm slides.

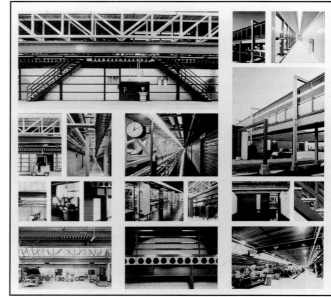

Sometimes a demand for reproduction-quality large-format transparencies may be satisfied relatively inexpensively by having the color lab produce 4x5in duplicates directly from high-quality 35mm slides. Similarly, 4x5in transparencies can be made at the lab directly from high quality 35mm color negatives using Kodak Type 4111 color print film. Both these strategies will often satisfy the most critical photo editor, especially if such copies are not identified as duplicates.

WHAT TO INCLUDE　　In Chapter 1, I discussed how to evaluate the portfolio of a professional architectural photographer. It is interesting to consider that we have come full circle, in the sense that many of the criteria that we previously applied to professional photographers must now be applied to our own work. Here is a review of the important points concerning a portfolio of architectural photography:
1. The photographs should be clear, detailed, and natural in color.
2. Special effects should have a readily perceived purpose.
3. The graphic approach should make immediate sense.
4. The images must logically apply to the situation at hand.
5. Do not show any more photographs than are absolutely necessary.

　The great temptation that must be overcome when assembling a professional portfolio is the impulse to include too much material. Quantity is no substitute for quality, and some restraint must always be exercised to prevent visual over-kill. Remember also that your audience will be looking for material that is applicable to their own special circumstances; it is wise to edit your portfolio for each presentation. The order in which photographs are presented is also important. In the commercial photography business the rule-of-thumb is to show your second-best image first, and your best image last.

CORPORATE CAPABILITY BROCHURES AND MAILERS

WORKING WITH A GRAPHIC ARTIST OR DESIGNER　　When the need arises for promotional material that can be distributed in large numbers, even photographically literate practitioners will have to turn to other professionals for assistance. Truly up-scale advertisements will be a sophisticated combination of good writing, good photography, good layout and design, together with good printing on quality paper. A graphic designer can coordinate all these varied creative components and find talented writers and printers if you do not happen to know any. However, our main interest here is the photographic component. My advice to anyone who wishes to produce visually strong promotional material is to engage a designer before any photography is undertaken. This is important because photographs that are intended to be integrated with other visual elements in a printed piece fulfill a different function than photos that are intended to stand alone. Consultation with the designer will inevitably result in a more effective effort.

　Professional designers charge $25–$75 per hour. A brochure may require 8–25 hours work, depending on size and degree of sophistication. You can expect the designer to consult with you about the overall visual approach, the specifics of photography, copy, format, typefaces, and print stock. The designer will deal with the printer regarding matters of cost, deadlines, and quality. Selecting a designer is a parallel exercise to selecting a professional photographer; a portfolio of previous work, good references, and a personal interview will all be necessary to assist in making an informed choice.

　It is uneconomical to make less than one or two thousand copies by mechanical reproduction. For such quantities, a well-produced color piece can cost anywhere from $.50 each for a folded 8 1/2x11in flyer to as much as $10.00 each for a glossy 24-page book. Some designers will help reduce costs and shorten delivery time through the use of desktop publishing techniques and equipment, although some loss in quality is to be expected if conventional printers are replaced entirely by electronic reproduction technology.

PHOTOCOPYING AND DESKTOP PUBLISHING　　These days many computer literate practitioners can bypass professional designers altogether by producing small runs of promotional material using their own personal computer (PC), a laser printer, and a color photocopier. Virtually any PC will do a great job of layout and typesetting so long as the operator has access to, and is fluent in, decent graphics software. If the essential peripherals (laser printer, $1500–$3000; color photocopier, $15,000–$40,000) are beyond your budget,

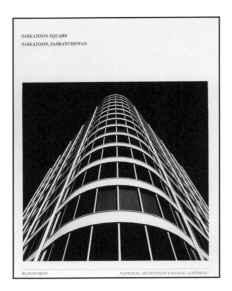

SASKATOON SQUARE
SASKATOON, SASKATCHEWAN

BLOUIN-IKOY NATIONAL ARCHIVES OF CANADA - GATINEAU

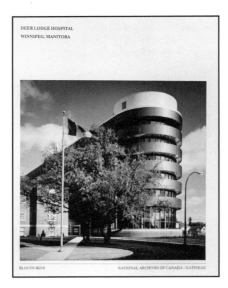

DEER LODGE HOSPITAL
WINNIPEG, MANITOBA

BLOUIN-IKOY NATIONAL ARCHIVES OF CANADA - GATINEAU

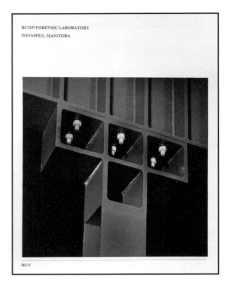

RCMP FORENSIC LABORATORY
WINNIPEG, MANITOBA

IKOY

These are project-specific promotional cover sheets intended for color photocopying—prepared from my photographs by IKOY Architects.

take your output disk to the "instant printer," the printing trade's equivalent of the one-hour photo lab. If an instant printer with the capability to read magnetic media cannot be found, most typesetting shops will be able to produce a first-class "hard-copy" (for a nominal fee), from which multiple photocopies can then be made. Photographs are incorporated into this process by preparing a set of prints at the exact size required for the layout. The pictures are trimmed and secured to the hard-copy sheets with a bit of glue. The resulting composite is then duplicated on an electrostatic copier as required. Using these techniques, quite pleasing results can be expected at about $.50 a page in quantities of 50–250. Note that photocopies tend to pick up considerable contrast, exaggerate some individual colors at the expense of others, and blur fine details.

Color photocopies and Polaroid photos can be used for rough but presentable images when deadlines are very pressing and no conventional photography of projects exists. A camera capable of using Polaroid film may be rented or borrowed. Not all Polaroid cameras are of the point-and-shoot variety: some even have interchangeable lenses. There are a variety of Polaroid film sizes as well—bigger is better for this work. I recommend Polaroid Type 664 for detailed black-and-white prints and Type 669 for low-contrast color prints. Type 668 yields snappier color prints for very low-contrast shooting situations. (Remember that the photocopier will increase contrast to some degree.) Any camera store or industrial photographic supplier can give you a number to call to get technical advice on all these matters directly from Polaroid Corporation.

The basic advice I have offered in previous chapters regarding lighting, point of view, time of day, exposure, etc., applies when shooting a building or interior with Polaroid materials. You will quickly find that exposure is the critical factor, but, happily, the narrow latitude of instant films is ameliorated by the instant feedback, so exposure settings can be fine-tuned quickly. Avoid making contact between skin or clothing and the chemically damp peel-away backing generated whenever a Polaroid shot is processed—carry along a bag for garbage.

The limitations of color photocopying will disguise most of the technical differences between Polaroid prints and conventional prints. Although I have found that high-quality color photocopiers will do a very readable rendering of a color print, there is no substitute for the real thing. If photocopies do not appeal, and it is necessary to produce a small number of top-quality promotion packages, you might consider a more expensive (but still manageable) alternative: multiple photographic prints. If you require only a few different images, have the lab quote on producing images to size, in quantity. At the lab I use, one hundred 8x10in prints from the same color negative cost only $1.75 each, and smaller prints are even less. Page-size photos can be punched and bound together with the copy, while smaller prints can be trimmed and secured with glue wherever appropriate spaces have been provided within the text. There is no doubt that this is a labor-intensive procedure, but the final results can be very satisfying.

AVAILABLE MATERIALS From time to time it will be necessary to prepare large photographs for display at professional meetings, competitions, building openings, or public forums. There are two basic approaches: large reflection prints and large transparencies (for which some sort of back lighting must be provided).

Conventional print materials are available in sheets up to 30x40in and in long rolls up to 48in wide. Not all labs can handle such big pieces, however, so such work may have to be sent out to specialized shops. Big prints made on conventional papers are vulnerable to all kinds of mechanical damage, so some sort of mounting and laminating is a prudent precaution. Masonite, plywood, Styrofoam, foam board, cardboard, and various types of plastic laminates can all be used for backing display prints. A clever, optically clear adhesive is now being used to face-mount prints directly onto sheets of Plexiglas, an operation that "frames" and protects in one step. It is often inconvenient to transport large rigid prints from place to place; however, ordinary prints will not stand up to repeated rolling and unrolling. When flexibility and durability are important, conventional photographic paper can be replaced by a very tough epoxy based material manufactured by Kodak called Duraflex. Although it is more expensive than ordinary paper, by about 50%, Duraflex can be processed normally despite the fact that it is virtually indestructible.

Two different technical approaches are possible when the glamour and effectiveness of back-lit displays prove irresistible. Kodak makes a companion product to Duraflex, called Duratrans. This material is used with color negatives and processed the same way as ordinary prints, but instead of an opaque backing, the emulsion is coated on a translucent plastic base that allows for lighting from behind. It is just as durable as Duraflex, and does an impressive job of turning images recorded on color negative film into super-sized transparencies. Back-lit displays are complicated to fabricate by oneself, so the best route is to locate an industrial supplier through the yellow pages ("displays systems," "advertising") or through a recommendation by the color lab. Ingeniously collapsible lightweight display units, starting around $1000, are the best technique if presentations must be made on a regular basis. One-time affairs may be dealt with by simply joining together two to four 4x8in sheets of foam board, Gatorboard, or suitably painted plywood to make an accordion-type stand to which prints and copy can be secured.

Ilford makes a very impressive (but more costly) alternate to Duratrans and Duraflex called Cibachrome Print Film. This gloriously accurate material is a material designed for printing directly from color slides. The color reproduction via Cibachrome is considered by some experts to be the very best available; however, it has an extremely high inherent contrast, requires more complicated and expensive chemistry, and works well with only certain slides. Nevertheless, if a competent Cibachrome printer is available, you might want to view some comparative samples of both print and transparency versions. Contrast masking is usually required for best results.

SUPPLEMENTING COMPETITION ENTRIES

Proposal calls and competitions demand some kind of photographic support, the effectiveness of which can be enhanced by a little effort. My advice regarding printed promotional material applies to this scenario as well, although in this case only one finished product is required as opposed to many.

To recap: any proposal or competition entry should be designed either by a professional designer or by someone familiar with the techniques. Photographs, drawings, perspectives, and written material should be carefully integrated into an effective layout with suitable type and clear, cogent headlines. In most cases this means mounting photographs and drawings made to size to several boards. Copy, captions, and headlines are hand lettered, typeset, or prepared by desktop publishing technology. Care is taken to ensure a professional, uncluttered representation of whatever is being "sold." Exact sizes for the boards will usually be supplied by whomever is running the competition. If the proposal is expected in the form of 35mm transparencies, the same techniques will work, except that accurate copy slides of the layouts are submitted rather than the boards themselves. A word of warning: your lab will be able to do a better job of producing color-matched prints to size if a reasonable time is allowed for the work. Do not wait until the last minute.

LONGEVITY OF PHOTOGRAPHIC MATERIALS

Because photographs look so good, people tend to assume that they will remain in the same state forever. Unfortunately, even carefully made images begin to deteriorate as soon as they are produced. Color photographs are composed of organic dyes, and, like all such pigments, they are subject to discoloration and fading by the action of a number of agents such as ultraviolet light, heat, moisture, and a wide variety of virtually unavoidable chemical pollutants. Black-and-white images are inherently more stable because they are composed of durable metallic silver, but even this seemingly permanent medium is vulnerable in several different ways.

The first consideration for ensuring the maximum life for photographs is proper processing. If black-and-white images are to be preserved over time they must be archivally processed, which involves an extra chemical bath, called Hypo-clear, that converts image-degrading by-products into more readily water-soluble forms that are then flushed away with clean running water. It is unlikely that commercial labs will take this kind of care unless special arrangements are made. Some fastidious fine-art photographers typically maintain archival standards, so the perfectionists among you could consider seeking out such people and enlisting their services to handle those black-and-white materials that must be protected for posterity. Life expectancy for commercially processed black-and-white materials might be twenty years, while archivally processed black-and-white materials that are stored in acid-free sleeves away from light will last two hundred or more years in pristine condition.

Unfortunately there are no special archival processes that will extend the life of color materials, so the only recourse for the preservation of important images past five or ten years is careful storage under controlled conditions. Films and prints will rapidly deteriorate (within one to five years) when exposed to light. Ultraviolet radiation from the sun or from fluorescent or mercury-vapor lamps is particularly damaging. Proper storage requires the use of acid-free archival sleeves, hermetically sealed plastic wrapping, and refrigeration. The main factor in image longevity is very low relative humidity.

INTRODUCTION

This last chapter is intended to help those aspiring or established professional photographers who would like to excel at architectural work. I will assume that the materials and equipment described in the previous chapters are fully understood. It is my belief that the skills required to successfully shoot buildings and interiors can be achieved by studying the working method of an experienced architectural photographer and by using trial-and-error experimentation. What follows is a "snapshot" of how I deal with assignments for architects and interior designers and some suggestions for applying my methods.

Many interesting building exteriors in North American cities are accessible from public walkways or streets; many public buildings have interesting interiors as well. Aspiring architectural photographers can freely experiment with my stalk-and-shoot technique long before approaching any paying customers.

PRELIMINARY STEPS Those of you who regularly shoot people and products will find that the first difficulty encountered in architectural work is the enormous scale of the subject. A technical corollary: large spaces and structures call for wide-angle lenses and a lot of legwork as opposed to the long lenses and small, fussy adjustments that are typical in the studio. Buildings are only slightly interactive; in architectural work, most photographically important variables are dependent on the whims of the gods.

Even though I have done it many times, I find that moving between regular commercial work and architectural work still takes some effort. Part of the change has to do with the slower schedule—commercial jobs rarely require more than a few hours to complete, while architectural work often needs days or sometimes weeks. There are physical considerations, as well. When a big assignment is coming up I intensify my workout program so that hiking around with a pile of equipment in tow will be less arduous.

If possible, I prefer to work without an assistant—I like to contemplate the target buildings and interiors in solitude and to shoot by available light whenever possible. I try to schedule at least twenty-four camera-free hours prior to the shoot under decent light conditions in order to select sun angles and useful vantage points. Whether I am shooting one building or many, I work out a detailed schedule. Each working day is divided into fifteen-minute intervals—I predetermine where I will be and what lenses I will use, weather permitting. Splitting the assignment into thinking time and technical time eliminates some of the stress associated with racing the sun from pre-dawn to post-dusk.

WORKING WITH ARCHITECTS

CLIENT RELATIONS Whether or not you are already an accomplished commercial photographer, when the time comes to start selling your architectural services I recommend that you begin modestly with uncomplicated projects. The reason for restraint has to do with the different working methods of architectural professionals and advertising industry professionals.

Designers of magazine advertisements, posters, billboards, or packaging never use photographs as stand-alone elements. They must be integrated with type, copy, and other graphics. In the marketing business, it is considered counter-productive not to be specific about how the photographs should look, so virtually all assignments will be carefully defined with the help of a detailed sketch or layout.

Architects, however, view their buildings much as a sculptor views sculpture—beautiful three-dimensional objects to be admired from every direction. It is the job of the photographer to cope with often messy complications of urban clutter and to gently shift building designers away from their illusion of splendid isolation. Such a task takes some doing.

I was lucky that my first architectural client was well versed in the ways of the graphic artist. Even so, it took six months before we were up to speed as a team, and twelve years later we are still learning. My advice, therefore, is to start slowly and build up an architectural vocabulary at a reasonable rate.

Due to current building practices, in which designers choose contractors by their bids, architects and interior designers deal with dozens, if not hundreds, of suppliers over a period of years. Because today's profit margins are so small, project managers and trades people are often at odds with each other. The main tool for guaranteeing that all deficiencies are properly corrected is the threat of withholding money; litigation is not uncommon.

It is important, therefore, for photographers to make a very conscious effort to establish relationships with architectural clients that are significantly different than the relationships those clients have with their other suppliers. Maintain and project a supportive, collegial attitude. Make certain that your clients understand that you are committed for the long term and that you intend to help them do well.

ABOUT MONEY Photographs produced for commercial purposes are usually incorporated into larger projects. This means that whoever commissions the work will be reselling the photographs as part of a larger campaign. The value of the original photo is consequently tied to the value of the larger project, so fees to the photographer escalate according to final use.

In architectural photography, however, whoever commissions the work is not likely to profit directly by reselling the images. The photos will not be mass-produced and redistributed, but will be put to work directly as promotional tools. Even if the photos are submitted for publication and appear in a professional journal, no money will change hands. The fees associated with this type of enterprise are limited by the financial resources of the architect and the architect's perception of the reputation of the photographer. Architectural journals do commission work directly, but the rates for editorial assignments are always substantially less than for commercial assignments.

If you are engaged in commercial photography, here is a simple rule-of-thumb for determining how to charge: simply divide your average day-rate in half. This is a fairly steep reduction, but consider that longer deadlines and nonvolatile subjects allow flexibility of scheduling. Architectural work, particularly near home, can be slotted into one's calendar very efficiently and the more leisurely pace can be a pleasant respite. I generally charge architectural clients about seventy-five percent of my commercial rate for film, processing, and prints.

Architectural assignments that take one away from home can be several days in length, so even modest day-rates will add up to acceptable levels. Architects and interior designers with substantial out-of-town projects are used to travel, since their work requires many planning meetings and regular inspection tours; therefore, it is not unreasonable to request that air fare, hotel, and rental car be arranged in advance and paid for directly by your client.

PRODUCTION

DOING THE WORK The attributes of high-quality architectural photography are clearly defined in the first chapter of this book. Also listed are twenty questions that professional photographers should put to architectural clients before undertaking an assignment. If this procedure is followed, problems in communication will be minimized.

Having previsualized the aesthetic requirements, the actual photography is, more or less, mechanical; the parameters are determined by the end use and by the budget. In my experience, the budget determines the photographic format. End use dictates whether the affordable format will suffice. This can sometimes require a very tricky balancing act.

Small-format photography is very inexpensive once the investment in quality equipment has been made. I shoot 35mm transparencies for slide presentations and for occasional journal submissions or competition entries. Small-format lenses and films have improved dramatically, so results can be very good. Almost always, the camera should be on a tripod to ensure maximum sharpness. I use Nikon equipment, and the 28mm Nikkor perspective control lens is my primary tool, but any optic from 20mm to 300mm (including zoom lenses) may be selected for particular shots. Other systems offer similar hardware—Canon has very recently introduced an expensive series of perspective control lenses with automatic diaphragms.

Although I recommend 35mm color negative film for non-professionals, I generally avoid it when clients request presentation prints. I own complete medium-format and large-format systems and I put up with the extra weight and longer shooting time in exchange for bigger negatives. Nevertheless, I try to use the smallest format that is practical for the job at hand.

IX

Good images are possible in medium format with Kodak Ektar 25 or Vericolor III Type S outdoor and Fuji Reala or Kodak Vericolor II Type L indoor. I use Hasselblad equipment for shooting one- to three-story exteriors and many interiors. My most used lens is the 40mm wide-angle.

For those modest budget jobs where extensive perspective controls are absolutely necessary, I switch to large-format equipment. But instead of using 4x5in sheet film, I save money and time by using a roll-film adapter. The adapter permits fast and cheap bracketing in tricky situations, and it cuts down on weight and bulk on location since boxes of film, film-holders, and a changing bag are not required. The only accommodation is the need for a plastic template to demarcate the smaller image size on the ground-glass focusing screen. Roll films save hassles at airport security as well, since inspectors are reluctant to pass sealed 4x5in film boxes without subjecting the contents to x-rays.

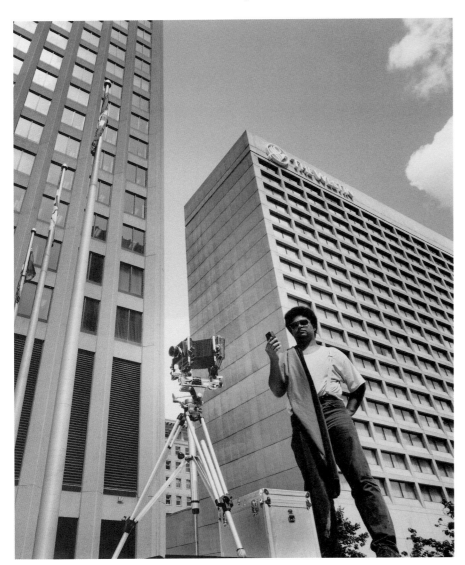

Photographer Michael Holder, dark cloth over his shoulder, takes a meter reading before shooting some buildings in downtown Winnipeg.

For assignments with larger budgets, I like to switch to full 4x5in format. The extra edge in quality is appreciated, but the main reason is physical—a 4x5in ground glass is easier to evaluate than a 6x7cm ground glass. Precise work with wide-angle lenses demands very close study of the ground-glass image, and a 6x7cm image (typical for a roll-film adapter) is just too small over a long shooting day.

Large-format equipment is, in fact, fairly large, so moving gear around and setting up for each shot can be difficult. On the job, I keep my Toyo monorail-type view-camera, equipped with a bag bellows, permanently mounted on the tripod. I keep the tripod legs extended to the correct length for an eye-level working height, which is satisfactory for the majority of shots. I use a folded velvet dark cloth as a shoulder pad on which to balance the camera-tripod combination when moving to a new location.

I carry a rigid case that opens from the top to store 47mm, 75mm, 90mm, 150mm, and 250mm lenses, a light meter, a polarizing filter, a center-weighted neutral density filter, a Polaroid back, a dozen pouches of Polaroid Type 54 film (ISO 100 coaterless black-and-white), a small plastic garbage bag, and a dozen loaded 4x5in sheet film holders. All lenses are equipped with appropriate adapter rings so the two filters will fit each lens. I keep twenty-four additional loaded film holders in the car when I shoot exteriors or at some central location during interior shoots.

My 250mm lens, a moderate telephoto, would normally require a long bellows and a monorail extension, but I avoided this extra baggage by making an extension lens board. This device is essentially a reversed recessed lens board, commonly available for use with wide-angle lenses. It allows the 250mm lens to focus with the same bag bellows and short monorail the other lenses require. Besides saving weight, this approach reduces set-up time. A similar advantage in set-up time is achieved with a specially made, extra deep, recessed lens board for the 4mm ultra-wide-angle lens.

NEGATIVES VERSUS SLIDES By now I have educated most of my clients to the multiple benefits of color negative/color print technology. Almost all of my large-format work is shot on Kodak Vericolor III Type S (daylight balanced) or Vericolor II Type L (tungsten balanced) film. I find that no camera filtration is required since color corrections are easily made in the darkroom. When large-format transparencies are ordered, I print the negatives onto Kodak Type 4111 print film. Since I process all my own work, I am aware of what the materials can cope with in terms of contrast and color. Except for rare circumstances, I am able to shoot interiors without supplementary photographic lighting. Since I work in a relatively small market, the time and expense saved by this approach are critical to my clients.

Conflicts with picky art directors or editors over the negative/transparency issue can be avoided by sending a short fax before submitting material for the first time—simply ask, "Will you accept reproduction-quality prints for publication?" It is not necessary to mention format size or whether or not transparencies of the project actually exist. If the reply is negative, transparencies can be made by your color lab.

THE COMMERCIAL PHOTOGRAPHER'S DARKROOM Aside from the actual shooting, architectural work involves the preparation of prints for display, journal submissions, and promotional presentations. Slides for reproduction and audio-visual productions are often requested, as are high-quality black-and-white prints for newspapers, newsletters, technical documentation, and photocopying. All this means that an opportunity exists for technically minded photographers to substantially increase their incomes from architectural accounts by processing all work in-house.

The mythology surrounding color processing discourages many people from trying it themselves. It is quite true that large-scale color work requires a substantial investment in complicated machinery, but matters are considerably simplified for small-scale processing, the category that encompasses almost all the work of interest here.

I regularly double, triple, or even quadruple my shooting fees by processing and printing my own film and prints. This is possible for four reasons. First, photographic material and chemistry are inexpensive compared to the value of finished work. A modest investment in training and equipment will generate a surprising amount of income. Second, architectural professionals are notoriously lax about publishing and presentation deadlines—because they are often late, they often require photographs in a hurry. Photographs made in your own darkroom overnight are worth more than photographs made at the color lab in two or more working days. Third, architects and designers often need multiple prints from the same negative. Since most of the time and expense in darkroom work is associated with determining the appropriate manipulations for a particular image for the first time, an order for multiple prints is essentially a license to print money. Finally, it is difficult to find a lab that will quickly and competently produce high-quality black-and-white work. Getting good black-and-white conversions from color negatives is a particular problem. This work is very easy to do, but there is so little around that commercial labs are not interested in setting up for it.

I process color negative and transparency film in 1.75 gallon (half normal size) deep tanks, which sit in a large water bath. Regular photographic tanks and sinks cost a fortune, but I was able to get everything I needed for less than $750. I bought the metal myself (type 618 chemical-resistant stainless steel), and had the cutting, bending, and heli-arc welding done at a shop that specializes in fabricating counters and fixtures for restaurants. The tanks sit in a water-filled sink that is insulated with one-inch Styrofoam; temperature is maintained at 95° with ordinary aquarium heaters.

I use Kodak E6 chemistry for transparency processing and Kodak C-41 chemistry for color negative processing. Prices are low for large quantities, so I buy containers of concentrate sufficient to make 25 gallons of working solution and dilute the concentrates to make what I need. Shelf life is reasonably long, and ordinary plastic graduates are accurate enough for reliable measurement.

A clever application of a very old technology combined with a number of new products make printing very quick and convenient. Some of my colleagues laugh when they learn that I do both color and black-and-white processing in old-fashioned trays rather than in processing machines, but I don't mind. I regularly make $200 to $400 an hour in the darkroom using this method. You see, processors are great for huge numbers of prints of

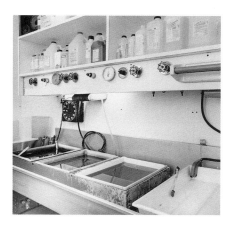

This photo shows my processing setup for making quick and inexpensive color prints. The three trays in the left foreground are sitting in a shallow "sink-within-a-sink" made of one-half-inch plastic. Tempered water flows under the trays from the temperature controller just visible on the floor (bottom left). Tray processing color prints is unconventional, but very efficient for low-volume work.

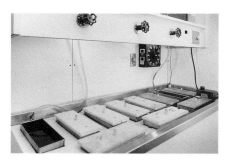

This photo shows my insulated, temperature-controlled sink for color film processing. The rectangular shapes are 1.75-gallon stainless steel tanks with plastic lids. The three tanks in the foreground are for color negatives. The seven tanks in the background hold the chemicals necessary for color transparencies.

IX

consistent quality, but they are expensive to buy and time-consuming to repair and clean. For the small numbers required for architectural work, trays are much faster and almost maintenance free, and can be used to make prints up to 11x14in. I made a shallow Plexiglas water bath that holds three 11x14in processing trays. Again, inexpensive aquarium heaters maintain the required temperature.

Kodak has recently introduced the RA (Rapid Access) line of papers and chemicals, which substantially reduce processing time and environmental impact. With RA, I can make a good print from a new negative in about five minutes, and can batch process twenty prints in about ten minutes. Happily for architectural photographers, RA color papers are now available in three contrast grades, so our difficult subjects can be more easily accommodated. Kodak Panalure paper, specially made for black-and-white prints from color negatives, is now available in low, medium, and high contrast, as well.

Kodak digital-imaging station including a high-resolution film scanner, a computer workstation, image-processing software, a photoCD writer, and a thermal printer.

DIGITAL IMAGING A new technology is emerging that will have fascinating implications in architectural photography. Kodak, among other companies, offers electronic systems with scanners that digitize photographic images captured on conventional film, computers that enhance the digitized image, and thermal printers that make full-color continuous-tone prints. Presently, an investment of tens of thousands of dollars is required. Though the quality of images produced electronically substantially exceeds that of color photocopiers, it falls noticeably short of that of conventional photographic prints. Despite the cost and the quality, the new techniques are certain to make an impact on the way architectural photographers do business in the very near future—we will all have to become computer literate.

The new technology will affect our work in two areas: photo retouching and the creation of presentations. Much of the labor in architectural photography is involved in controlling perspective and eliminating unpleasant street-level clutter or nearby buildings. Electronic image enhancement makes this a two-minute operation—fancy cameras and years of experience might well be replaced with 35mm snapshots and a computer mouse. Presently the technology yields prints that are not satisfactory for reproduction in architectural journals, but quite suitable for reproduction by color copier. Over the next ten years, as output devices improve, conventional printing will become obsolete.

Scanners and printers are very expensive devices, but scanning and printing services can be purchased from existing computerized graphic arts/typesetting houses in much the same way as photofinishing is purchased from the color lab. My advice to professional photographers is to start with a computer of reasonable speed and power—a suitable type can be had for $3000–$5000. An additional purchase of a software program like Adobe Photoshop ($400–$700) will permit the most sophisticated electronic modifications to digitized images. This approach will insure that your experience is not wasted and that you are not left behind as technology progresses. It will allow you to perform all the subtle photographic tricks that sophisticated clients demand, and it will permit you to expand your business as others face an inevitable decline.

GLOSSARY

ABERRATION An imperfection in lens performance. All lenses only approximate the ideal.

ANGLE OF INCIDENCE The angle at which light strikes a surface.

ANGLE OF ACCEPTANCE The angle that describes the width of the field encompassed by a particular lens. A wide-angle lens has a relatively wide angle of acceptance while a telephoto lens has a relatively narrow angle of acceptance. Also called "field of view."

ANGLE OF REFLECTANCE The angle at which light bounces off a surface. For perfectly flat surfaces the angle of reflectance is always equal to the angle of incidence.

APOCHROMATIC (APO) LENS A photographic lens in which all aberrations have been carefully minimized so that performance is very nearly perfect.

AUTOMATIC DIAPHRAGM A diaphragm (typically in the lens of an SLR camera) that automatically closes to a preset size just before an exposure is made, then automatically opens to its maximum size immediately after the exposure. Sometimes "automatic diaphragm" is used to refer to the entire actuating mechanism of springs and levers in both camera body and lens.

AUTOMATIC FOCUS The process during which a modern electro-mechanically governed camera measures the distance between the camera and a photographic subject.

AXIS OF POLARIZATION The orientation of the light-blocking "slots" or "gates" of a polarization filter. Photographic polarizers are mounted on special rings so that the axis of polarization may be rotated to achieve the most desirable affect.

BACK SWING The rotation about a vertical axis of the back standard of a view camera.

BACK TILT The rotation about a horizontal axis of the back standard of a view camera.

BAG BELLOWS An extra-flexible bellows required whenever short focal length (wide-angle) lenses are used with a view camera.

BALL-AND-SOCKET HEAD A mechanism used to attach a camera to a tripod. The camera is connected to a metal ball by means of a short metal stem. The ball is secured inside a metal cup, which is slightly larger than the ball. A clamp is used to lock the ball in position within the cup at an appropriate camera position.

BARREL DISTORTION A type of aberration often associated with extreme wide- angle prime lenses and wide-angle zoom lenses in which vertical and horizontal lines appear curved or bowed away from the center of the image.

BATTERY-POWERED PORTABLE FLASH A compact, self-contained electrical device, energized by a battery, which produces a brief but bright burst of light (flash) in synchronization with the opening of a camera shutter. The smallest versions of these devices are mounted directly on the camera while larger versions include a "power pack" carried in a case with a shoulder strap and a "flash-head" which is mounted on the camera and connected to the power pack with an electrical cable. Portable flash units are used to illuminate a photographic subject under conditions that would otherwise be too dark to conveniently make a hand-held exposure.

BELLOWS The very flexible accordion-like light-proof box that joins the front and back standard of a view camera. The bellows allows the necessary technical contortions of the view camera while completely blocking all non-image-forming light.

BEHIND-THE-LENS (BTL) METER Also known as "through-the-lens (TTL) meter." An electrical or electro-mechanical device built into the body of an SLR camera. Such a meter measures the light reflected by the subject and transmitted by the lens in order to determine, automatically or mechanically, the correct shutter speed and diaphragm opening required for the proper exposure of a particular subject/film combination.

BLACK-AND-WHITE NEGATIVE FILM A type of photographic film that records a monochromatic image in reverse tones: what is bright in the subject is rendered dark on the film, and vice versa.

BOUNCE LIGHT A photographic technique in which light from an artificial source (such as an electronic flash or a photo floodlight) is bounced off a reflective surface (a white card or a light-colored wall). This technique transforms a source of "hard" light into a source of "soft" light.

BRACKETING The technique of exposing a series of frames of film at slightly under and slightly over the measured exposure. This technique is sometimes necessary in order to accommodate the many variations of light, subject reflectance, and film responses that make predetermining a single, exact exposure setting difficult.

BRIGHTNESS RANGE The subject brightness range; the range of luminance in the subject.

BRIGHTNESS RATIO Brightness range expressed mathematically, i.e., 128:1.

BTL METER See "behind-the-lens meter."

BURN-IN A technique of photographic printing in which a darkroom worker darkens certain specific areas of a photograph.

CABLE RELEASE A very flexible remote-control trigger (usually six to twenty-four inches in length) used to trip a shutter in order to prevent the vibration that might otherwise be induced by direct physical contact between a photographer and tripod-mounted camera.

CENTER-WEIGHTED NEUTRAL-DENSITY FILTER An optical device that is mounted in front of a photographic lens (usually an extreme wide-angle lens) in order to reduce the amount of light transmitted through the center of the lens. Permits an even exposure from edge to edge with those lenses that exhibit a fall-off in light transmission at the outer extremes of their image field.

CHARACTERISTIC CURVE A diagram of the effect on the film of every degree of exposure and a particular developer.

COATERLESS Refers to those Polaroid instant print films that retain a permanent image without the necessity of applying a chemical coating.

COLOR COMPENSATING/COLOR BALANCING FILTER An optical device that is placed in front of a photographic lens in order to adjust the overall color balance (e.g., a 30M [30 magenta] filter for cool fluorescent lighting and daylight-balanced color film). Such filters work by reflecting or absorbing light of specific wavelengths.

COLOR CONVERSION FILTER A filter, stronger than a light-balancing filter, designed to allow daylight film to be used under tungsten and vice versa.

COLOR FIDELITY The degree to which a photograph mimics the exact color of a real object or scene.

COLOR NEGATIVE FILM A type of photographic film which records a full color image in reverse tones. Specific colors are represented by their complements: i.e., red is reproduced as green, blue as yellow, etc. The colors are reversed again to their normal values when the color negative is printed on appropriate photographic paper.

COLOR POSITIVE FILM A type of photographic film that records a full spectrum image in actual (rather than reversed), natural color.

COLOR PRINT FILM A special type of color negative film for making color transparencies directly from original color negatives.

CONTRAST-CONTROL MASKING A sophisticated darkroom technique that allows negatives and transparencies with unsuitable density ranges to be successfully printed.

CONTROLLED-FLARE A photographic technique that permits the brightness range of a photograph to be reduced by the introduction of non-image-forming light into the optical system.

COPY-SLIDE A 35mm transparency made by photographing text, a drawing, or another photographic image.

COUPLED RANGE FINDER A range finder mechanically linked to the focusing mechanism of the camera's lens.

CURVILINEAR DISTORTION A type of distortion introduced by a lens that renders straight lines as curved. See pincushion and barrel distortion.

DARK CLOTH An opaque cloth that is used to block extraneous light from striking the ground glass of a view camera.

DAYLIGHT BLUE FILTER GEL A tough, temperature-resistant, blue filter that is placed in front of a tungsten photographic light in order to change the spectrum radiated by the light to one more closely matched to normal daylight.

DEGREE OF REFLECTIVITY The amount of light reflected from a particular surface as compared to the amount of light that strikes that surface—usually expressed as a percentage.

DENSITOMETER An electrical device that measures the degree of reflectivity or transmittance of photographs, negatives, or transparencies.

DEPTH-OF-FIELD The range around a particular point of focus that is rendered as acceptably sharp in a photograph. For example, if a lens is focused at ten feet but objects at eight feet and twelve feet appear clearly rendered in the photograph, then the depth-of-field is said to be four feet. Depth-of-field varies with the f-stop.

DEPTH-OF-FIELD PREVIEW BUTTON A device that permits a visual evaluation of depth-of-field by overriding the automatic diaphragm mechanism in SLR cameras.

DIAPHRAGM An aperture of variable size that changes the intensity or brightness of light passing through a lens.

DIFFRACTION The change of direction (bending) that is induced whenever a ray of light passes a sharp edge. This effect is responsible for a degree of photographic image degradation when the lens is set to a very small diaphragm opening.

DOCUMENTARY PHOTOGRAPHY A type of photography that attempts to make a very realistic (true-to-life) representation of a particular subject.

DODGE A technique of photographic printing in which a particular area in a photograph is lightened.

EDGE CUTOFF The outer limit of the image projected by a photographic lens.

EDGE FALLOFF An optical property of lenses that renders the outer edges of the projected image as darker than the center.

EFFECTIVE FILM SPEED A measure of the sensitivity of photographic film dependent on, and varying with, processing, lens aperture, filter factor, and shutter speed.

EXPOSURE The process of allowing a controlled quantity of image-forming light to strike a piece of photographic film.

EXPOSURE CONTROL Refers to the process of determining the optimum camera settings for a particular combination of film sensitivity and subject brightness.

EXPOSURE (LIGHT) METER An electrical or electro-mechanical device that measures the brightness of light reflected by a scene or object.

EXTENSION TUBE A light-tight cylinder of specific length that is interposed between the lens and body of an SLR camera, allowing the making of photographs at a closer distance than normal.

FLATBED CAMERA/FIELD CAMERA A type of large-format view camera that does not use a monorail but instead uses a hinged platform (bed) to support the lens; usually folds up to a relatively compact size when not in use.

FIELD OF VIEW See "angle of acceptance."

FILM BACK A device for holding photographic film in proper position on view cameras or modular style, medium-format cameras.

FILM HOLDER A light-tight device for handling photographic sheet film.

FILM SPEED A quantitative measure of the sensitivity of photographic film to light. Film is assigned a number that represents its relative sensitivity to light so that proper exposure can be determined with the aid of a light meter.

FILTERS Optical devices that modify various qualities of light such as color, polarization, and intensity.

FOCAL LENGTH The distance (usually expressed in millimeters) from the rear principal focus or point of intersection of a lens and the film plane when the lens is focused on a very distant object.

FRAME LINES Bright lines within an optical viewfinder that indicate the approximate image area encompassed by a particular camera/lens combination.

FRESNEL LENS A lens made up of a concentric series of simple lens sections; this construction permits a thin lens to have a short focal length and large diameter

FRONT FALL The downward movement of the front standard of a view camera.

FRONT RISE The upward movement of the front standard of a view camera.

FRONT SHIFT The rotation of the front standard of a view camera about a vertical axis.

FRONT TILT The rotation of the front standard of a view camera about a horizontal axis.

F-STOP The number that expresses the size of the lens opening relative to focal length.

GRADUATED GRAY SCALE A strip of cardboard on which is printed a series of neutral gray patches of increasing density; used to determine correct exposure and effective film speed.

HOT SPOT A small (but photographically significant) spot of abnormal brightness in a photograph, in a scene, or on the surface of an object.

IMAGE DENSITY The quantitative measure of reflectance or transmittance in a photographic print, negative, or transparency.

INCIDENT LIGHT METER A light meter that measures the intensity of the ambient light impinging on a particular area.

INTERNEGATIVE A copy negative made from a slide; required when a print from a slide is to be made on photographic paper intended for use with color negatives.

KELVIN COLOR TEMPERATURE SCALE A method for describing the quality of light according to color. Normal daylight is 5500°K. Tungsten lights are typically 3200°K.

LARGE-FORMAT CAMERA Any camera that is intended for use with film 4x5in or larger.

LENS SHADE A device that is mounted on the front of a photographic lens in order to block any extraneous non-image forming light from reaching the front surface of the lens.

LIGHT-BALANCING FILTER Photometric filter designed to raise or lower, by small increments, the color temperature of the image-forming light.

LIGHT METER A device for measuring illumination.

LIGHT TABLE A table or counter with a translucent, illuminated top intended for viewing photographic negatives and transparencies.

LOCK A device for rendering immovable the adjustable parts of a view camera or a tripod.

LOUPE A high quality magnifier used to evaluate photographic materials or to assist in setting precise focus for a view camera.

MASKS A specially prepared black-and-white negative or positive transparency which is sandwiched in perfect registration together with an original negative or transparency for the purpose of contrast control in photographic printing.

MAXIMUM EXPOSURE LEVEL Properly called D-max, the maximum obtainable film or paper density.

MINIMUM LEVEL OF SENSITIVITY The exposure threshold of film or paper.

MONORAIL A rigid tube of square or round cross-section that supports the front and back standards of a view camera.

NEUTRAL DENSITY FILTER An optical device that is fitted in front of a photographic lens in order to reduce light transmission by a known amount without changing the color of the transmitted light.

OPTICAL VIEWFINDER A device (usually built into a non-SLR camera) consisting of a simple optical system used to give a close approximation of the field of view encompassed by a particular lens.

OUTTAKE Any photographs or slides eliminated or discarded during the editing process.

PAINTING WITH LIGHT A technique that allows a large scene to be illuminated by smoothly sweeping the beam of a photographic light during a long exposure.

PC LENS See "perspective control lens."

PERSPECTIVE CONTROL (PC) LENS A specially designed lens that mimics view camera perspective-control movements; intended for use with SLR cameras.

PERSPECTIVE DISTORTION The unnatural appearance of objects in photographs made without the use of perspective controls.

PHOTOCELL A device for changing light energy into electrical energy.

PHOTONS A quantum of radiant energy. The smallest "package" of light found in nature.

PICTORIAL PHOTOGRAPHY Nineteenth- century phrase that describes a romantic, highly stylized type of landscape photography. The term also refers to any photography that is not documentary in nature.

PINCUSHION DISTORTION An optical aberration of photographic lenses (usually zoom lenses) in which vertical and horizontal lines are rendered as curving inward toward the center of the image.

PLANE OF FOCUS A plane that describes a sharply focused image of a flat photographic subject.

POLARIZATION A process of modifying the orientation of the plane of vibration of light waves, a photographically significant property of light. Useful in controlling reflected light from certain surfaces without altering color.

POLARIZING FILTER An optical device that causes light to be polarized. Allows the axis of polarization to be varied.

PREVISUALIZATION A term, coined by photographer Ansel Adams, that describes the process of intellectually predetermining the properties of a photographic image before an exposure is made.

PROCESS LENS An apochromatic lens used in various non-photographic printing processes.

PULLING A darkroom technique for reducing film speed and/or reducing contrast by removing film from the developer before normal processing time has elapsed.

PUSHING A darkroom technique for in-creasing film speed and/or increasing contrast by allowing the film to remain in the developer longer than normal processing time.

RANGE FINDER A device that measures camera-to-subject distance by means of triangulation.

REAR FALL The downward movement of the back standard on a view camera.

REAR RISE The upward movement of the back standard on a view camera.

REAR SHIFT The sideways movement of the back standard of a view camera.

REAR TILT The rotation about a horizontal axis of the back standard of a view camera.

REAR SWING The rotation about a vertical axis of the back standard of a view camera.

RECIPROCITY EFFECT More correctly, reciprocity failure. The loss of film speed and contrast that occurs at a long exposure time under low levels of illumination.

REFLECTION DENSITOMETER A densitometer that measures the light reflected from photographic print material.

RELATIVE BRIGHTNESS Describes the difference of brightness of two areas or objects within a scene. See "brightness range" and "brightness ratio."

RELATIVE COLOR Describes the difference in color balance between scenes illuminated by sources of different color or the difference in color balance between two photographs of the same scene made with different filtration.

RETROFOCUS LENS A specially designed lens that allows a wider displacement between the lens and the film plane than would be required by a lens of conventional design. This innovation allows enough room for the incorporation of a swinging mirror behind the lens in SLR cameras.

REVERSAL FILM A photographic film (either color or black-and-white) that records an image in which dark areas of the subject are rendered as dark on the film, and light areas of the subject are rendered as light on the film. See "slide film."

SHUTTER A mechanical or electro-mechanical device that opens and closes a light-tight barrier for a predetermined length of time to allow controlled exposure of light-sensitive materials in a camera.

SINGLE LENS REFLEX (SLR) CAMERA A camera design, incorporating a mirror and a prism, that allows the photographer to see in the viewfinder whatever the taking lens sees.

SLIDE FILE A system of organizing and storing 35mm color transparencies; usually involves 8x11in polyethylene sheets with twenty 2x2in pockets.

SLIDE FILM Reversal film; generally used to describe 35mm color transparency film.

SLR CAMERA See "single lens reflex camera."

SMALL-FORMAT CAMERA Any camera that uses 35mm film.

SPECIAL EFFECTS FILTER An optical device placed in front of a photographic lens in order to modify the image in an unusual way (e.g., diffusion, multiple image).

SPECULARITY Describes the relative size of a light source. Only a point source is truly specular. All other sources are diffuse or semi-diffuse.

STANDARD A mechanical device for securing a lens or a film back to a view camera monorail. A well-designed and constructed standard allows the precise movements of rise, fall, shift, and tilt.

TECHNICAL CAMERA See "view camera."

TELEPHOTO LENS A lens of a longer-than-normal focal length with a relatively short physical length. Not all long lenses are of tele design.

THROUGH-THE-LENS (TTL) METER see "behind-the-lens (BTL) meter"

TONALITIES The various densities recorded on a photographic print or transparencies.

TRANSPARENCY FILM See "reversal film."

TRANSMISSION DENSITOMETER A densitometer that measures the light transmitted through photographic negatives or transparencies.

TRIPOD A rigid, three-legged device of adjustable height for securing a camera in position during long exposures.

TRIPOD HEAD A device for securing a camera to a tripod. Allows control of the horizontal and vertical orientation of the camera.

TTL METER See "through-the-lens meter."

ULTRAVIOLET FILTER An optical device that blocks ultraviolet radiation from entering a photographic lens.

VIEW CAMERA A camera design that allows the photographer to manipulate various optical parameters by altering the relative orientation of a film back and a lens linked together by a flexible light-tight bellows. The image is viewed on a ground glass screen in the film back.

WIDE-ANGLE DISTORTION The unnatural appearance of foreground objects in a photograph made with a wide-angle lens.

WIDE-ANGLE LENS A photographic lens with a wide field of view.

WIDE-ANGLE PROJECTION LENS A wide-angle lens specifically designed to allow a shorter-than-normal distance between a slide projector and screen.

INDEX

AERIAL PHOTOGRAPHY 72-3

ARCHITECTURAL PHOTOGRAPHY
as different from commercial advertising 8, 12-2, 16-7, 66
characteristics of good 8, 13
costs 15-7, 19-20, 24, 72-3
dispute handling (aesthetic, financial) 19-20

ARTIFICIAL BACKGROUNDS 90-1

BARREL DISTORTION 60

BILLING 15-6, 19, 104-5, 115

BRACKETING 62-3, 74, 95, 99

CABLE RELEASES 60, 73, 79, 86

CAMERAS
basic workings 14, 28, 32, 58
flatbed/field 14
large format 13-4, 46, 98-100
medium format 31, 96-7
non-SLR medium format 97-8
purchasing 58-9
selection of 31-2, 47, 58-9, 66, 95-100
single lens reflex (SLR) 30-1, 34, 54, 94

CLIENTS, NEEDS AND RELATIONSHIPS
architectural firms 15, 18, 42, 114-5
billing 15-6, 19, 104-5, 115
interaction 15, 18-20, 42, 107
print media 46, 102-7
scheduling 19, 114-5

COLOR
balance 89
evaluation 44-5
fidelity 89
manipulation (see also filters) 45

COMPETITION ENTRIES 111

COMPUTERS 47
desktop publishing 109-10
digital imaging 118

CONTAMINANTS 53, 64, 92-3

CUSTOM LABS
capabilities 37-40, 63, 73, 82, 90, 107
processing 37-9
relationships with 73, 82, 107

CONSTRUCTION SITES, PHOTOS 92-93

DARKROOMS 117-18

DENSITOMETER 35

DEPTH-OF-FIELD 34, 53, 58, 86, 90

DIGITAL IMAGING 118

DETAIL PHOTOGRAPHY 86-7

DISPLAYS/PRESENTATIONS 111

DOCUMENTARY PHOTOGRAPHY 42

DOCUMENTATION/RECORDS 64, 73, 83

DRAWINGS, PHOTOGRAPHS OF 88-90

ENLARGEMENTS, STANDARD SIZES 45

EQUIPMENT, BASIC 28-34, 58-61

EQUIPMENT, USED 58-60, 98

EXPOSURE
indices 61
long, difficulties with 60, 79-80, 94
reciprocity effect 80, 86, 94
techniques 33, 60, 79-80, 94

EXTERIOR SHOTS 66-73
see also light evaluation, site evaluation

FILM
black and white 35-6, 106-7
color negative 35-7, 39-40, 45, 82, 106
color positive (transparency) 35-7
contrast 35-6
general overview 30, 35-37, 45, 61, 63, 66, 86
resolution 35-6
selection 63, 66, 94-5, 99, 105-7, 117
see also prints

FILTERS 53, 61, 69-70
neutral density 81
polarizing 53, 70-1, 86

FLASH 94-5

IN-HOUSE PHOTOGRAPHY
assistants, use of 100
basic guidelines 24-5
equipment needed 24-5, 59-61, 98-100
when appropriate 24-6, 37, 39-40, 96

INTERIOR SHOTS 73-81
see also light evaluation

ISO EVALUATION 61-2

KELVIN MEASUREMENT 44, 74

LENS SHADES 60

LENSES 34, 55
apochromatic (APO) 88
fixed focal length 53, 59-60
long telephoto 53
medium telephoto 49, 53, 59
normal 48-9, 59
perspective control 32, 47, 53-5, 60, 95-7
retrofocus 98
selection 67-8, 86, 88, 95-100
wide-angle 49, 55-6, 59, 80-1
zoom 53, 59-60

LIGHT 42-44
contrast/brightness 34, 74
diffuse 42-44
evaluation 42-5, 66-7, 69, 74, 86